Elisabetta 'Kuky' Drudi
FABRIC TEXTURES & PATTERNS

LES TISSUS : TEXTURES ET MOTIFS
TEJIDOS: TEXTURAS Y MOTIVOS
TESSUTI: STRUTTURA E MOTIVI
STOFF: GEWEBE UND MUSTER

1

COLOPHON

The Pepin Press
P.O. Box 10349
1001 EH Amsterdam
T +31 20 4202021
F +31 20 4201152
mail@pepinpress.com
www.pepinpress.com

Concept & Drawings: Elisabetta 'Kuky' Drudi
Text: Elisabetta 'Kuky' Drudi with additions by Kevin Haworth and Pepin van Roojen
Editorial supervision: Kevin Haworth
Design: Pepin van Roojen

ISBN 978 90 5768 112 7

10 9 8 7 6 5 4 3 2
2014 13 12 11 10 09 08

Manufactured in Singapore

Elisabetta 'Kuky' Drudi obtained her degree at the Istituto d'Arte F. Mengaroni in Pesaro, Italy. Since then, she has worked as a designer and illustrator for many well-known international fashion houses. Her books *Figure Drawing for Fashion Design* and *Wrap & Drape Fashion* , both published by The Pepin Press in several language editions, have become classics in the field of fashion illustration and are used by professionals and students the world over. Her new title, *Fashion Prints: How to Design and Draw*, will be published by The Pepin Press in 2008 with an accompanying CD.
Elisabetta Drudi continues to be very active creating fashion and textile designs for world-famous brands.

CONTENTS

Free CD-ROM inside back cover

CD-ROM and Image Rights

The names of the files on the CD-ROM correspond with the page numbers in this book. For non-professional applications, single images can be used free of charge. The images cannot be used for any type of commercial or otherwise professional application – including all types of printed or digital publications – without prior permission from The Pepin Press/Agile Rabbit Editions. Our permissions policy is very reasonable and fees charged, if any, tend to be minimal.

For inquiries about permissions and fees, please consult our website http://www.pepinpress.com or contact us at:
mail@pepinpress.com | Fax +31 20 4201152

CONTENUTO

CD-ROM gratuito nel retrocopertina

CD-ROM e diritti d'immagine

I nomi dei file sul CD ROM corrispondono ai numeri di pagina indicati nel libro. Delle singole immagini possono essere utilizzate senza costi aggiuntivi a fini non professionali. Le immagini non possono essere utilizzate per nessun tipo di applicazione commerciale o professionale – compresi tutti i tipi di pubblicazioni stampate e digitali – senza la previa autorizzazione della Pepin Press/Agile Rabbit Editions. La nostra gestione delle autorizzazioni è estremamente ragionevole e le tariffe addizionali applicate, qualora ricorrano, sono minime.

Per ulteriori domande riguardo le autorizzazioni e le tariffe, vi preghiamo di consultare il nostro sito web http://www.pepinpress.com o di contattarci ai seguenti recapiti:
mail@pepinpress.com | Fax +31 20 4201152

INHALT

Gratis CD-ROM befindet sich hinten im Buch

SUMARIO

CD-ROM gratuito en el interior de la solapa posterior

TABLE DES MATIÈRES

CD-ROM gratuit à l'intérieur de la couverture arrière

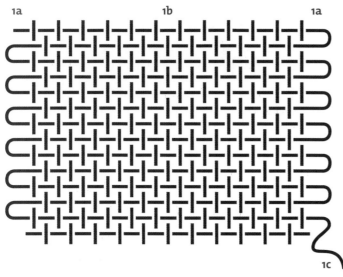

1a **1b** **1a**

1c

1d

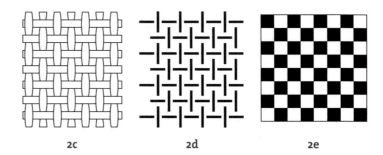

2a **2b** = ■ = □

2c **2d** **2e**

Basic fabric structure
1a selvage / selvedge
1b warp threads
1c weft threads
1d width of the fabric

Struttura basica del tessuto
1a vivagno (o cimosa)
1b fili dell'ordito
1c fili della trama
1d larghezza / altezza del tessuto

Grundsätzliche Gewebestruktur
1a Webkante
1b Kettfäden
1c Schussfäden
1d Stoffbreite

Estructura básica del tejido
1a orillo
1b hilos de urdimbre
1c hilos de trama
1d anchura de la tela

Structure de base du tissu
1a la lisière
1b le fil de chaîne
1c le fil de trame
1d la largeur du tissu

Fabric weave drawing and diagram
In a standard weaving process, threads can only interact in two ways – the warp thread either passes over the weft (2a top) or under it (2a bottom). These can be represented in a weave diagram by using black (warp over weft) and white (warp under weft) squares (2b).
2c drawing of a fabric sample with a simple weave
2d simplified drawing of the same fabric (as in 2a)
2e weave diagram of this fabric (as in 2b)

Il disegno della trama e lo schema di armatura
Nel processo standard della tessitura i fili possono interagire tra loro solo in due modi – i fili dell'ordito passano sulla trama (2a in alto) o sotto di essa (2a in basso). Nel realizzare lo schema del tessuto, ciò può essere reso usando quadrati neri (trama o ordito) e bianchi (trama o ordito) (2b).
2c schema di un campione di tessuto a tessitura semplice
2d disegni semplificati dello stesso tessuto (come in 2a)
2e schema di armatura di questo tessuto (come in 2b)

Bindungsbild
Beim normalen Webverfahren können Fäden nur auf zwei Arten aufeinander einwirken – die Webkette wird entweder über (2a oben) oder unter den Schuss (2a unten) geführt. Diese werden in einem Bindungsbild mit schwarzen (Webkette über dem Schuss) und weißen Quadraten (Webkette unter dem Schuss) wiedergegeben (2b).
2c Zeichnung eines Stoffes mit einem einfachen Webmuster
2d vereinfachte Zeichnung des gleichen Stoffes (wie in 2a)
2e Bindungsbild dieses Stoffes (wie in 2b)

f b

3a

3b

3c

3d

Dibujo y representación gráfica de los ligamentos
En un proceso de calada estándar, los hilos solo interactúan de dos formas: el hilo de urdimbre pasa por encima de la trama (2a, arriba) o por debajo de esta (2a, abajo). Gráficamente, esto puede representarse con cuadros negros (urdimbre sobre trama) y blancos (urdimbre bajo trama) (2b).
2c dibujo de una muestra de tejido con un ligamento simple
2d dibujo simplificado del mismo tejido (como en 2a)
2e representación gráfica del ligamento de este tejido (como en 2b)

Dessins d'armure
Dans le processus de tissage courant, les fils peuvent s'entrecroiser de deux façons : le fil de trame peut passer soit sur la chaîne (2a en haut) soit sous la chaîne (2a en bas). On peut les représenter dans un dessin d'armure au moyen de carrés noirs (la trame sur la chaîne) et blancs (la trame sous la chaîne) (2b).
2c dessin d'un échantillon de tissu à armure toile
2d dessin simplifié du même tissu (comme dans 2a)
2e dessin d'armure de ce tissu (comme dans 2b)

Examples of weave patterns
3a cloth weave
3b twill weave 2/2
3c twill weave 2/1
3d satin weave
f front of fabric
b back of fabric

Esempi di modelli di tessitura
3a armatura a tela
3b armatura a batavia
3c armatura a saia o levantina
3d armatura satin
f davanti del tessuto
b dietro del tessuto

Beispiele von Webmuster
3a Leinwandbindung
3b Köperbindung 2/2
3c Köperbindung 2/1
3d Satinbindung
f Vorderseite des Stoffes
b Rückseite des Stoffes

Ejemplos de ligamentos
3a ligamento de tafetán
3b ligamento de sarga (2/2)
3c ligamento de sarga (2/1)
3d ligamento de raso
f haz del tejido
b envés del tejido

Exemples d'armures
3a armure unie
3b armure sergé (2/2)
3c armure sergé (2/1)
3d armure satin
f avant du tissu
b arrière du tissu

This book contains an array of fabrics reinterpreted for use in fashion design and selected on the basis of the reproducibility of their surfaces. Many 'plain' textiles and textiles that do not have a visible weave or pattern have, therefore, been excluded. For an introduction to basic fabric terminology and weave diagrams, please see pages 4 and 5.

Fabric

Fabric is the result of the interweaving of "warp" (or "chain") threads that run vertically – in the direction of the length of the roll – and "weft" threads that run horizontally. Together these become a uniform structure that varies in flexibility, texture, strength, thickness and density according to the yarn used and the fabric weave. The warp threads, laid out parallel to each other, determine the length of the fabric and run perpendicular to the weft threads. The width of the fabric is determined by the number and spacing of warp threads and is bounded on both sides by selvages (or selvedge), a small number of threads equal or superior in strength to the warp threads. A fabric is defined according to its width, weight per metre (or yard), the number of weft and warp threads per centimetre (or inch), the thread weight and the weave.

The Yarn

Yarns (or threads) can be made from fibres of animal origin (e.g. wool and silk), of plant origin (e.g. linen and cotton) or that have been made synthetically (e.g. acrylic and latex). The yarn count is a measure of the quality and indicates the length of yarn in relation to its weight: the higher the count, the finer and more delicate the yarn.

Before yarn is spun, raw fibres are carded, a process which loosens and separates the fibres, aligns them and removes impurities. After carding, the fibres can also be combed to remove short fibres, arrange the remaining fibres in a more uniform and parallel configuration and remove any remaining impurities. Combed yarns are smoother and stronger than yarns that have only been carded and are, therefore, used to make higher quality fabrics.

Weaves

The pattern that regulates the way in which the weft and warp threads are interlaced is called the weave. There are countless different types of weaves and each can be represented graphically using a weave diagram. The process of making a weave diagram is described on pages 4 and 5. Some common types of fabric weaves include:

Cloth Weave

A cloth weave is the simplest weave of all. The weft threads alternate passing over 1 warp and under 1 – this is a 1/1 weave. A weave diagram of a simple cloth weave looks like a basic checkerboard (see 3a on page 5). The front and back of the fabric are identical.

Twill weave

Fabrics with a twill weave have a strong diagonal visual effect and turn out to be very pliable. Two examples of twill weaves are pictured on page 5. In a 2/2 twill weave (3b on page 5), the weft thread passes over 2 warp threads and under 2 – front and back of the fabric look the same. In a 2/1 twill weave (3c on page 5), the weft passes over 2 warp and under 1 – front and back of the fabric are not the same.

Numerous fabrics are woven using variations of twill weaves, these include: Prince of Wales, houndstooth, tweed, gabardine, denim, velvet and corduroy.

Satin weave

In a satin weave, the interlacing of the warp and weft threads is more widely spaced. This gives the effect of evenly distributed points rather than a strong diagonal line (see 3d on page 5). Primarily weft threads are visible on one side of the fabric while warp threads predominate on the other side. The most common satin weaves are satin numbers 5 and 8. In these fabrics, the interweaving of warp threads is repeated at intervals of 5 or 8 wefts, respectively.

Fabric Treatments

After weaving, fabrics can be further treated in a number of ways. Examples of these treatments include:

fulling: a process designed to make wool and felt fabrics stronger, more compact and more resistant to moisture

teasing: a process used to create a soft, fuzzy surface

coating: applying a (usually synthetic) additive to the fabric to make it waterproof, add sheen or change the way it looks and/or feels.

IL TESSUTO: NOZIONI DI BASE

Questo libro illustra una serie di armature tessili, reinterpretate per il design di moda e selezionate in base alla resa grafica del loro disegno. Sono state escluse, quindi, tutte le tipologie tessili ad armatura semplice e tutti quei tessuti che non presentano una trama o un modello chiaro e definito. Per un'introduzione alla terminologia di base dei tessuti e agli schemi di armatura si faccia riferimento alle pagine 4 e 5.

Tessuto

Un tessuto è il risultato dell'intreccio tra i fili di *ordito* (o *catena*) tesi sul telaio in verticale – ossia in direzione della lunghezza del rullo – e quelli di "trama", posti in orizzontale. La combinazione di questi fili crea una struttura omogenea che varia in quanto a morbidezza, consistenza, resistenza, spessore e pesantezza, a seconda del tipo di filato utilizzato e della trama del tessuto stesso. I fili di ordito, disposti parallelamente l'uno all'altro, determinano la lunghezza del tessuto e sono perpendicolari ai fili della trama. La larghezza/altezza del tessuto è definita dal numero e dalla distanza (passo) dei fili di trama ed è delimitata, a destra e a sinistra, dalle cimosse (o vivagni), la cui armatura può essere diversa da quella del tessuto, in genere è uguale o più resistente. Un tessuto viene definito in base alla sua larghezza/altezza, al peso per metro, al numero di fili di trama e ordito per centimetro, al titolo dei filati e all'armatura.

Il Filato

Il filato (o fili) è l'insieme di fibre di origine animale (ad esempio lana e seta), vegetale (ad esempio lino o cotone) o sintetica (ad esempio acrilico). Il titolo del filato ne definisce la qualità e indica il rapporto tra la lunghezza e il peso dello stesso: a un titolo maggiore corrispondono una qualità superiore e una maggiore leggerezza del filato.

Prima di procedere con la filatura, la fibra grezza deve essere cardata per districare e separare le fibre, allinearle e rimuovere ogni impurità. In seguito le fibre possono anche essere sottoposte al processo di pettinatura, in modo da scartare quelle più corte, ordinare le rimanenti – la cosiddetta parallelizzazione delle fibre – ed eliminare eventuali impurità residue. Un filato sottoposto a pettinatura risulta più uniforme e più resistente. Per questo motivo i filati pettinati vengono utilizzati per produrre tessuti di qualità superiore.

Armatura

Il modello che regola l'intrecciatura dei fili di ordito con quelli di trama è detto armatura. Le combinazioni di intrecci e quindi le tipologie di armatura sono pressoché infinite e si possono rappresentare graficamente utilizzando degli schemi di armatura. Il processo di rappresentazione grafica dell'arma-tura – la messa in carta – è descritto alle pagine 4 e 5. Ecco alcuni tra i più comuni schemi di armatura:

Armatura a tela

È il tipo di armatura più semplice e si ottiene inserendo i fili di trama alternati su quelli di ordito – il rapporto è di 1:1. Questa struttura si può rappresentare graficamente come una scacchiera (vedi grafico 3a a pagina 5) e lo schema è identico su entrambe le facce del tessuto.

Armatura a batavia o a saia (levantina)

I tessuti con armatura a batavia o a saia presentano un tipico effetto ottico diagonale e sono particolarmente flessibili ed elastici. A pagina 5 sono raffigurati due di questi. Se il rapporto è di 2:2 (armatura a batavia, 3b a pagina 5), il filo di trama passa prima sopra a due fili di ordito e poi sotto ad altri due – le stoffe che si ottengono hanno il diritto uguale al rovescio. Se il rapporto è di 2:1 (armatura a saia, 3c a pagina 5), il filo di trama passa prima sopra a due fili di ordito e poi sotto a uno – il diritto e il rovescio sono diversi.

I tessuti realizzati con variazioni di armatura a batavia o a saia sono ad esempio: il principe di Galles, il pied de poule, il tweed, il gabardine, il denim, il velluto e il velluto a coste.

Armatura a raso

In questo tipo di armatura l'intreccio dei fili di ordito e di trama è più rado e dà luogo a punti distanziati e regolarmente distribuiti (vedi immagine 3d a pagina 5). I fili di trama sono visibili su un lato del tessuto, mentre quelli di ordito predominano sull'altro lato. Le armature a raso più comuni sono il raso da 5 e il raso da 8. In questi tipi di tessuto l'intreccio dei fili di ordito è ripetuto rispettivamente a intervalli di cinque o otto fili di trama.

Trattamenti ai quali possono essere sottoposti i tessuti

Dopo la filatura i tessuti possono essere sottoposti a ulteriori processi trattanti, quali ad esempio la follatura, un'operazione che permette di rendere la lana e il feltro più resistenti, compatti e impermeabili, la garzatura, che consiste nel sollevare le fibre dei fili di un tessuto per renderlo morbido e soffice, e la spalmatura, ovverosia l'applicazione di un additivo – in genere sintetico – che rende il tessuto idrorepellente, lo lucida o ne cambia l'aspetto o la sensazione al tatto.

Dieses Buch enthält eine große Anzahl von Stoffen, die für die Verwendung im Modedesign neu interpretiert wurden und auf der Basis der Reproduzierbarkeit ihrer Oberflächen ausgewählt wurden. Aus diesem Grund wurden viele Stoffe, die »glatt« sind oder an denen kein Gewebe oder Muster sichtbar ist, nicht inbegriffen. Eine Einführung in grundlegende Gewebeterminologie und Bindungsbilder ist auf Seite 4 und 5 zu finden.

Stoff

Stoff ist das Ergebnis der Durchwebung der Fäden der »Webkette«, die vertikal verlaufen – in der Längsrichtung der Rolle – und der Fäden des »Schusses«, die horizontal verlaufen. Diese bilden zusammen eine einheitliche Struktur, die in Hinsicht auf Flexibilität, Beschaffenheit, Festigkeit, Dicke und Dichte abhängig vom eingesetzten Garn und der Webart variiert. Die Fäden der Webketten, die parallel zueinander verlaufen, bestimmen die Länge des Stoffes und verlaufen senkrecht zu den Schussfäden. Die Breite des Stoffes wird von der Anzahl und dem Abstand der Fäden der Webketten bestimmt. Der Stoff wird auf beiden Seiten von Leisten begrenzt, einer kleinen Anzahl von Fäden, die in Bezug auf die Festigkeit den Webketten gleich sind oder diese sogar übertreffen. Ein Stoff wird gemäß seiner Breite, Gewicht pro Meter, der Anzahl der Schuss- und Kettfäden pro Zentimeter, dem Garngewicht und der Webart definiert.

Das Garn

Garn (oder Fäden) kann aus Fasern tierischen Ursprungs (z. B. Wolle oder Seide) oder pflanzlichen Ursprungs (z. B. Leinen oder Baumwolle) gewonnen werden oder synthetisch hergestellt werden (z. B. Acryl und Latex). Die Garnnummer ist eine Qualitätseinheit und gibt die Garnlänge in Bezug auf sein Gewicht an. Je höher die Nummer, desto feiner und dünner ist das Garn.

Bevor Garn gesponnen wird, werden die unbehandelten Fasern gekardet, ein Prozess der die Fasern lockert und trennt, ausrichtet und Verunreinigungen entfernt. Nach dem Karden können die Fasern ebenfalls zum Entfernen kurzer Fasern gekämmt werden. Die verbleibenden Fasern erhalten eine einheitlichere parallele Anordnung und verbleibende Verunreinigungen, die noch vorhanden sind, werden ebenfalls entfernt. Gekämmte Garne sind glatter und stärker als Garne, die nur gekardet wurden und werden aus diesem Grund zur Herstellung von Stoffen verwendet, die eine höhere Qualität besitzen.

Webarten

Das Muster, das bestimmt in welcher Art die Schuss- und Kettfäden verflochten werden, wird die Webart genannt. Es gibt unzählige unterschiedliche Webarten und jede davon kann grafisch mithilfe eines Bindungsbildes dargestellt werden. Eine Beschreibung des Verfahrens mit dem ein Bindungsbild erstellt wird, ist auf Seite 4 und 5 zu finden. Nachfolgend werden einige herkömmliche Webarten beschrieben.

Leinwandbindung

Die einfachste Webart ist die Leinwandbindung. Die Schussfäden verlaufen über eine (1) Webkette und unter einer (1) – dies ist eine 1/1 Bindung. Ein Bindungsbild einer einfachen Leinwandbindung ähnelt dem Muster eines Schachbretts (siehe 3a auf Seite 5). Die Vorder- und Rückseite des Stoffes sind identisch.

Köperbindung

Stoffe mit einer Köperbindung besitzen einen starken diagonalen visuellen Effekt und das Endprodukt ist äußerst biegsam. Auf Seite 5 sind zwei Beispiele von Köperbindungen abgebildet. In einer 2/2 Köperbindung (3b auf Seite 5) wird der Schussfaden über 2 Kettfäden und unter 2 geführt – die Vorder- und Rückseite des Stoffes sehen gleich aus. In einer 2/1 Köperbindung (3c auf Seite 5) wird der Schussfaden über 2 Kettfäden und unter einem Faden (1) geführt – die Vorder- und Rückseite des Stoffes sehen nicht gleich aus.

Zahlreiche Stoffe werden mit Variationen von Köperbindungen gewebt, dies sind einige Beispiele: »Prince of Wales«, Pepita, Tweed, Gabardine, Denim, Samt und Kordsamt.

Satinbindung

In einer Satinbindung ist die Verflechtung von Kett- und Schussfäden weniger engmaschig. Dies führt zum Effekt von gleichmäßig verteilten Punkten anstatt einer starken diagonalen Linie (siehe 3d auf Seite 5). In erster Linie sind die Schussfäden auf einer Seite des Stoffes sichtbar, während Kettfäden auf der anderen Seite vorherrschen. Die häufigsten Satinbindungen sind Satinnummern 5 und 8. In diesen Stoffen wird die Verflechtung der Kettfäden mit Intervallen von 5 bzw. 8 Schussfäden wiederholt.

Behandlung von Stoffen

Nach dem Weben können Stoffe auf eine Anzahl von Arten weiterbehandelt werden. Beispiele dieser Behandlungen sind:
Walken: ein Verfahren mit dem Wolle und Filzstoffe verstärkt, verdichtet und widerstandsfähiger gegen Feuchtigkeit gemacht werden.
Zupfen: ein Verfahren mit dem eine weiche, fusselige Oberfläche erzielt wird.
Beschichten: der Auftrag eines (im Normalfall synthetischen) Zusatzes mit dem der Stoff wasserdicht gemacht wird, Glanz hinzugefügt wird oder das Aussehen / der Griff des Stoffes verändert wird.

NOCIONES BÁSICAS DEL DISEÑO DE TEJIDOS

Este libro ilustra una serie de tejidos reinterpretados para su utilización en el diseño de moda y seleccionados en base a la capacidad de reproducción de sus superficies. En consecuencia, los tejidos «básicos» y los que carecen de un calado o motivo visible se han excluido. Para familiarizarse con la terminología básica de los tejidos y las representaciones gráficas de los ligamentos, véanse las páginas 4 y 5.

Tejido

El tejido es el resultado de entretejer los hilos de «urdimbre», dispuestos vertical o longitudinalmente, y los de la «trama», dispuestos horizontal o transversalmente. Juntos, estos hilos crean una estructura uniforme de flexibilidad, textura, rigidez, grosor y densidad variables en función del hilado y la tejeduría de calado. Los hilos de urdimbre, distribuidos en paralelo, determinan la longitud del tejido y están dispuestos en perpendicular a los hilos de trama. La anchura del tejido depende de la cantidad y el espaciado de los hilos de urdimbre, y queda delimitada a ambos lados por los orillos, unos cuantos hilos de igual o mayor resistencia que los hilos de urdimbre. Los tejidos se definen según la anchura, el peso por metro, la cantidad de hilos de urdimbre y de trama por centímetro, el peso del hilo y el ligamento.

Hilo

El hilo se obtiene a partir de fibras de origen animal (como la lana o la seda), vegetal (lino y algodón) o sintético (acrílico y látex). La numeración de los hilos es un estándar de calidad que indica la longitud del hilo con relación a su peso: cuanto mayor sea el número, más fino y delicado será el hilo.

Antes de proceder al hilado, la materia prima se carda. El cardado consiste en abrir y separar las fibras, mecharlas y limpiarlas de impurezas. Tras el cardado, las fibras también pueden peinarse para eliminar las fibras más cortas, distribuir el resto de las fibras de un modo más uniforme y retirar las impurezas que hayan podido quedar. Las fibras peinadas son más suaves y resistentes que las que solo se cardan, de ahí que se reserven para los tejidos de más calidad.

Ligamento

La forma en que los hilos de la trama y la urdimbre se entrecruzan en cada pasada se denomina *ligamento*. Existen infinitos tipos de ligamentos, y todos ellos pueden representarse gráficamente. Para averiguar cómo hacerlo, véanse las páginas 4 y 5. Algunos de los ligamentos más habituales son los siguientes:

Ligamento de tafetán

El ligamento de tafetán o ligamento 1/1 es el más sencillo. Los hilos de trama pasan alternativamente por encima y por debajo del hilo de urdimbre. La representación gráfica de un ligamento de tafetán básico recuerda a un tablero de ajedrez (véase 3a en la página 5). El haz y el envés del tejido son idénticos.

Ligamento de surga

El ligamento de sarga presenta una distribución al bies muy evidente y es muy flexible. En la página 5 se muestran dos ejemplos de ligamentos de sarga. En un ligamento de sarga 2/2 (véase 3b en la página 5), cada hilo de trama se cruza alternativamente por encima y por debajo de dos hilos de urdimbre; el haz y el envés del tejido son idénticos. En un ligamento de sarga 2/1 (véase 3c en la página 5), cada hilo de trama se cruza por encima de 2 hilos de urdimbre y por debajo de 1 hilo de urdimbre alternativamente; el haz y el envés del tejido son distintos.

El ligamento de sarga es la base de distintos tipos de tejidos, como por ejemplo el cuadro príncipe de Gales, la pata de gallo, el *tweed*, la gabardina, el *denim*, el terciopelo y la pana.

Ligamento de raso

En el ligamento de raso, los hilos de urdimbre y de trama se entrecruzan de una forma más espaciada. El efecto recuerda más bien a una serie de puntos distribuidos uniformemente que a una marcada línea al bies (véase 3d en la página 5). Los hilos de trama quedan visibles a un lado del tejido, mientras que los de urdimbre predominan en el otro. Los ligamentos de raso más habituales son los números 5 y 8. En ellos, el entrecruzamiento de hilos de urdimbre se repite en intervalos de 5 u 8 tramas, respectivamente.

Acabado de los tejidos

Después del ligamento, los tejidos pueden someterse a distintos tratamientos, como por ejemplo los siguientes:

abatanado: proceso que se aplica a los tejidos de lana y fieltro para que queden más fuertes, compactos y resistentes a la humedad
cardado: proceso que se aplica para crear una superficie mullida y encrespada
recubrimiento: aplicación de un aditivo (normalmente sintético) al tejido para impermeabilizarlo, darle lustre o modificar la apariencia y/o el tacto del mismo.

Ce livre contient un éventail de tissus étudiés pour être utilisés en création de mode et sélectionnés sur la base de la reproductibilité de leur surface. Plusieurs tissus unis, ainsi que les tissus dont le tissage ou le motif n'est pas clairement visible, ont par conséquent été exclus. Pour une introduction à la terminologie des tissus et des dessins d'armure, veuillez consulter les pages 4 et 5.

Le tissu

Le tissu est le résultat de l'entrelacement de fils de « chaîne » qui courent verticalement, c'est-à-dire dans le sens de la longueur du tissu, et des fils de « trame » qui courent horizontalement. Ils forment ensemble une structure uniforme qui varie en flexibilité, en texture, en force, en épaisseur et en densité selon le fil utilisé et le tissage. Les fils de chaîne, qui sont parallèles les uns aux autres, déterminent la longueur du tissu et courent perpendiculaires aux fils de trame. La largeur du tissu est déterminée par le nombre et l'espacement des fils de chaîne et est limitée de chaque côté par la lisière, un petit nombre de fils de force égale ou supérieure aux fils de chaîne. Le tissu est défini selon sa largeur, son poids au mètre, le nombre de fils de trame et de chaîne au centimètre, le poids du fil et le tissage.

Le fil

Le fil peut être fait de fibres d'origine animale (par ex. la laine et la soie), végétale (par ex. le lin et le coton) ou synthétique (par ex. l'acrylique et le latex). Le numéro du fil est la mesure de la qualité et il indique la longueur du fil par rapport à son poids : plus le numéro est élevé, plus le fil est fin et délicat.

Avant le filage, les fibres brutes doivent subir un cardage, un procédé qui démêle et sépare les fibres, les aligne et en élimine les impuretés. Après le cardage, les fibres peuvent également être peignées pour enlever les fibres courtes, agencer les fibres restantes de manière plus uniforme et parallèle et éliminer les impuretés restantes. Les fils peignés sont plus doux et plus forts que les fils qui ont été seulement cardés ; ils servent par conséquent à la fabrication de tissus de meilleure qualité.

L'armure

Le modèle qui détermine la façon dont les fils de chaîne et les fils de trame sont croisés s'appelle l'armure. Il existe une multitude de types d'armures et chacune peut être représentée graphiquement à l'aide d'un dessin d'armure. Le processus pour faire un dessin d'armure est décrit aux pages 4 et 5. Vous trouverez ci-dessous certaines des armures les plus communes.

L'armure unie

L'armure unie (ou croisée, toile ou taffetas) est l'armure la plus simple. Les fils de trame passent alternativement sous 1 fil de chaîne et sur 1 fil de chaîne – c'est une armure 1/1. Le dessin d'armure de l'armure unie ressemble à un damier (voir 3a à la page 5). Le devant et l'envers du tissu sont identiques.

L'armure sergé

Les tissus à armure sergé ont un effet visuel diagonal prononcé et s'avèrent très souples. Deux exemples d'armure sergé sont illustrés à la page 5. Dans une armure sergé 2/2 (3b à la page 5), le fil de trame passe sur 2 puis sous 2 fils de chaîne – le devant et l'arrière du tissu sont identiques. Dans une armure sergé 2/1 (3c à la page 5), le fil de trame passe sur 2 puis sous 1 fil de chaîne – le devant et l'arrière du tissu sont distincts.

Beaucoup de tissus sont faits avec des variantes de l'armure sergé, tels le Prince de Galles, le pied-de-poule, le tweed, la gabardine, le denim, le velours et le velours côtelé.

L'armure satin

Dans l'armure satin, le croisement des fils de trame et des fils de chaîne est plus espace. Ceci donne un effet de points répartis régulièrement dans l'espace plutôt que d'une forte ligne diagonale (voir 3d à la page 5). Ce sont surtout les fils de trame qui sont visibles d'un côté du tissu alors que les fils de chaînes dominent de l'autre côté. Les armures satin les plus communes sont les satins de 5 et de 8. Dans ces tissus, l'entrelacement des fils de chaîne se répète à intervalles de 5 ou 8 fils de trame, respectivement.

Les traitements

Après le tissage, on peut traiter les tissus de nombreuses manières. En voici quelques exemples :
Le foulage : procédé servant à renforcer les étoffes de laine et de feutre, à les rendre plus compactes et plus résistantes à l'eau.
Le crêpage : procédé utilisé pour donner au tissu une surface douce et duveteuse.
Le revêtement : application d'un additif (habituellement synthétique) sur le textile pour le rendre imperméable, lui donner du lustre ou modifier son apparence ou sa texture.

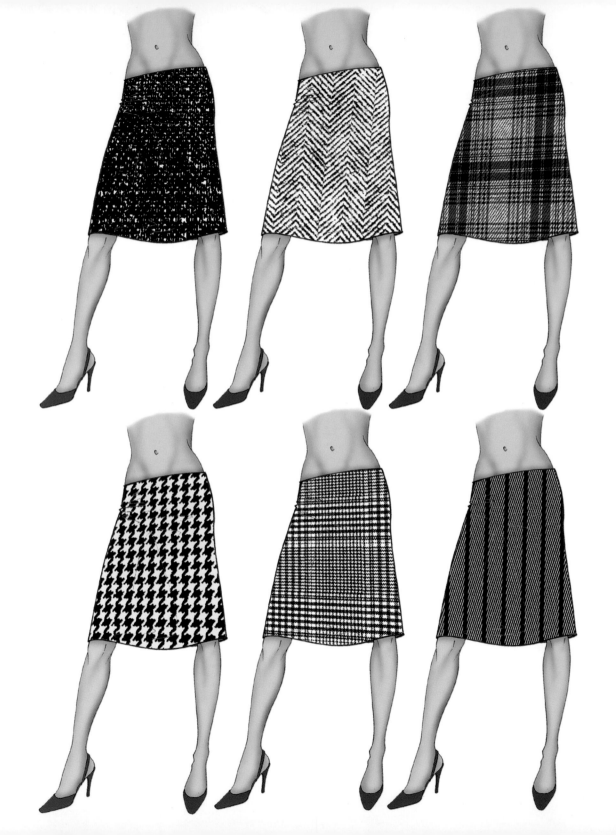

FABRIC AND FASHION DRAWINGS

TESSUTO E FASHION DESIGN

STOFF UND MODE-ZEICHNUNGEN

TEJIDOS Y FIGURINES

DESSINS DE TISSUS ET DE MODE

English

Fabric and Fashion Drawings

Fashion illustrations and technical drawings are used to visualise new clothing designs. It is, of course, of the utmost importance that these be clear, easy to understand, and that they accurately represent the artistic aims of the designer. The fabric samples included in this book are based on major woven fabric types – weaves and patterns that can be used to visualize colour, texture and 'feel' in both fashion illustrations and technical drawings. See for yourselves how the same item of clothing can be changed with the insertion of different fabric designs from this book. They will enable you to quickly experiment with fabric swatches and visualise the end product.

Italiano

Tessuto e fashion design

I figurini e i disegni tecnici di moda vengono utilizzati per visualizzare la progettazione dei nuovi abiti. È assai importante che siano chiari, semplici da comprendere e che rappresentino accuratamente le intenzioni artistiche dello stilista. I campioni di tessuto presenti in questo libro sono basati sui più importanti tipi di tessuto – armature e modelli che possono essere utilizzati per visualizzare il colore, la trama e per 'sentire' il capo tanto nei figurini quanto nei disegni tecnici. Vedrete coi vostri occhi come cambia lo stesso indumento se si utilizzano fantasie diverse, avrete l'opportunità di farvi un'idea dei vari campioni di tessuto e di visualizzare il prodotto finale.

Deutsch

Stoff und Modezeichnungen

Modezeichnungen und technische Zeichnungen werden zur bildlichen Darstellung neuer Kleidungsentwürfe verwendet. Es ist natürlich äußerst wichtig, dass diese deutlich und einfach zu verstehen sind und die künstlerischen Absichten des Entwerfers genau wiedergeben. Die Stoffmuster, die diesem Buch beiliegen, basieren auf gewebten Stofftypen, die häufig eingesetzt werden. Diese Webarten und Muster können zur Veranschaulichung von Farbe, Gewebe und »Griff« sowohl in Modezeichnungen als auch technischen Zeichnungen eingesetzt werden. Probieren Sie selbst aus wie das gleiche Kleidungsstück verändert werden kann, indem unterschiedliche Stoffdessins aus diesem Buch benutzt werden. Diese ermöglichen es Ihnen auf einfache Art mit Stoffproben zu experimentieren und das Endprodukt zu visualisieren.

Español

Tejidos y figurines

Los figurines y los dibujos técnicos permiten visualizar los nuevos diseños textiles. Lógicamente, es imprescindible que resulten sencillos y fáciles de entender, además de representar con precisión los objetivos artísticos del diseñador. Las muestras de este libro están inspiradas en los tipos de tejidos más importantes, cuyos ligamentos y estampados pueden utilizarse para visualizar el color, la textura y el «tacto» de los figurines de moda y los dibujos técnicos. Compruebe cómo cambia una prenda al insertarle uno o varios de los diseños que se incluyen en este libro. De esta forma podrá experimentar fácilmente con los retales y visualizar el resultado final.

Français

Dessins de tissus et de mode

Les illustrations de mode et les dessins techniques sont utilisés pour visualiser les nouveaux styles de vêtements. Il est bien sûr de la plus grande importance que ceux-ci soient clairs, faciles à comprendre et qu'ils représentent avec précision le but du créateur. Les dessins de tissus inclus dans ce livre reposent sur les principaux types d'étoffes tissées – les armures et les motifs qui peuvent être utilisés pour visualiser la couleur, la texture et le « toucher » dans les dessins de mode ainsi que dans les dessins techniques. Voyez par vous-même comment le même vêtement peut être modifié en lui appliquant divers dessins de tissus de ce livre. Ces derniers vous permettront d'expérimenter avec des échantillons de tissus et de visualiser rapidement le produit fini.

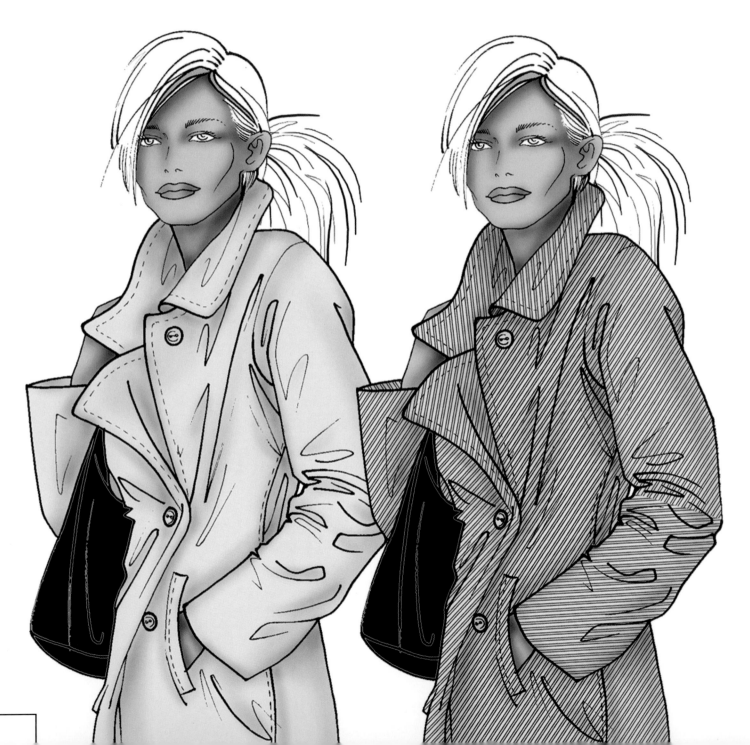

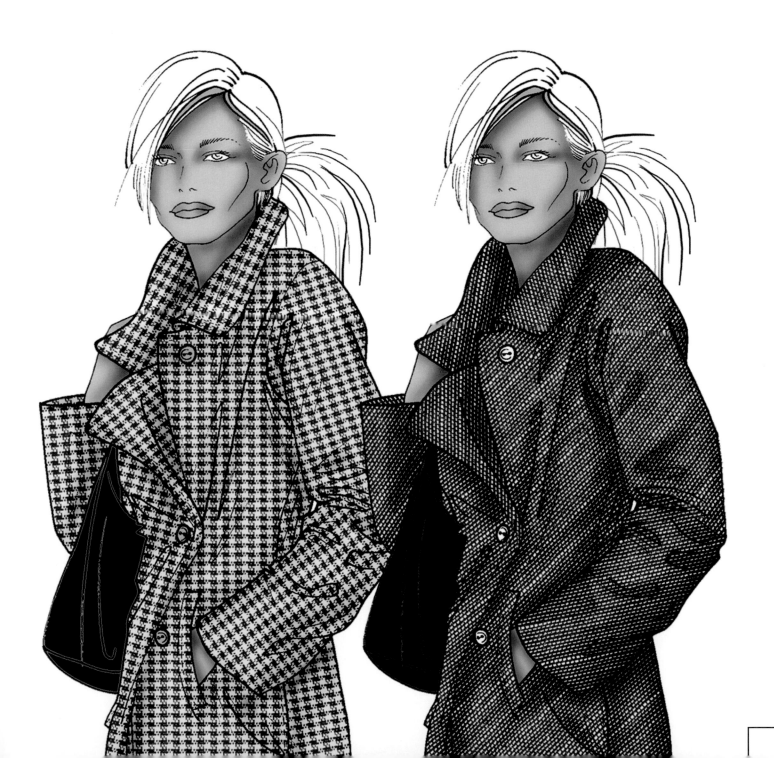

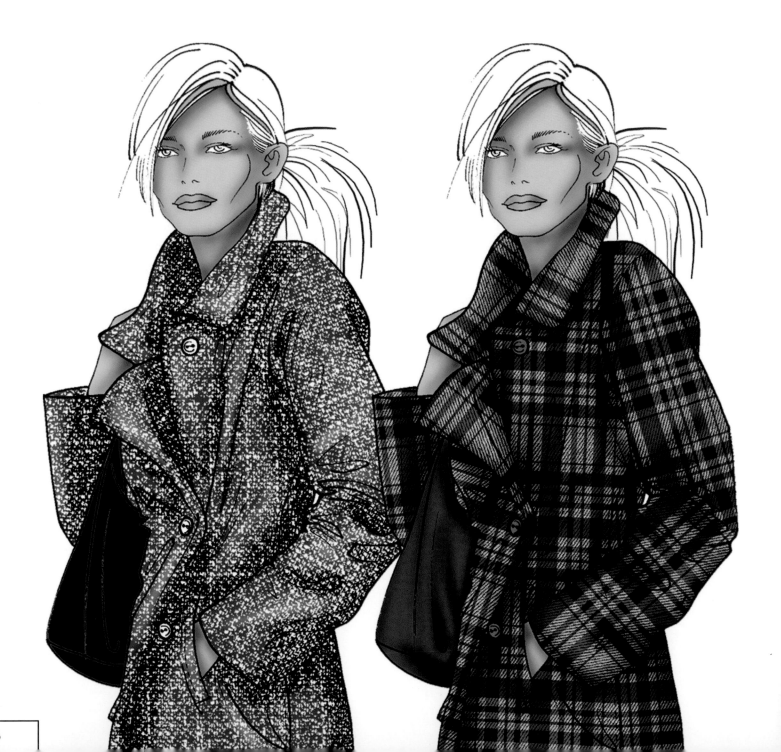

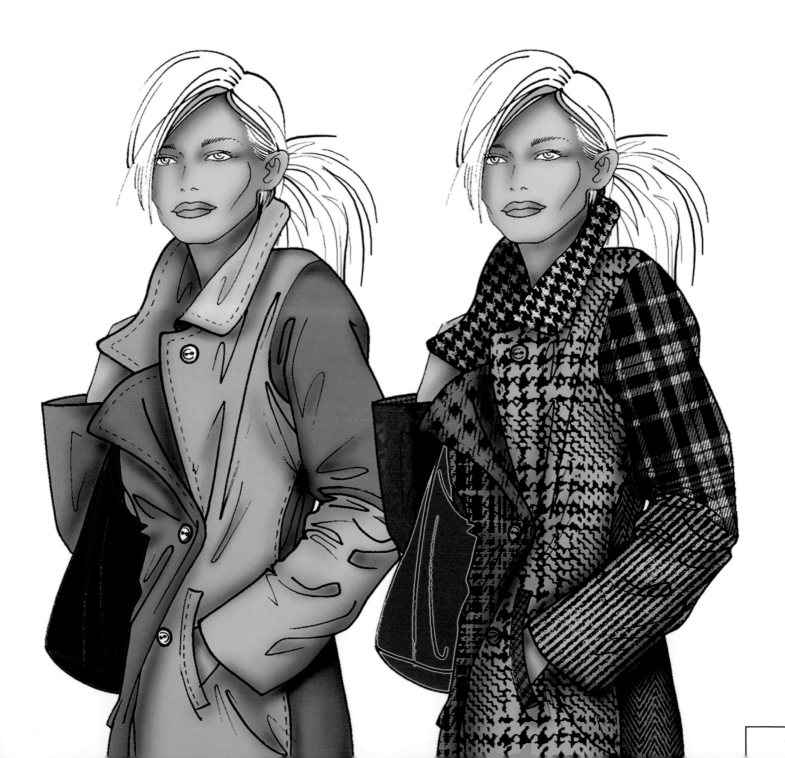

Inserting a Fabric Design

The insertion of a fabric design within a drawing can be achieved either by hand or digitally. When working by hand, cut out the inside of the drawing to create a template. This template can then be set against the desired fabric or pattern. If using a computer, select the area to be filled and apply the design to the selection.

Whether working by hand or digitally, you can insert the design without varying the direction of the fabric print (see page 20, left) or try to follow the lines of the garment to obtain a more realistic effect (see page 20, right). Once the fabric has been inserted into the drawing, you can choose to maintain the outlines (as on page 20) or to remove them (as on page 21).

On pages 22–23, you can see various examples of a fabric pattern applied to a T-shirt.

Inserire un modulo tessile

Una fantasia può essere inserita in un disegno a mano o in digitale. Se si lavora a mano, bisogna tagliare l'interno del disegno per creare una mascherina. Il tessuto o motivo desiderato può poi essere posizionato sotto la mascherina. Se si usa un computer, si deve selezionare l'area da riempire e poi applicare la fantasia alla selezione.

Sia che si lavori a mano, sia che si lavori al computer, si può inserire la fantasia senza variare la direzione del motivo (vedi pagina 20, a sinistra) oppure provare a seguire le linee dell'indumento per ottenere un effetto più realistico (vedi pagina 20, a destra). Una volta che la fantasia è stata inserita nel disegno, si può scegliere se mantenere i contorni (come a pagina 20) o se rimuoverli (come a pagina 21).

Alle pagine 22 e 23 potete ammirare vari esempi di un motivo applicato a una T-shirt.

INSERTING A FABRIC DESIGN

INSERIRE UN MODULO TESSILE

FÜGEN SIE EIN STOFFDESSIN EIN

INSERCIÓN DE UNA MUESTRA DE TEJIDO

INTRODUCTION D'UN DESSIN DE TISSU

Fügen Sie ein Stoffdessin ein

Das Einfügen des Stoffdessins in einer Zeichnung kann entweder mit der Hand oder auch digital durchgeführt werden. Wenn Sie mit der Hand arbeiten möchten, müssen Sie die Innenseite der Zeichnung ausschneiden, um eine Schablone zu erstellen. Diese Schablone kann dann gegen den gewünschten Stoff oder das Muster gehalten werden. Wenn Sie einen Computer verwenden, wählen Sie den Bereich aus, den es auszufüllen gilt und wenden Sie das Dessin an der Auswahl an.

Unabhängig davon, ob Sie mit der Hand oder digital arbeiten, können Sie das Dessin einfügen ohne dabei die Richtung des Stoffdrucks zu ändern (siehe Seite 20, links) oder folgen sie den Linien des Kleidungsstücks, um eine realistischere Wirkung zu erzielen (siehe Seite 20, rechts). Nachdem der Stoff in der Zeichnung eingefügt wurde, können Sie wählen, die Umrisse (wie auf Seite 20 dargestellt) beizubehalten oder zu entfernen (wie auf Seite 21).

Auf Seite 22–23 werden unterschiedliche Beispiele eines Stoffdessins gezeigt, das auf einem T-Shirt angewandt wurde.

Inserción de una muestra de tejido

La inserción de una muestra de tejido en un dibujo puede realizarse manual o digitalmente. Si trabaja a mano, recorte el interior del dibujo para crear una plantilla. A continuación, aplíquela sobre el tejido o el estampado elegido. Si trabaja con ordenador, seleccione el área que desea rellenar y aplique el diseño a la selección.

Tanto si trabaja a mano como con el ordenador, puede insertar el diseño sin modificar la dirección del estampado del tejido (véase la página 20, izquierda) o intentar seguir las líneas de la prenda para obtener un efecto más realista (véase la página 20, derecha). Una vez insertado el diseño en el dibujo, puede conservar el relieve (véase la página 20) o eliminarlo (véase la página 21).

En las páginas 22 y 23 encontrará varios ejemplos de la aplicación de una muestra de tejido en una camiseta.

Introduction d'un dessin de tissu

L'introduction d'un dessin de tissu dans un dessin de mode peut se faire à la main ou à l'ordinateur. Lorsqu'on travaille à la main, on découpe l'intérieur du dessin pour créer un gabarit. Ce gabarit peut être placé sur le tissu ou le motif désiré. Si l'on se sert d'un ordinateur, on choisit l'emplacement à remplir et on y applique le motif.

Ou'on travaille à la main ou à l'ordinateur, on peut introduire le motif sans varier le sens de l'imprimé du tissu (voir page 20, à gauche) ou essayer de suivre les lignes du vêtement pour obtenir un effet plus réaliste (voir page 20, à droite). Une fois que le tissu est introduit dans le dessin, on peut choisir de conserver les contours (comme à la page 20) ou de les enlever (comme à la page 21).

Aux pages 22–23, divers exemples de motifs de tissus ont été appliqués à un T-shirt.

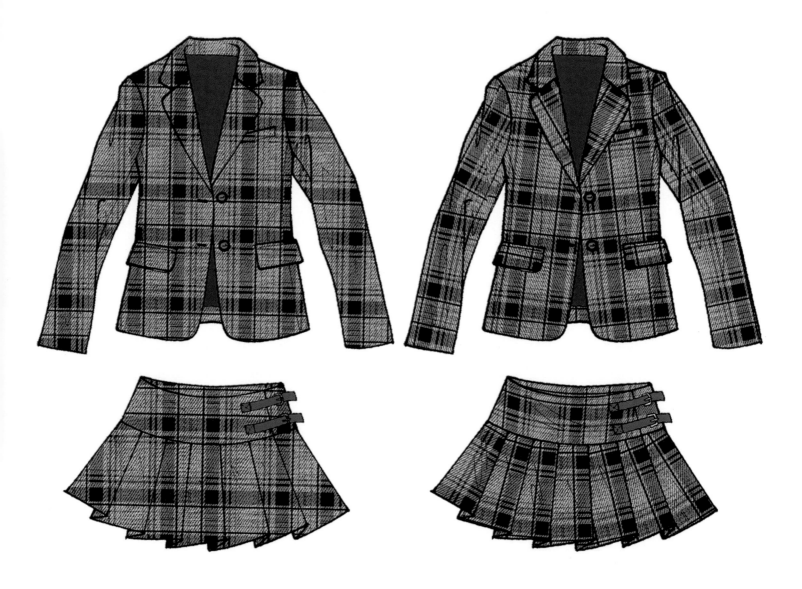

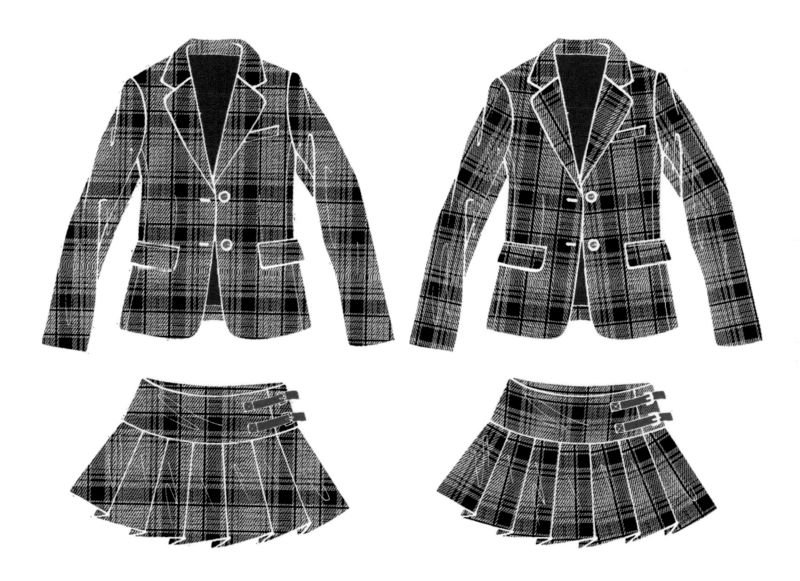

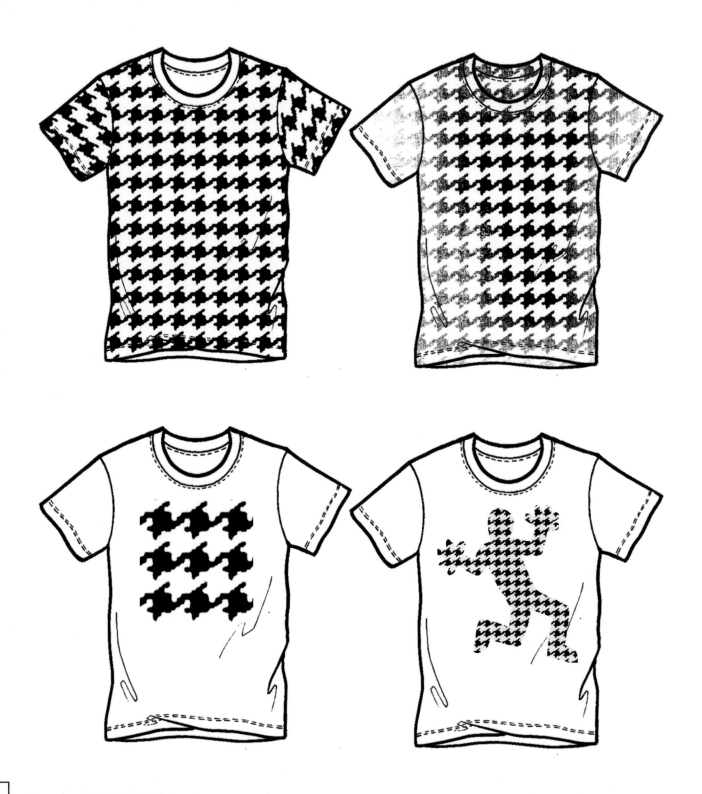

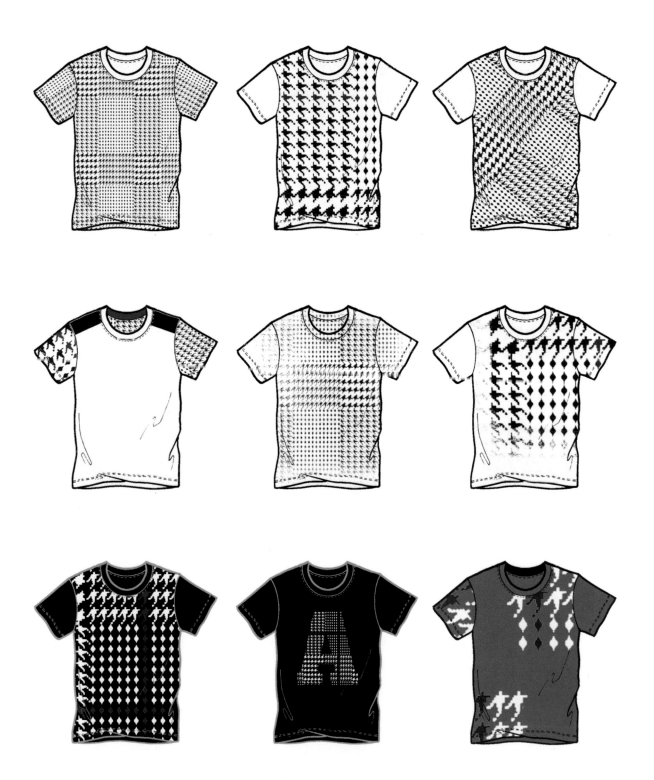

English

Bouclé

From the French verb "boucler", meaning: to curl. Fabric of medium or winter weight made from a carded yarn, used mainly for knitwear, which is characterised by the presence of 'curls' that create little knots and/or rings. Due to the structure of the yarn, this fabric exhibits an uneven and wavy surface with small ringlets and curls. Jackets and jumpers made from this yarn/fabric have been popular since the 1950s.

Italiano

Bouclé

Dal verbo francese *boucler*, che vuol dire 'arricciare'. È un tessuto di peso medio o invernale, tessuto in genere con un filo cardato, usato principalmente per la maglieria e caratterizzato dalla presenza di 'ricci' che creano piccoli nodi o anelli. Per via della struttura del filo questo tessuto presenta una superficie irregolare e ondulata, con riccioloni e anelli. Le giacche e i maglioni in questo tessuto sono noti fin dagli anni Cinquanta.

Deutsch

Bouclé

Stammt vom französischen Verb »boucler« ab, Bedeutung: sich einrollen. Es sind Stoffe mit einem mittleren oder Wintergewicht, die aus einem gekardeten Garn hergestellt und hauptsächlich für Maschenware verwendet werden. Diese werden durch die Anwesenheit von »Locken« charakterisiert, die kleine Knoten und/oder Ringe bilden. Aufgrund der Garnstruktur weist dieser Stoff eine unebene und wellige Oberfläche mit kleinen Ringen und Locken auf. Jacken und Pullover, die aus diesem Garn/Stoff hergestellt werden, sind seit den 50ern sehr beliebt.

Español

Bouclé

El origen de este término es el verbo francés *boucler*, que significa 'rizar'. Tejido de entretiempo o invierno elaborado con un tipo de hilo cardado que se utiliza sobre todo para la ropa de punto y se caracteriza por la presencia de «rizos» que crean una especie de pequeños nudos y/o anillos. Debido a la estructura del hilo, este tejido se caracteriza por la superficie irregular y ondulada con pequeños tirabuzones y rizos. Las chaquetas y los jerséis confeccionados con este tejido se pusieron de moda en la década de 1950 y hasta hoy.

Français

Le bouclé

Tissu de poids moyen fait de laine cardée utilisée surtout pour le tricot et qui se caractérise par la présence de boucles qui forment de petits nœuds ou des annelets. À cause de la structure du fil, cette étoffe présente une surface inégale et bouclée. Les vestes et les chandails faits avec ce fil et ce tissu sont très populaires depuis les années 1950.

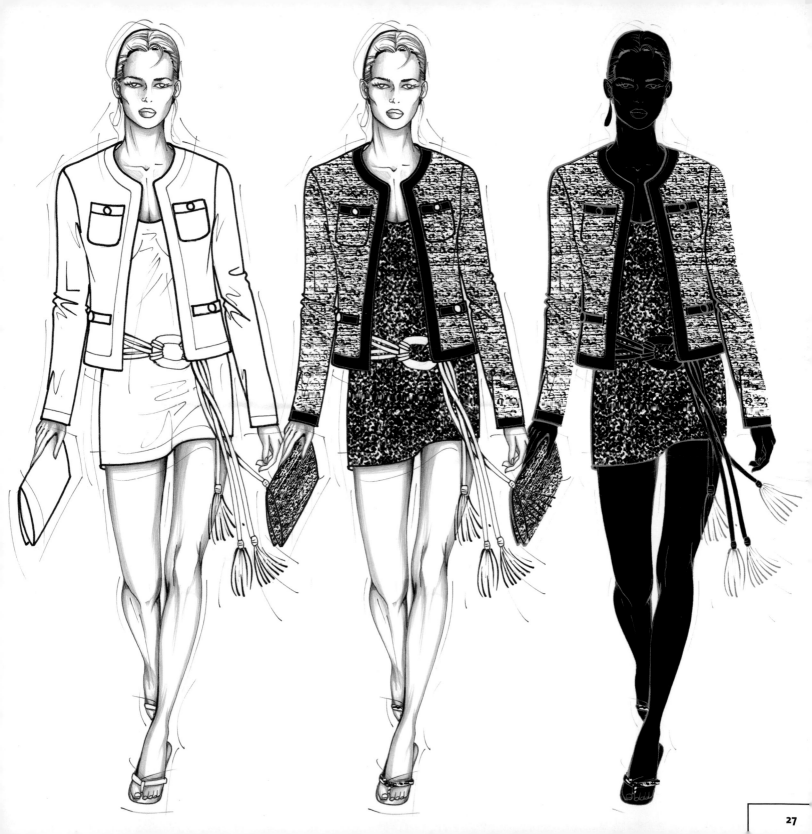

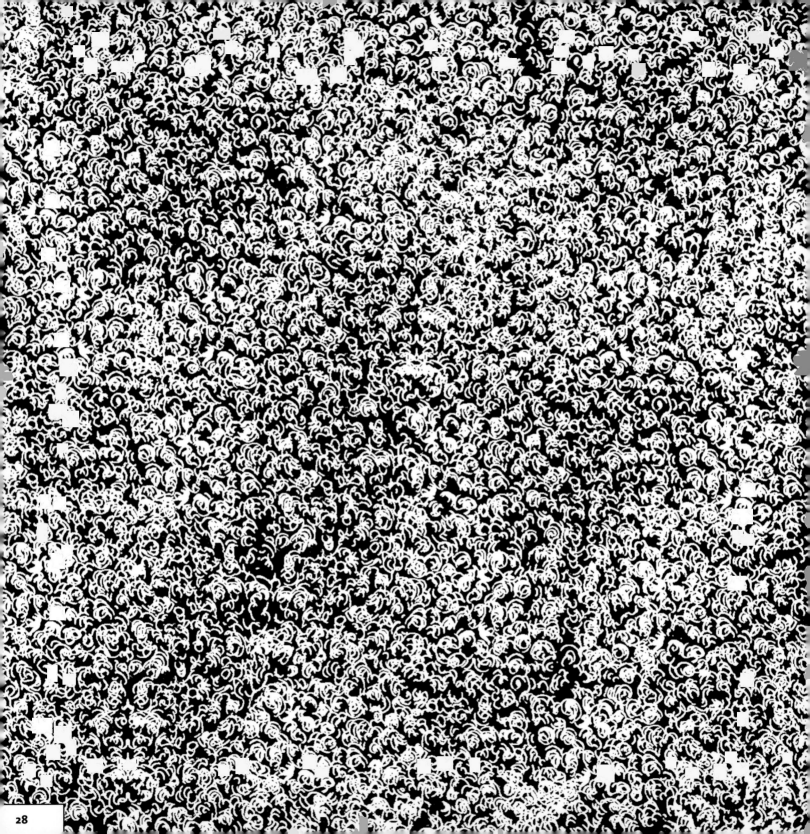

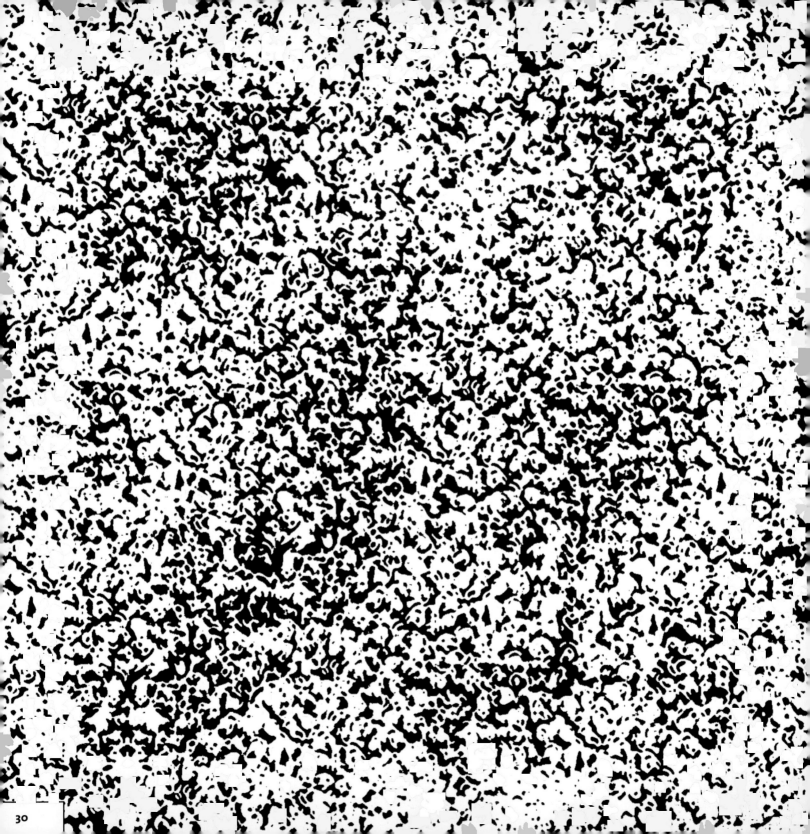

English

Denim

Very durable cotton fabric with a diagonal ribbing, made from tightly twisted yarn – usually a blue warp and white weft – worked in a twill weave. Denim often undergoes special treatments – washes, dyes and aging processes – that give it a variety of appearances ranging from luxurious to vintage or weathered. The name may be derived from the fabric "serge de Nimes", but the structure of the fabric is more closely related to the "jean" fabric produced in Genoa in the 16th century. Whatever its origins, denim was originally a fabric used to make work clothes. In the 1930s and 40s, denim jeans reached a wider audience thanks to American cowboy films and U.S. soldiers stationed overseas during and after World War II. Through Hollywood films of the 1950s and youth cultures of the 1960s and 70s, blue jeans achieved an iconic status in popular culture. Since the 1960s, designers have used denim to make clothing and accessories of all kinds.

Italiano

Denim

Un tessuto in cotone molto resistente, creato con una lavorazione a coste diagonali, fatto con un filo ritorto – in genere l'ordito è blu e la trama bianca – lavorato in un'armatura a batavia o levantina. Il denim è sottoposto in genere a speciali trattamenti – lavaggio, tintura e invecchiamento – che gli danno aspetti assai diversi, che vanno dal lussuoso, al vintage, all'effetto consumato. Il nome deriva probabilmente da quello del tessuto *Serge de Nimes*, ma la sua struttura è più simile a quella del tessuto *jean*, prodotto a Genova nel XVI secolo. Qualunque sia la sua origine, questo tessuto all'inizio veniva utilizzato per fabbricare abiti da lavoro. Negli anni Trenta e Quaranta, il denim jeans raggiunse un pubblico più vasto grazie ai film western e grazie alla presenza di soldati americani in Europa. Grazie ai film di Hollywood degli anni Cinquanta e alla cultura giovanile degli anni Sessanta e Settanta i blue jeans sono diventati uno "status symbol" nella cultura popolare. A partire dagli anni Sessanta gli stilisti hanno usato il denim per confezionare indumenti e accessori di ogni tipo.

Deutsch

Denim

Äußerst widerstandsfähiger Baumwollstoff mit diagonalen Rippen, der aus einem eng verdrillten Garn hergestellt – normalerweise mit blauen Kettfäden und weißen Schussfäden – und mit einer Köperbindung verarbeitet wird. Denim wird oft besonderen Behandlungen unterzogen – Wasch-, Färbe- und Alterungsverfahren – die dem Stoff unterschiedliches Aussehen verleihen – von luxuriös bis zu klassisch oder verwittert. Der Name stammt wahrscheinlich vom Stoff »Serge de Nimes«, aber die Struktur des Stoffes hat eine engere Verwandtschaft mit dem »Jean«-Stoff, der im 16. Jahrhundert in Genua hergestellt wurde. Unabhängig vom Ursprung war Denim ursprünglich ein Stoff, der zur Herstellung von Arbeitskleidung verwendet wurde. In den 30ern und 40ern erreichten die Jeans ein breiteres Publikum dank den amerikanischen Cowboyfilmen und den US Soldaten, die während und nach dem zweiten Weltkrieg in Übersee stationiert waren. Dank den Hollywoodstreifen der 50er und auch der Jugendkultur der 60er und 70er erreichten die »Blue Jeans« einen Kultstatus in der Popkultur. Seit den 60ern haben Modeschöpfer Denim für die Herstellung der verschiedensten Kleidungsstücke und Accessoires verwendet.

Español

Denim

Tejido de algodón muy resistente que se caracteriza por el estriado al bies que se consigue con hilos muy retorcidos (en general con la urdimbre azul y la trama blanca) entrecruzados en forma de ligamento de sarga. El *denim* suele someterse a distintos tratamientos (como los procesos de lavado, desteñido y envejecimiento) para conseguir los acabados más variados, desde el más suntuoso hasta el más antiguo o ajado. Probablemente, el origen del término se deba al tejido *serge de Nîmes*, aunque la estructura es más parecida a la del *jean* que se fabricaba en Génova en el siglo XVI. Sea cual sea su procedencia, en sus orígenes el *denim* se utilizó para confeccionar ropa de trabajo. En las décadas de 1930 y 1940, los pantalones de *denim* se pusieron de moda gracias a las películas del Oeste y a los soldados norteamericanos destinados en el extranjero después de la Segunda Guerra Mundial. Con el cine de Hollywood de los años cincuenta y la cultura juvenil de los años sesenta y setenta, los vaqueros se convirtieron en todo un icono de la cultura popular. Desde la década de los sesenta, los diseñadores no han dejado de confeccionar prendas y accesorios de todo tipo con este sufrido tejido.

Français

Le denim

Tissu de coton très robuste, à armure sergé, fait de fil très serré, dont la chaîne est de coloris bleu indigo et la trame écrue ou blanchie. Le denim subit souvent des traitements particuliers – lavage, teinture, vieillissement – qui lui donnent une variété d'apparences, de luxueuse à vieillie. Le nom est dérivé de la « serge de Nîmes », mais la structure du tissu est plus proche du tissu sergé produit à Gênes au XVIe siècle. Quelles que soient ses origines, le denim a été à l'origine utilisé pour la fabrication de vêtements de travail. Dans les années 1930 et 1940, le jean en denim acquit une grande popularité grâce aux westerns américains et aux GI affectés outre-mer durant et après la Seconde Guerre mondiale. Grâce aux films d'Hollywood des années 1950 et à la culture juvénile des années 1960 et 1970, le blue-jean est devenu un élément phare de la culture populaire. Depuis les années 1960, les couturiers utilisent le denim pour faire des vêtements et accessoires de toute sorte.

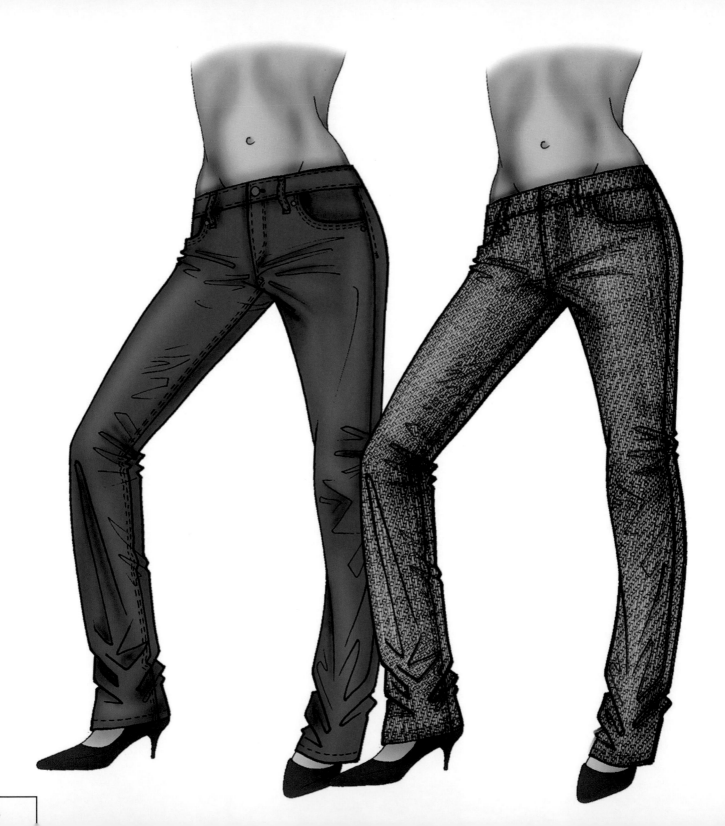

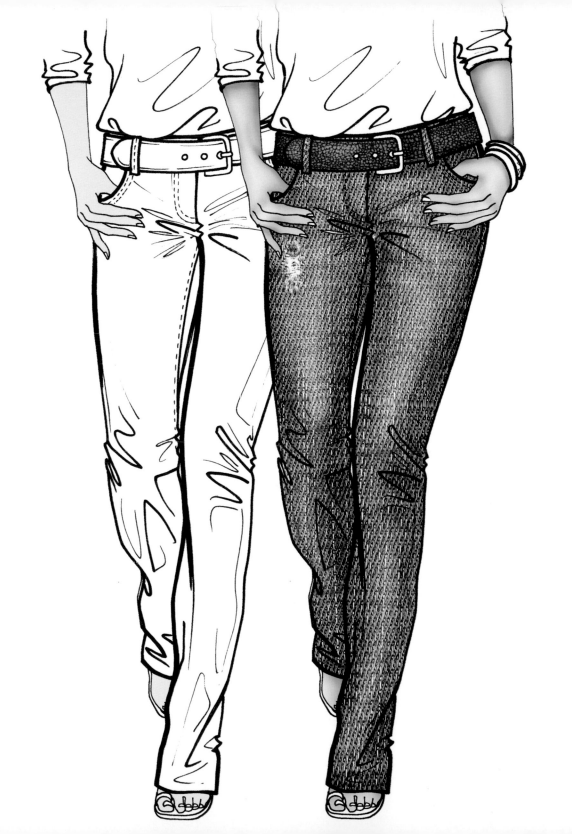

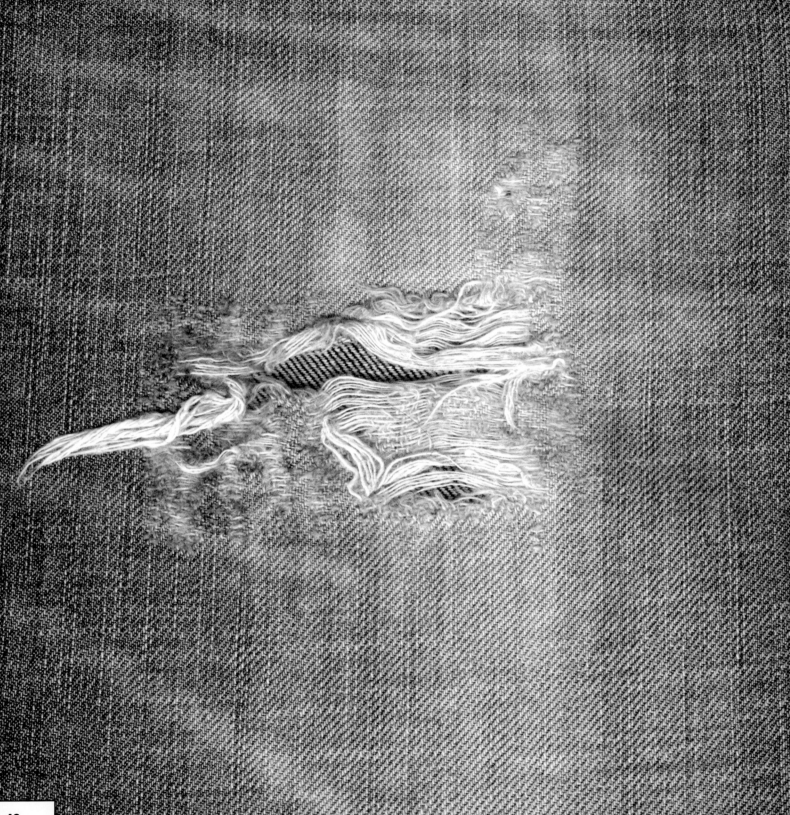

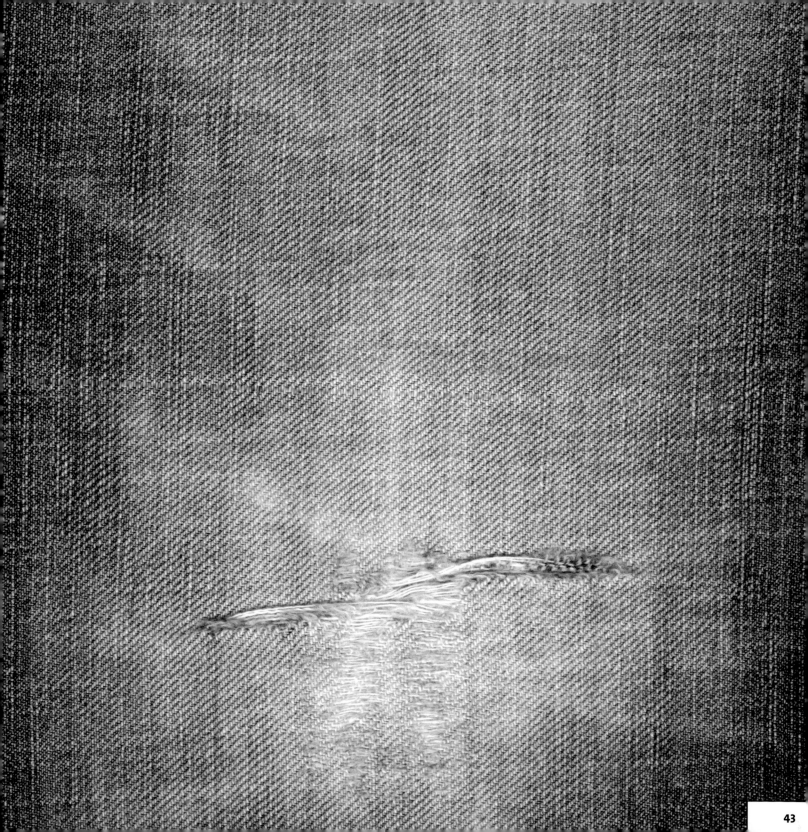

43

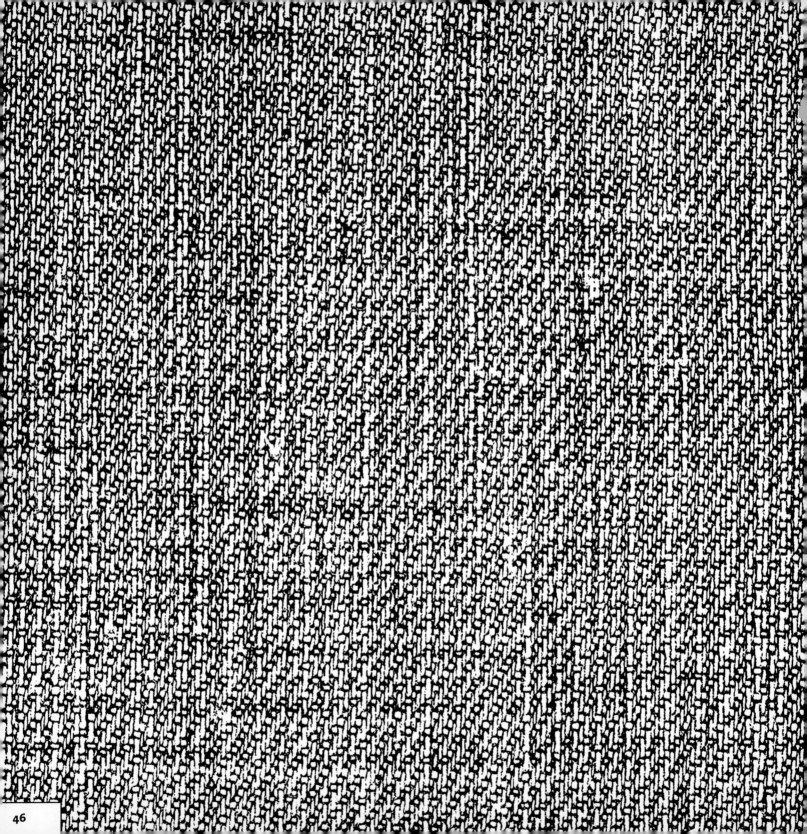

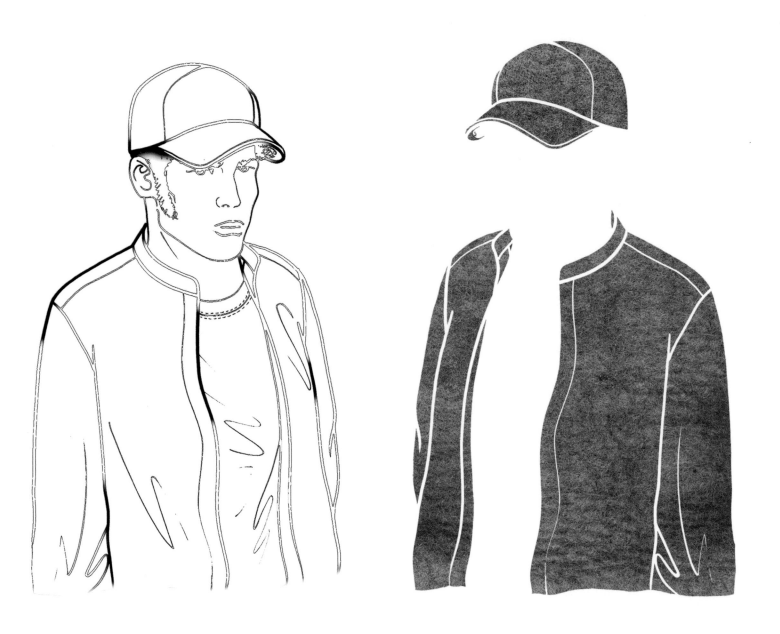

English

Felt

Woollen textile made from unspun wool fibres which become interlocked and compacted during the milling process, creating a fabric with a rustic and unrefined, crushed look. Felt predates woven fabrics and was probably the first form of fabric made by man. Originally made from the fur of rabbits or beavers, it is currently produced using wool or a range of other fibres.

Italiano

Feltro

Il feltro è un manufatto di lana ricavato da fibre di lana non filate, le cui squame si incastrano tra loro durante la follatura, dando origine a strati lanosi più o meno compatti e dall'aspetto pressato rustico e poco raffinato. Il feltro è stato con tutta probabilità il primo tipo di tessuto creato dall'uomo. Realizzato in origine con pelo di coniglio o di castoro, viene attualmente prodotto, oltre che con fili di lana, anche con altre fibre.

FELT
FELTRO
FILZ
FIELTRO
FEUTRE

Deutsch

Filz

Wollstoff, der aus ungesponnenen Wollfasern gemacht wird. Die Fasern werden während dem Spinnverfahren verriegelt und ineinander verhakt, wodurch ein Stoff entsteht, der eine rustikale und rohe, zerknitterte Erscheinung hat. Filz geht gewebten Stoffen voraus und war wahrscheinlich die früheste Form von Stoff, die der Mensch hergestellt hat. Ursprünglich wurde er aus dem Fell von Kaninchen oder Bieber gefertigt. Heute wird er mit Wolle oder eine Reihe anderer Fasern gemacht.

Español

Fieltro

Tejido obtenido mediante el entrelazamiento y el conglomerado de fibras de lana sin hilar durante el proceso de abatanado, con el resultado de un tejido de apariencia rústica, poco refinada y aplastada. El fieltro es anterior a los tejidos de lana, y probablemente fuera el primer tejido creado por el hombre. Aunque antiguamente se obtenía de pieles de conejo o castor, hoy en día se fabrica a partir de la lana y muchos otros tipos de fibras.

Français

Le feutre

Tissu laineux fait de fibres de laine non filée qui deviennent entrecroisées et compactes durant le procédé de foulage, créant un tissu à l'air rustique, brut et froissé. Le feutre précède les étoffes tissées et fut probablement la première forme d'étoffe fabriquée par l'homme. Élaboré à l'origine à partir de fourrure de lapin ou de castor, il est actuellement produit avec de la laine et une variété d'autres fibres.

English

Lightweight Wool

Light wool fabric, also known as 'cool wool', made from high-quality, tightly twisted yarn from combed wool, worked into a somewhat open and sparse weave. Lightweight and crease-resistant, it is often used for men and women's suits for spring, summer and autumn.

Italiano

Fresco lana

Il fresco lana, o fresco di lana, è ottenuto tessendo filati molto ritorti delle migliori qualità, lavorati in armatura a trama piuttosto aperta e rada. Leggero e difficile da sgualcire, è indicato per la produzione di capi estivi o di mezza stagione, quali tailleur e abiti sia maschili che femminili.

LIGHTWEIGHT WOOL
FRESCO LANA
LEICHTE WOLLE
LANA FRÍA
TISSU LÉGER DE LAINE

Deutsch

Leichte Wolle

Leichter Wollstoff, ebenfalls auch als »Cool Wool« bekannt, wird aus hochqualitativem, eng verdrilltem Garn aus gekämmter Wolle hergestellt, die eine etwas offene und netzartige Bindung hat. Er ist leicht und faltenresistent und wird oft für Damen- und Herrenanzüge für Frühling, Sommer und Herbst verwendet.

Español

Lana fría

La lana fría o ligera es un tejido fabricado con hilos de alta calidad muy retorcidos que se obtienen de la lana cardada y que después se trabajan en un ligamento algo abierto y espaciado. Lana fría y resistencia a las arrugas son dos términos que suelen ir asociados a los trajes masculinos y femeninos de primavera, verano y otoño.

Français

Le tissu léger de laine

Le tissu léger de laine, aussi appelé « laine fraîcheur » et « laine de printemps », est fait de fils de laine peignée de grande qualité étroitement tressés et tissés à mailles lâches. Léger et résistant au froissement, il est souvent utilisé pour les complets et les tailleurs de printemps, d'été et d'automne.

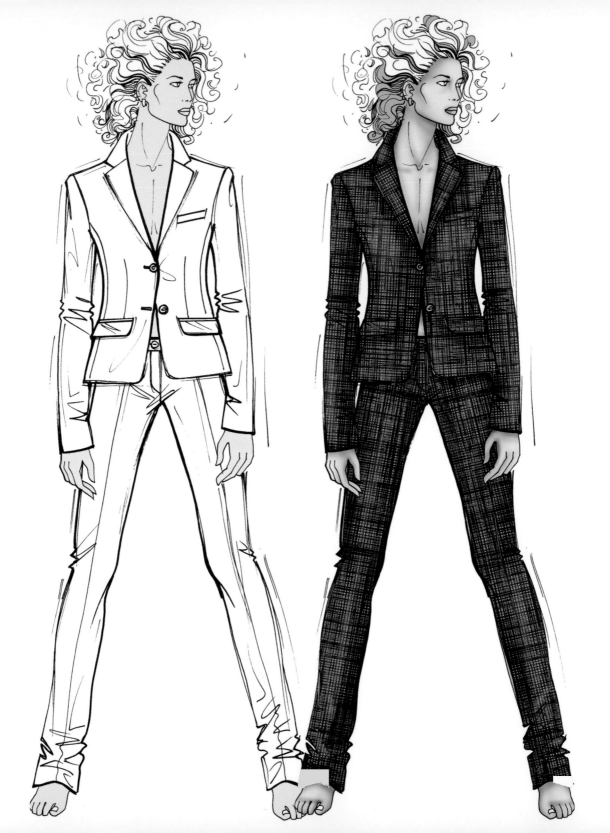

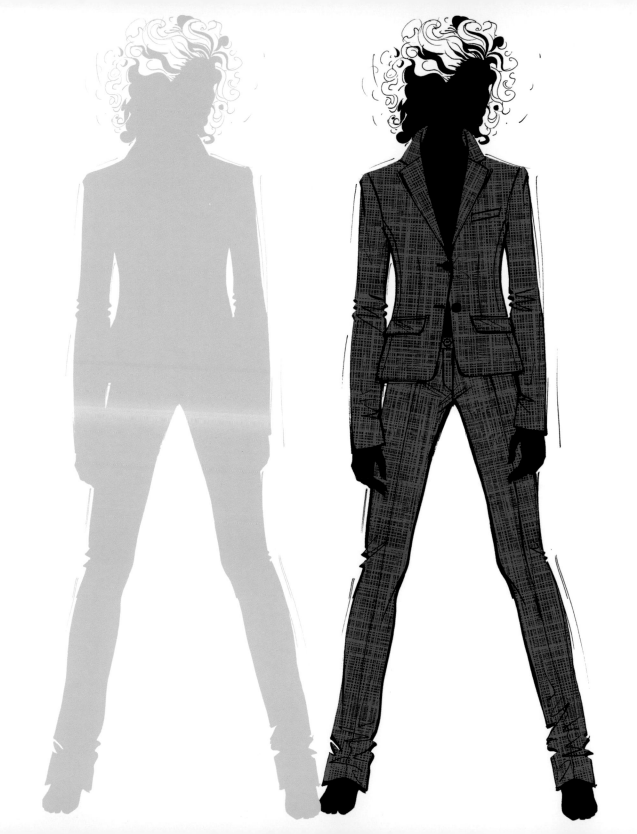

English

Gabardine

A durable, tightly woven fabric with a diagonal effect in the weave. It can be made from natural fibres, like wool or cotton, or from synthetics. Available in a variety of medium weights, it is used in the making of dresses, suits, skirts and jackets, as well as outerwear and raincoats. When used for outerwear, the fabric is often treated to make it more resistant to water and weather.

Italiano

Gabardine

È un tessuto resistente, a trama stretta, lavorato con un effetto ottico diagonale. Può essere costituito da fibre naturali, come la lana o il cotone, o sintetiche. Solitamente di medio peso, viene utilizzato, oltre che per la produzione di abiti, completi, gonne e pantaloni, anche per la realizzazione di capispalla e impermeabili, capi per i quali viene sottoposto a ulteriori trattamenti.

Deutsch

Gabardine

Ein widerstandsfähiger, enggewebter Stoff mit einem diagonalem Effekt in der Bindung. Er kann entweder aus natürlichen Fasern wie Wolle oder Baumwolle oder aus Synthetik gemacht werden. Er ist in einer Vielfalt von mittleren Gewichten erhältlich und wird in der Manufaktur von Kleidern, Anzügen, Hemden und Jacken sowie von Oberbekleidung und Regenmänteln eingesetzt. Bei der Verwendung für Oberbekleidung wird der Stoff oftmals behandelt, um eine höhere Widerstandsfähigkeit gegen Wasser und andere Witterungsbedingungen zu erreichen.

Español

Gabardina

Tejido resistente y comprimido cuyo ligamento crea un vistoso efecto al bies. Puede obtenerse a partir de fibras naturales, como la lana o el algodón, o bien sintéticas. Disponible en distintos pesos medios, se utiliza para confeccionar vestidos, trajes, faldas y chaquetas, además de prendas de abrigo e impermeables. Cuando se utiliza para prendas de abrigo, la gabardina suele tratarse para que ofrezca una mayor protección frente al agua y las inclemencias del tiempo.

Français

La gabardine

Étoffe durable, tissée serrée avec un effet de côtes diagonales. Elle peut être faite de fibres naturelles comme la laine ou le coton ou de fibres synthétiques. La gabardine est offerte dans une variété de poids moyens ; elle sert à confectionner les robes, les complets, les jupes et les vestes, ainsi que les vêtements d'extérieur et les imperméables. Lorsqu'on l'utilise pour les vêtements d'extérieur, elle est souvent traitée pour la rendre plus résistante à l'eau et aux intempéries.

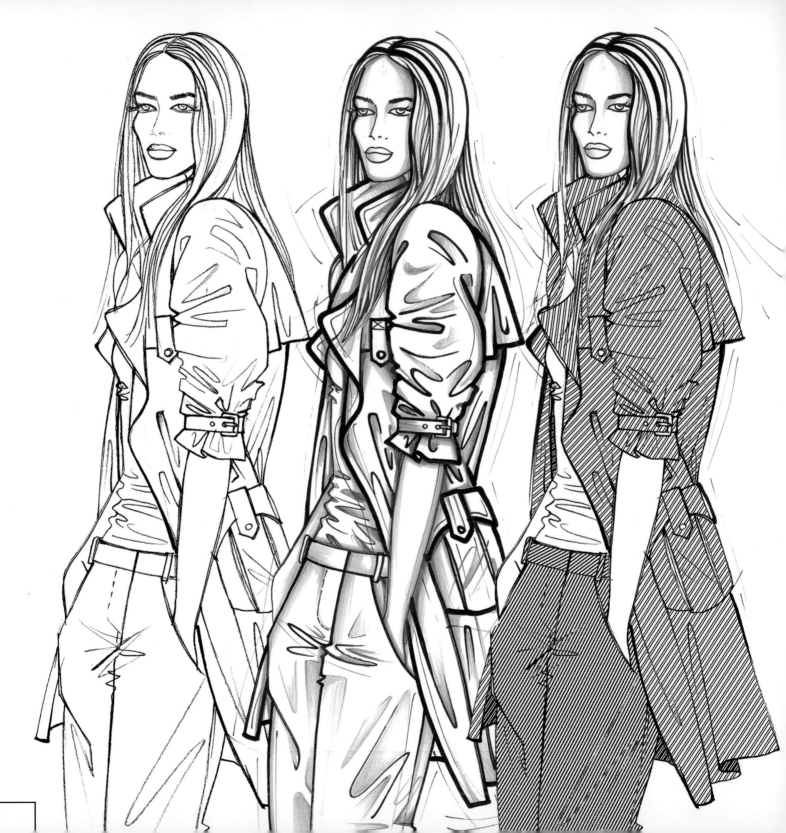

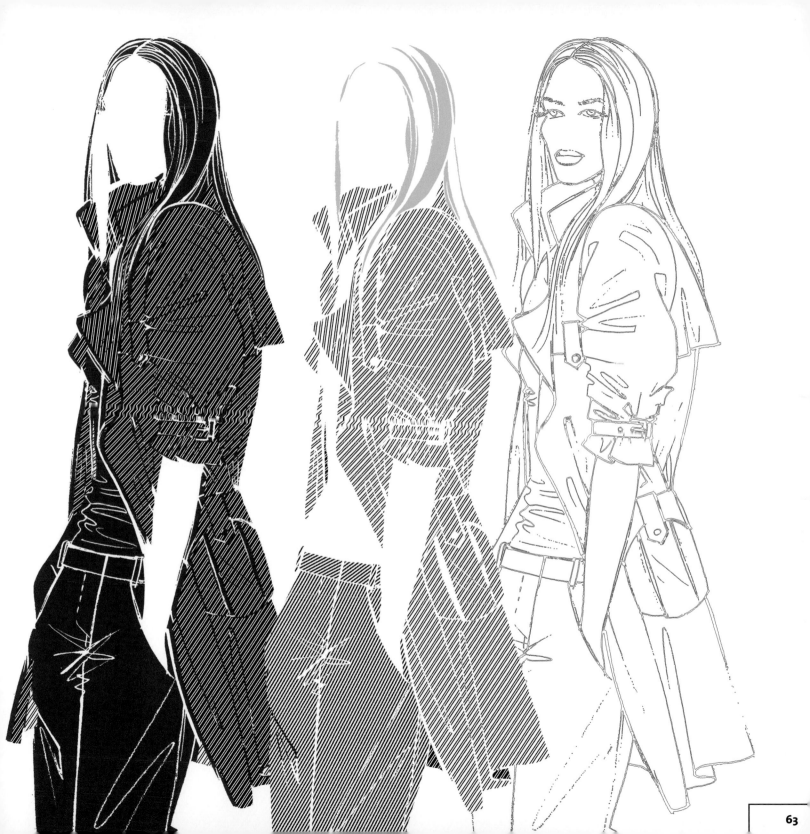

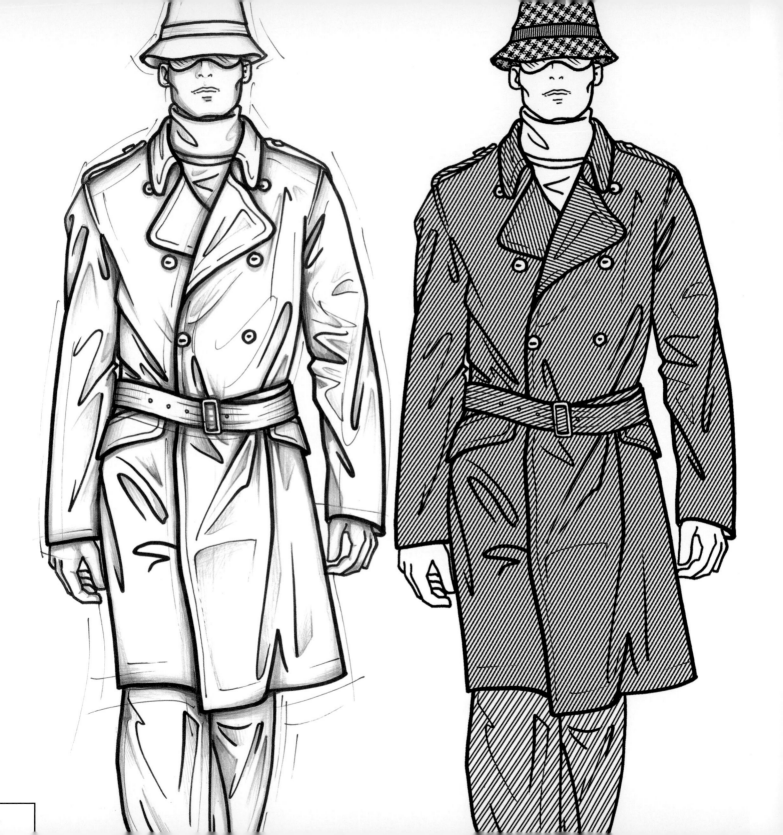

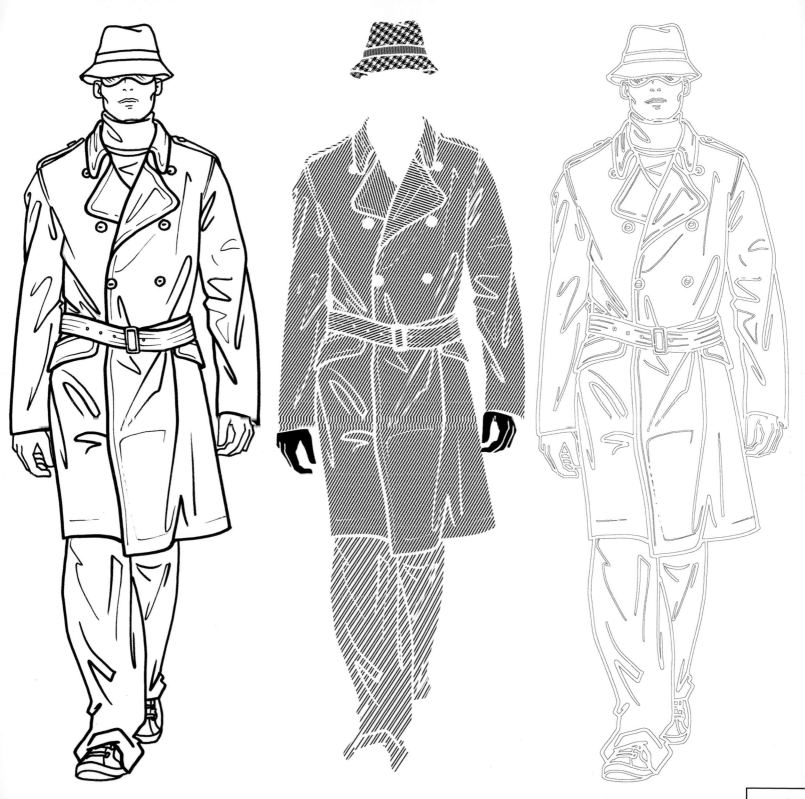

67

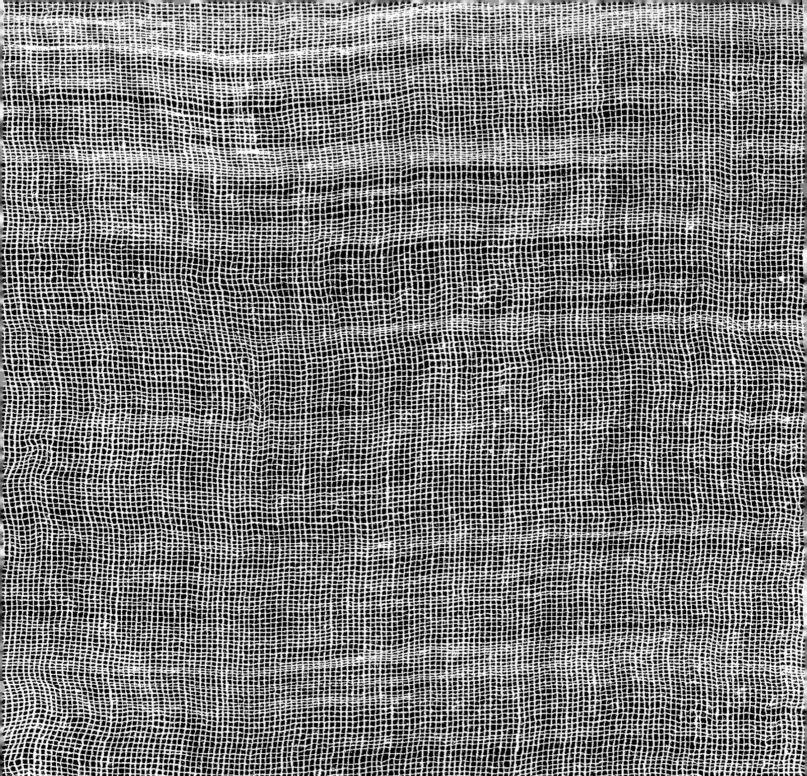

English

Gauze

A lightweight fabric of cotton or silk with a very open weave, made from especially fine yarns, mainly used for medical dressings in the form of sterile compresses. From the 19th century onwards, it has also been used as a decorative fabric for drapes and fashion accessories and is also commonly adopted for the production of shirts, women's clothing and kaftans.

Italiano

Garza

Tessuto rado e leggero, di cotone o seta, composto da filati particolarmente sottili lavorati a trama larga. Usato principalmente in campo medico, per la preparazione di compresse idrofile sterilizzate, venne utilizzato sin dal XIX secolo per fabbricare tende e accessori di moda. Al giorno d'oggi è utilizzato comunemente anche per la realizzazione di camicie, abiti femminili e kaftani.

Deutsch

Gaze

Ein leichter Stoff aus Baumwolle oder Seide mit einer sehr offenen Bindung, wird aus besonders feinem Garn hergestellt und hauptsächlich für medizinische Verbände in der Form von sterilen Kompressen verwendet. Ab dem 19. Jahrhundert wurde es auch als dekorativer Stoff für Vorhangstoffe und Modeaccessoires verwendet und wird ebenfalls häufig in der Herstellung von Hemden, Damenkleidung und Kaftans benutzt.

Español

Gasa

Tejido ligero de algodón o seda con un ligamento muy abierto obtenido con hilos muy finos que se utiliza sobre todo para fabricar apósitos sanitarios en forma de compresas estériles. Desde el siglo XIX, también se emplea como tejido ornamental para confeccionar cortinas y accesorios de moda, así como camisas, prendas femeninas y caftanes.

Français

La gaze

Tissu léger de coton ou de soie avec une armure à jour, fait de fil particulièrement fin, il est surtout utilisé pour les pansements sous forme de compresses stériles. À partir du XIXe siècle, on utilise également la gaze comme tissu décoratif pour les tentures et les accessoires de mode et elle est aussi communément adoptée pour la production de chemises, de vêtements féminins et de caftans.

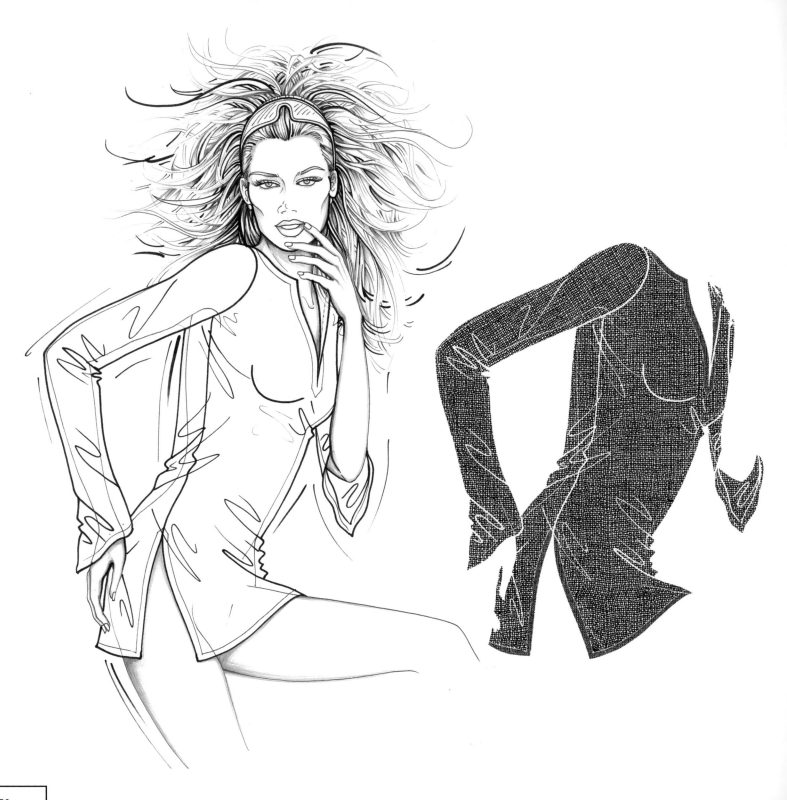

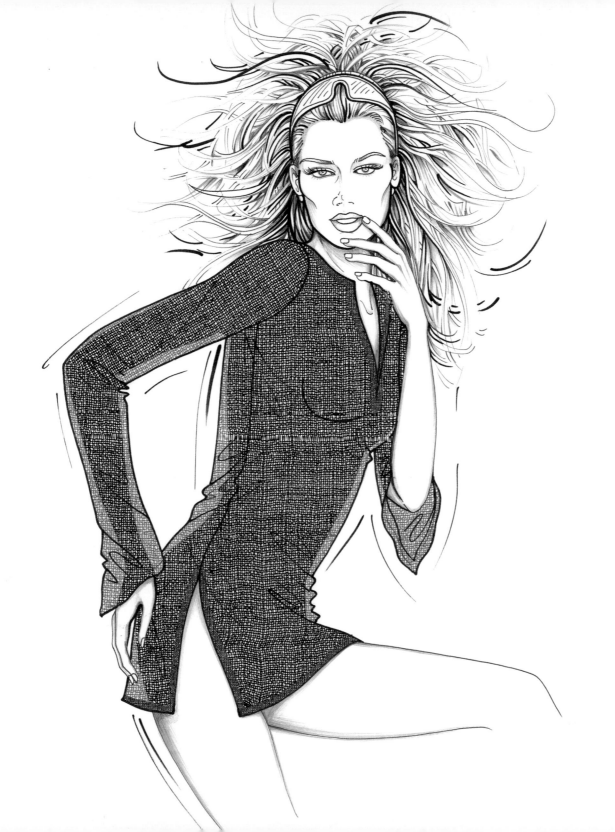

Linen

Fabric made from a plant of the linaceae family (flax or linseed) which, when harvested and retted at the correct time, produces a prized fibre. The yarn is durable, smooth to the touch and can vary both in terms of weight and grain. Depending on the type of weave used, it is possible to produce anything from a very fine, lightweight textile (such as cambric) to a coarse, thick and rough textile (such as canvas).

The earliest records of the industrial production of linen come from Egypt (4000 years ago) but the origins of linen are much older. In fact, linen may well be the oldest plant-based textile in the world. Since it was particularly suited to fine embroidery and handwork and because of difficulties in mechanising linen production, it was the last fibre to be introduced to machine manufacture, in 1811. Throughout the 19th century linen was used for lingerie and, from the 20th century to the present, has been used for a wide array of outer garments and for household linen, drapes and upholstery.

Jute

Jute (also called hessian or burlap) is a cheap, extremely versatile fibre produced from plants in the Malvaceae family (genus corchorus). Originally cultivated in the region of Bangladesh, jute is currently second only to cotton in the amount produced worldwide and the variety of uses. Coarse fibres from the ends of the plant are used to make rope, rugs, inexpensive cloth and even shoes, while the finest fibres can be used to imitate silk.

Lino

È un tessuto che deriva da una pianta annuale delle *linacee* che, opportunamente lavorata e macerata, fornisce una fibra pregiata. Il filato che ne deriva, robusto e liscio al tatto, può variare nel peso, nella grana e nel tipo di armatura tessile utilizzata. È possibile produrre lino leggerissimo e sottile – come il *cambrì* – o ruvido, più spesso e grezzo, come la tela.

I primi attestati di una produzione in serie risalgono all'antico Egitto (4000 anni fa), ma le origini di questo tessuto sono ancora più antiche. Poiché è particolarmente adatto per il ricamo e la lavorazione manuale, fu l'ultima fibra che si lavorò a macchina, nel 1811. Venne utilizzato nel corso del XIX secolo per la produzione di biancheria intima e nel XX secolo per la realizzazione di una vasta gamma di capi d'abbigliamento, di biancheria per la casa, tendaggi e tappezzerie.

Juta

La juta è una fibra tessile a basso costo, estremamente versatile, che viene prodotta da una pianta della famiglia delle *malvacee* (genere *Corchorus*). Coltivata in origine nella regione del Bangladesh, la juta al momento è seconda solo al cotone per la quantità di materiale prodotto nel mondo e per la varietà di uso. Le fibre grezze delle estremità della pianta vengono utilizzate per produrre corde, tappetini, vestiti a basso costo e scarpe, mentre le fibre più fini vengono utilizzate per imitare la seta.

Leinen

Stoff, der von einer Pflanze der Linaceae-Familie (Flachs oder Leinsamen) gewonnen wird. Wenn die Ernte und das Rösten zum richtigen Zeitpunkt erfolgt, produziert die Pflanze eine erstklassige Faser. Das Garn ist widerstandsfähig, fühlt sich weich an und kann in Bezug auf Gewicht und Strich variieren. Abhängig von der Webart, die benutzt wird, kann alles von einem sehr feinen, leichten Stoff (wie beispielsweise Batist) bis zu einem groben, dicken und rauem Stoff (wie Segeltuch) produziert werden.

Die ältesten Aufzeichnungen über die industrielle Produktion von Leinen stammen aus Ägypten (vor 4000 Jahren), aber die Ursprünge von Leinen liegen noch viel weiter zurück. Leinen ist sehr wahrscheinlich weltweit der älteste pflanzliche Stoff. Da sich das Material besonders gut für feine Stickereien und Handwerk eignete und aufgrund von Problemen bei der Mechanisierung der Leinenproduktion war es die letzte Faser, die 1811 in die maschinelle Produktion eingeführt wurde. Leinen wurde im 19. Jahrhundert für Unterwäsche verwendet und ab dem 20. Jahrhundert bis zum heutigen Tag wird der Stoff in einer breiten Palette von Oberbekleidung, im Haushalt und als Bezugsstoff eingesetzt.

Jute

Jute (ebenfalls als Juteleinen bezeichnet) ist eine kostengünstige, äußerst vielseitige Faser, die von Pflanzen aus der Familie der Malvengewächse (Genus Corchorus) gewonnen wird. Ursprünglich wurde Jute in der Region von Bangladesch angebaut. Inzwischen ist Jute nach Baumwolle der Stoff, der weltweit am meisten produziert wird und die meisten Verwendungszwecke hat. Grobe Fasern von den Enden der Pflanze werden bei der Herstellung von Seilen, Teppichen, kostengünstigem Stoff und sogar Schuhen verwendet, während die feinen Fasern zur Imitation von Seide benutzt werden.

Español

Lino

Materia textil que se obtiene de una planta de la familia de las lináceas (lino o linaza) que, una vez recolectadas y enriadas en la época adecuada, permiten obtener una fibra muy apreciada. El hilo es duradero, suave al tacto y posee un peso y un grano variables. Según el tipo de ligamento utilizado, es posible obtener desde una textura muy fina y ligera (como la batista), hasta un tejido basto, grueso y tosco (como la lona).

La producción industrial del lino está documentada por primera vez en Egipto (4000 años atrás), aunque el origen de este tejido es mucho anterior. De hecho, podría tratarse del primer tejido de origen vegetal del mundo. Puesto que era especialmente adecuado para los bordados y los trabajos hechos a mano, y dadas las dificultades de mecanización de la producción de lino, fue la última fibra que empezó a fabricarse mecánicamente, en 1811. Durante todo el siglo XIX, el lino se utilizó para confeccionar lencería y, desde el siglo XX hasta hoy, ha servido para confeccionar todo tipo de prendas exteriores, así como ropa blanca, cortinas y tapicerías.

Yute

El yute (también denominado *arpillera*) es una fibra económica y extremadamente versátil que se obtiene de las plantas de la familia de las malváceas (género *Corchorus*). Cultivado originalmente en Bangladesh, actualmente el yute es el segundo tejido, después del algodón, con una mayor producción mundial y unos usos más variados. Las fibras toscas de los extremos de la planta se utilizan para fabricar cuerdas, alfombras, ropa económica e incluso zapatos, mientras que las más finas pueden utilizarse como imitación de la seda.

Français

Le lin

Cette plante de la famille des linacées, qu'on récolte et qui doit subir un rouissage, produit une fibre prisée. Le fil qu'on en tire est durable, doux au toucher et peut varier par son poids et son grain. Selon le type de tissage, il peut servir à produire un tissu qui varie de la toile légère (comme la batiste) à la toile rude, épaisse et grossière (comme le canevas).

Les plus anciens documents mentionnant la production industrielle du lin proviennent d'Égypte (il y a 4000 ans), mais les origines du lin sont beaucoup plus anciennes. En fait, le lin est probablement le tissu d'origine végétale le plus ancien du monde. Comme il se prêtait bien à la broderie fine et aux travaux d'aiguille et à cause des difficultés à mécaniser sa production, le lin a été la dernière fibre à être introduite dans le processus industriel, en 1811. Durant tout le XIX^e siècle, le lin a été utilisé pour la lingerie et depuis le XX^e siècle, il est utilisé pour une grande variété de vêtements, de draps, de tentures et de tissus d'ameublement.

Le jute

Le jute est une étoffe bon marché et très polyvalente produite à partir de plantes de la famille des malvacées (les corchorus). Cultivé à l'origine dans la région du Bangladesh, le jute est uniquement devancé par le coton en matière de production mondiale et de variété d'utilisations. Les grosses fibres des extrémités de la plante sont utilisées pour fabriquer des cordes, des paillassons, un tissu bon marché et même des chaussures, alors que les fibres les plus fines peuvent être utilisées pour imiter la soie.

English

Oxford

Oxford is a weave named after the English city of same name. This fabric is a micro-weave, generally made of cotton and used mainly to make men's shirts. Its characteristic surface design, with its two-colour dotted appearance, is produced by weaving warp and weft threads of different weights and colours – the warp yarn is finer than that used for the weft.

Italiano

Oxford

Questo tessuto, che prende il nome dall'omonima città inglese di Oxford, è una microarmatura, in genere di cotone, usato principalmente per la confezione di camicie da uomo. La caratteristica fantasia dall'aspetto puntinato bicolore è costituita dall'intreccio di fili di ordito differenti da quelli di trama per finezza e colore – l'ordito ha un filato più fine di quello usato per la trama.

Deutsch

Oxford-Gewebe

Oxford ist ein Gewebe, das nach der englischen Stadt mit dem gleichen Namen benannt wurde. Dieser Stoff ist ein Mikrogewebe, das im allgemeinen aus Baumwolle gefertigt wird und hauptsächlich für die Fertigung von Herrenhemden benutzt wird. Das charakteristische Oberflächendessin mit seiner zweifarbigen, gepunkteten Erscheinung, wird mit Kett- und Schussfäden unterschiedlicher Gewichte und Farben hergestellt – die Kettfäden sind feiner als die, die für die Schussfäden verwendet werden.

Español

Oxford

El tejido Oxford, que lleva el nombre de la ciudad británica homónima, es un microligamento, en general elaborado con algodón y utilizado sobre todo para confeccionar camisas. El diseño de la superficie, caracterizado por los puntos de dos colores, se obtiene tejiendo hilos de urdimbre y de trama de distintos pesos y colores (el hilo de urdimbre es más fino que el de trama).

Français

L'oxford

L'oxford tire son nom de la ville d'Angleterre. Ce tissu à microarmure, généralement fait de coton, est utilisé principalement pour la fabrication de chemises pour homme. Son motif de surface caractéristique, avec une apparence pointillée bicolore, s'obtient en tissant des fils de chaîne et des fils de trame de différents poids et couleurs ; le fil de chaîne est plus fin que le fil de trame.

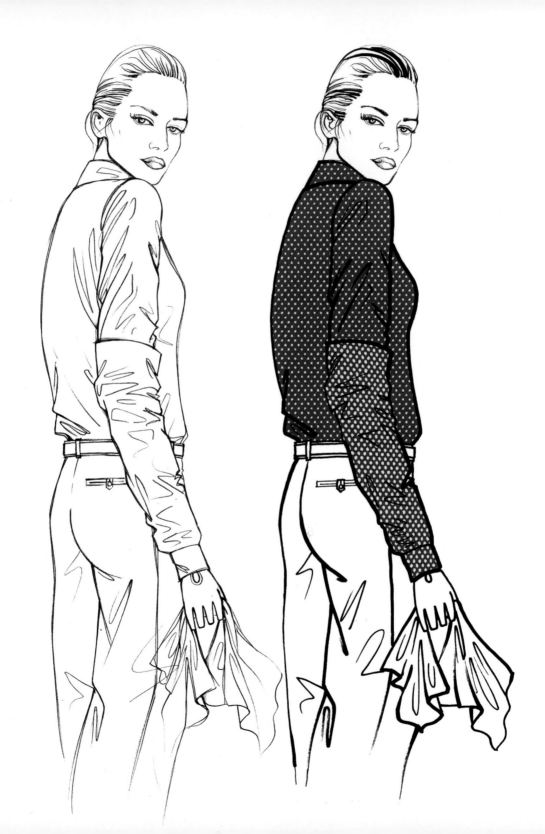

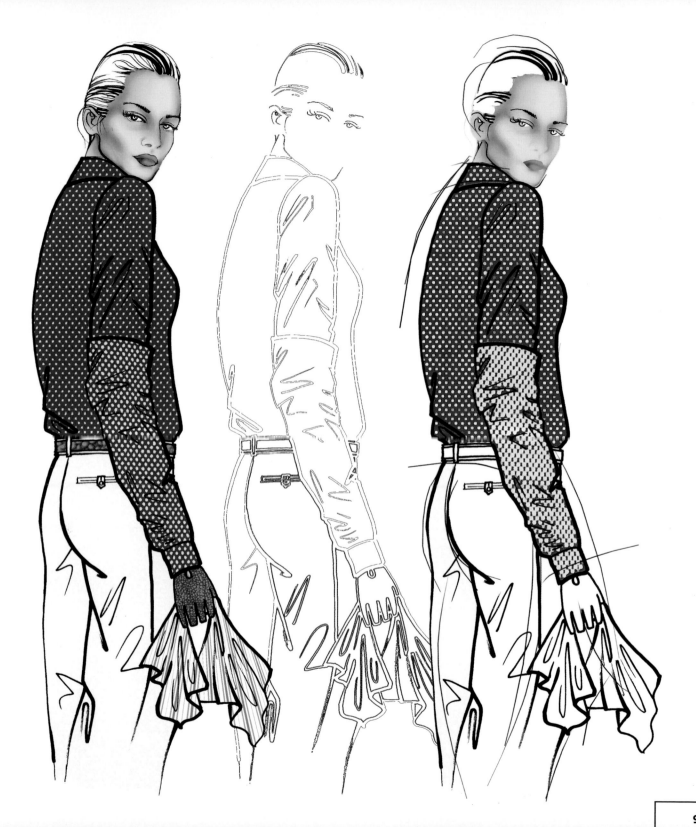

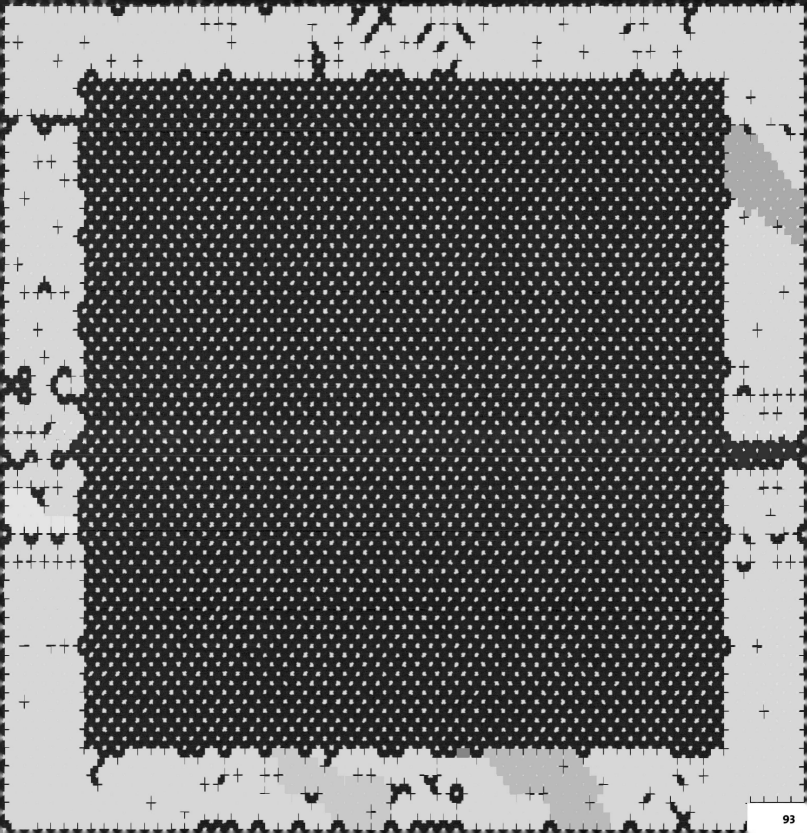

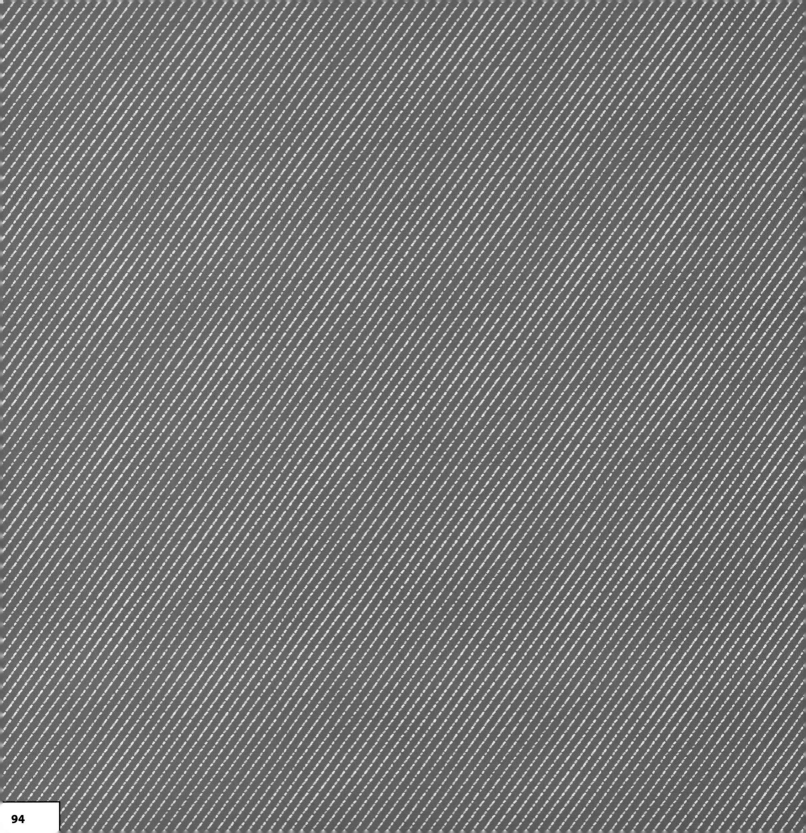

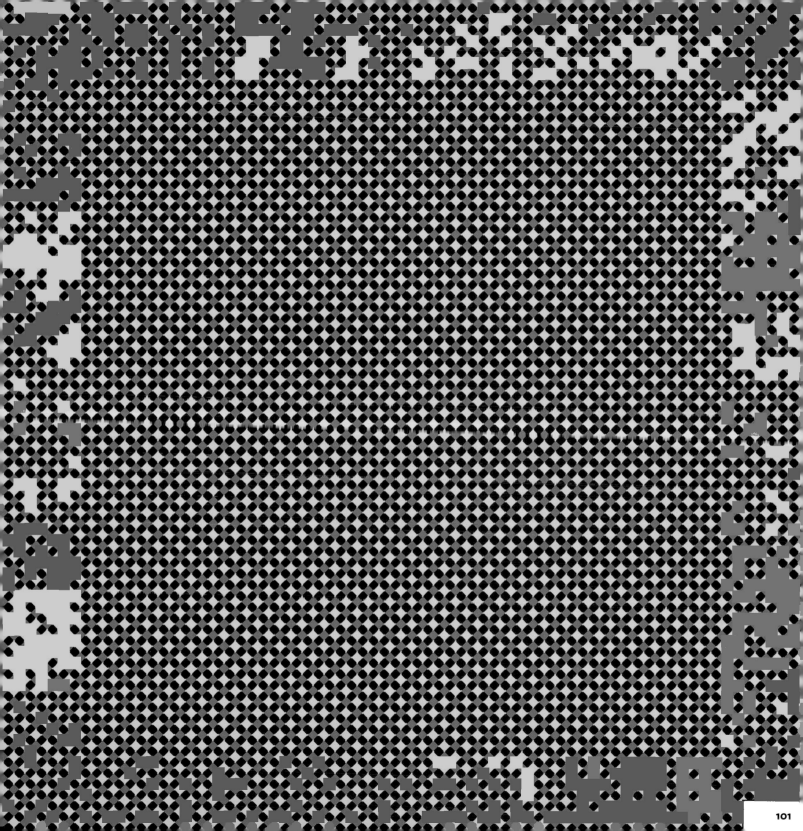

English

Leathers and skins

Animal skins and furs were most likely the basis for man's first clothes and are still used today in the manufacture of clothing and accessories. The most common leather/skin varieties are produced from cow, goat, sheep and pig hides, but exotic skins – such as alligator, ostrich, snake, stringray, fish and many others – are widely available for use in fashion design. Many leathers are also available in synthetic versions.

Italiano

Pelle e pellami

Molto probabilmente le pelli e le pellicce degli animali sono state la base dei primi indumenti dell'uomo e sono usate ancora oggi nella manifattura di capi d'abbigliamento e accessori. Le più comuni varietà di pelle o cuoio sono quelle prodotte dalle mucche, dalle capre, dalle pecore e dai maiali, ma alcune pelli esotiche – come quelle dei coccodrilli, degli struzzi, dei tritoni, di alcuni pesci e altro ancora – vengono spesso usate nel design di moda. Molti tipi di pelle sono disponibili anche in versione sintetica.

Deutsch

Leder und Häute

Tierhäute und -felle haben sehr wahrscheinlich als Basis für die ersten Kleider des Menschen gedient und werden heute immer noch in der Herstellung von Kleidern und Accessoires verwendet. Die häufigsten Variationen von Leder und Häuten werden von Rindern, Schafen und Schweinen gewonnen, aber exotische Häute – wie beispielsweise von Alligatoren, Straußenvögeln, Schlangen, Stechrochen und vielen anderen – werden im Modedesign ebenfalls oft benutzt. Zahlreiche Leder sind ebenfalls in einer synthetischen Ausführung erhältlich.

Español

Cuero y pieles

Probablemente, las pieles de animales fueron la primera vestimenta del hombre, y aún hoy siguen utilizándose para confeccionar prendas y accesorios de vestir. Las variedades más habituales se obtienen del cuero de la vaca, la cabra, la oveja y el cerdo, aunque las pieles exóticas como la de caimán, avestruz, serpiente, raya y peces, entre muchas otras, también se utilizan mucho en el mundo de la moda. Hoy en día existen versiones sintéticas de muchos tipos de pieles.

Français

Les cuirs et les peaux

Les peaux et les fourrures ont tout probablement servi de vêtements aux premiers hommes et sont encore utilisées aujourd'hui dans la fabrication de vêtements et d'accessoires. Les variétés les plus communes de cuir sont produites à partir de peaux de vache, de chèvre, de mouton et de porc, mais des cuirs exotiques – comme l'alligator, l'autruche, le serpent, la raie, le poisson et bien d'autres – sont largement utilisés dans la création de mode. Plusieurs cuirs sont aussi offerts en version synthétique.

LEATHERS AND SKINS
PELLE E PELLAMI
LEDER UND HÄUTE
CUERO Y PIELES
LES CUIRS ET LES PEAUX

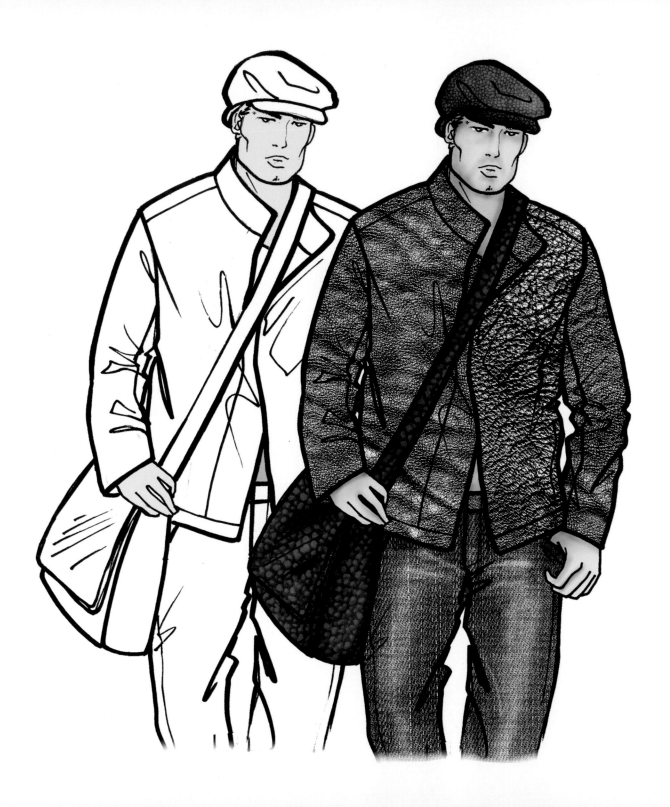

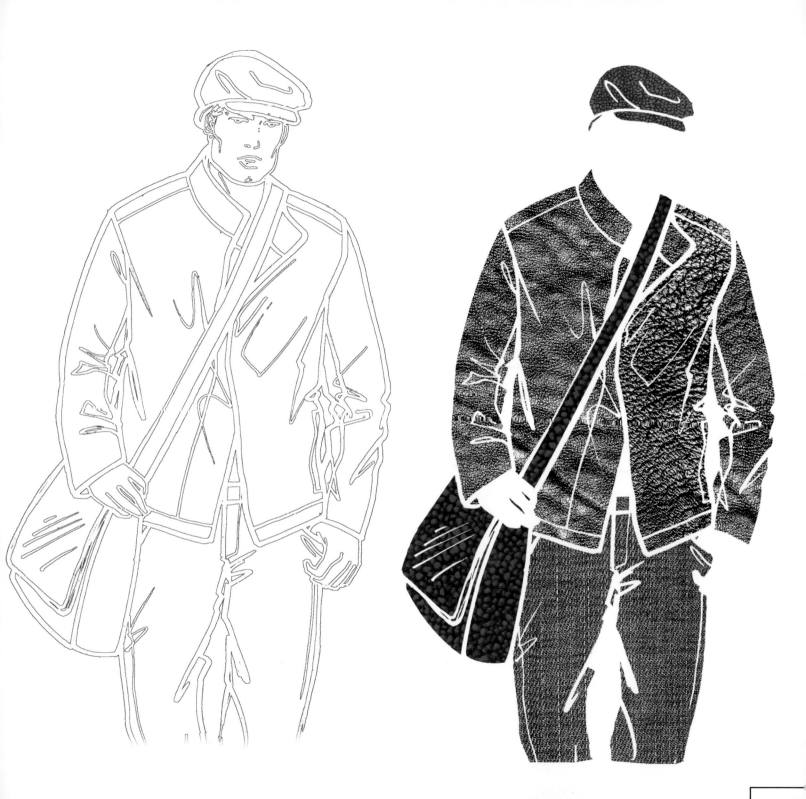

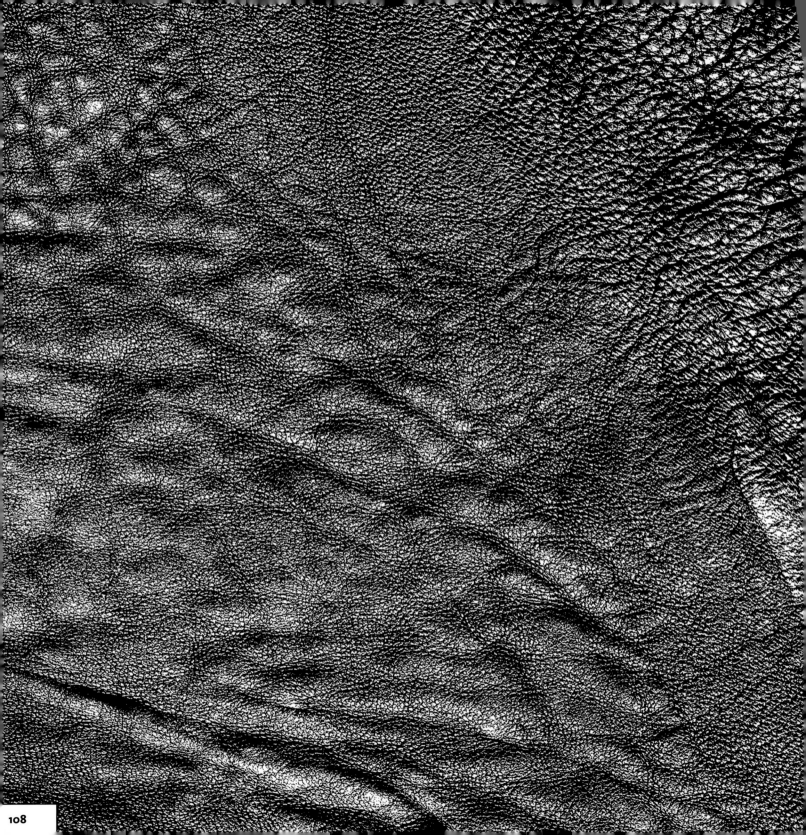

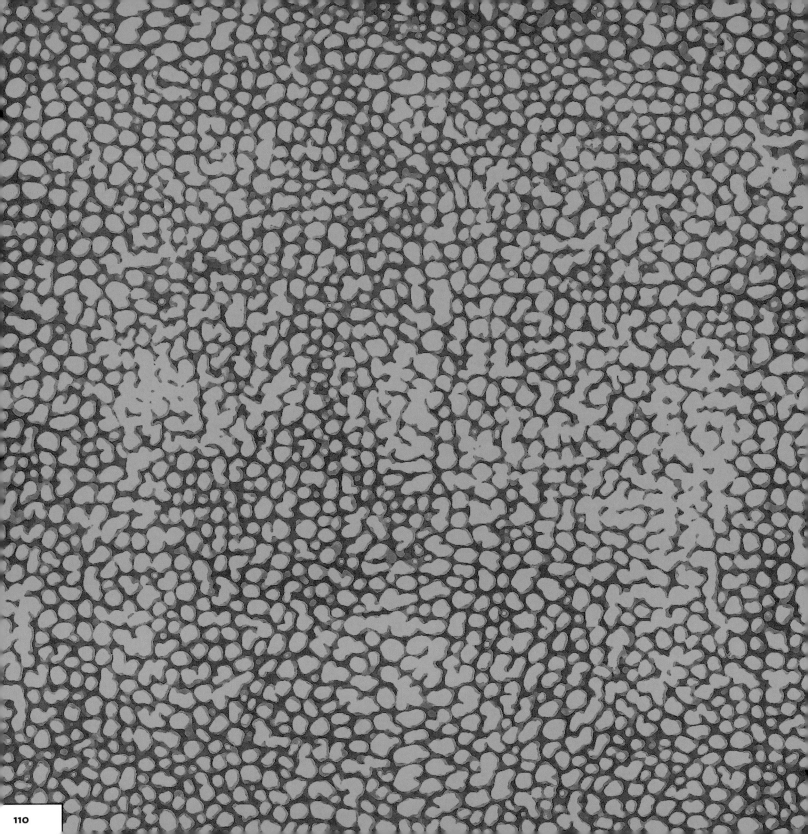

English

Houndstooth Check

Houndstooth (also written "hound's tooth") is a woollen fabric characterized by its pattern of broken or jagged checks – sometimes referred to as four-point stars. The name probably derives from the fact that the jagged checks resemble the back teeth of a hound. Usually woven in two colours, it has been popular since the 19th century for use in jackets, skirts and trousers. The term 'houndtooth' refers more to the pattern than to a specific type of fabric or weave.

Italiano

Pied de poule

Il nome di questo tessuto deriva dall'omonima espressione francese per indicare la zampa della gallina, probabilmente perché il suo disegno a quadretti irregolari ricorda le squame che ricoprono le zampe di una gallina. Solitamente a due colori, divenne popolare a partire dal XIX secolo per la confezione di giacche, gonne e pantaloni. Il termine *pied de poule* viene utilizzato più per indicare il disegno che non un particolare tipo di tessuto o armatura.

Deutsch

Pepita

Pepita ist ein Wolltextil, das durch sein Muster von gebrochenen oder gezackten Karos charakterisiert wird. Es wird manchmal auch als Stern mit vier Punkten bezeichnet. Normalerweise ist der Stoff zweifarbig und er ist seit dem 19. Jahrhundert für die Verwendung in Jacken, Röcken und Hosen beliebt. Der Begriff »Pepita« bezieht sich mehr auf das Muster als auf eine bestimmte Stoff- oder Webart.

Español

Pata de gallo

La pata de gallo es un tejido de lana que se caracteriza por el estampado que recuerda a las extremidades inferiores de estas aves. Normalmente ligado en dos colores, se puso de moda en el siglo XIX y aún hoy se utiliza para confeccionar chaquetas, faldas y pantalones. Más que designar un determinado tipo de tejido o ligamento, el término *pata de gallo* se refiere más bien al estampado.

Français

Le pied-de-poule

Le pied-de-poule est un tissu de laine dont les motifs évoquent les empreintes des pattes de poule. Habituellement tissé en deux couleurs, il est populaire depuis le XIXe siècle pour faire des, vestes des jupes et des pantalons. Le terme « pied-de-poule » se rapporte davantage au motif qu'à un type particulier de tissage ou d'armure.

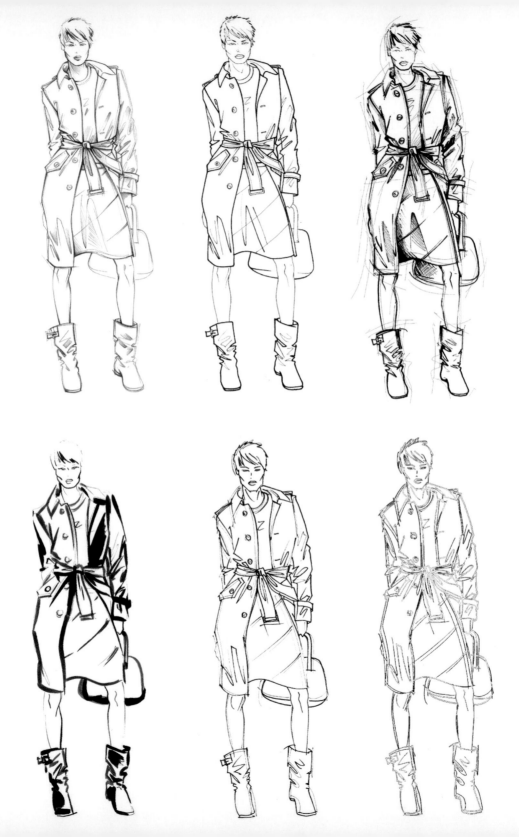

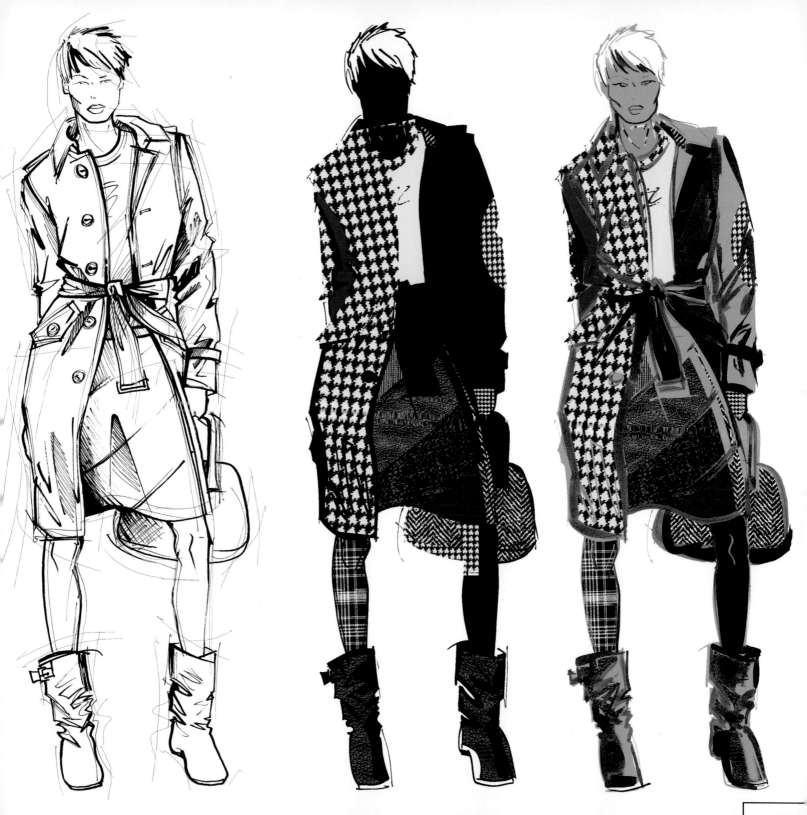

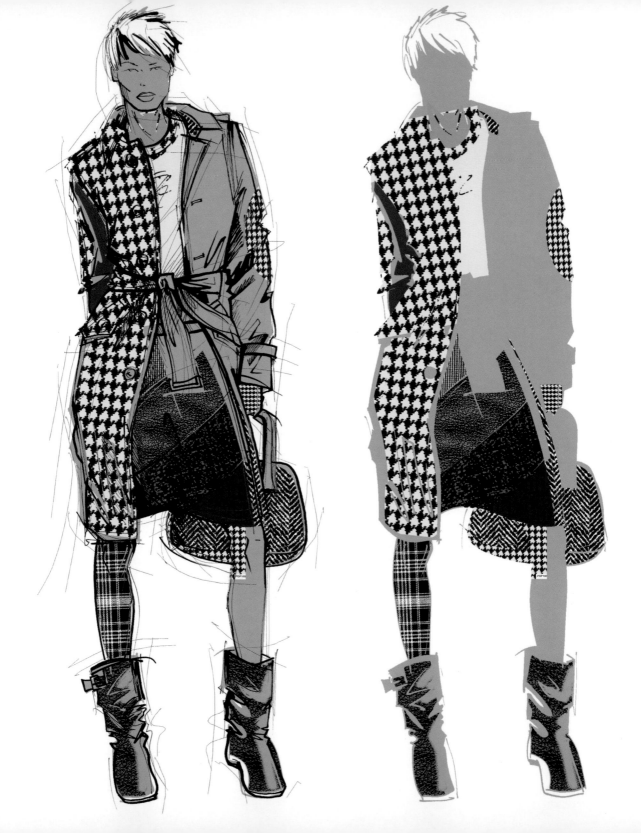

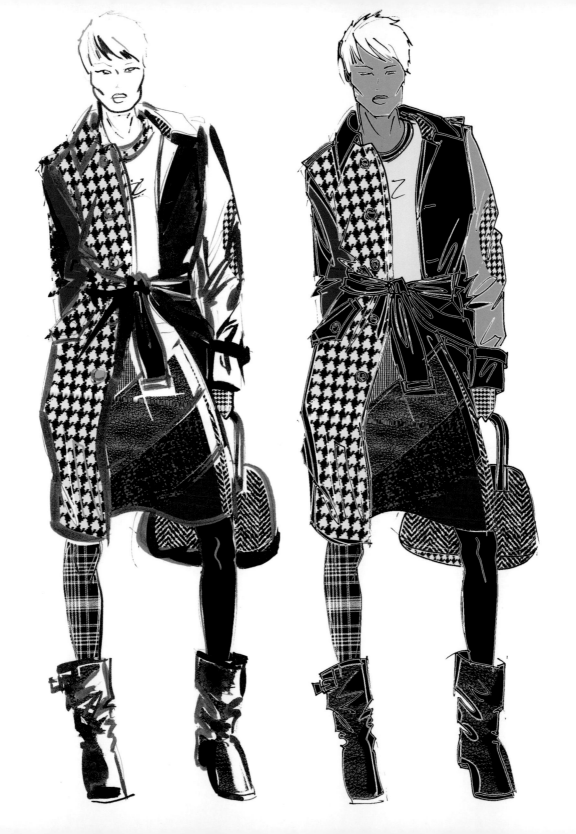

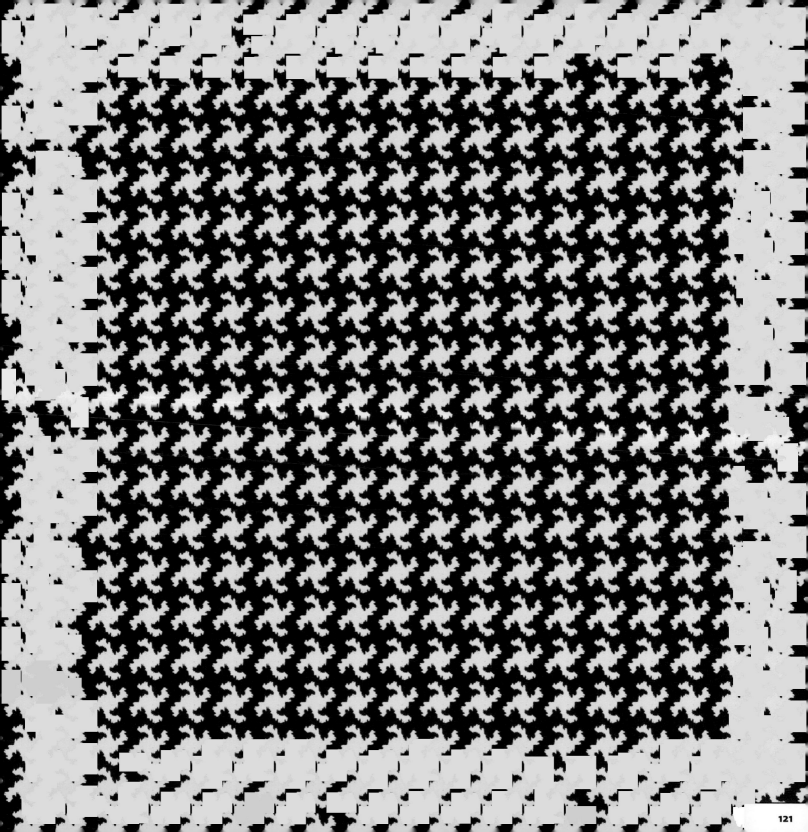

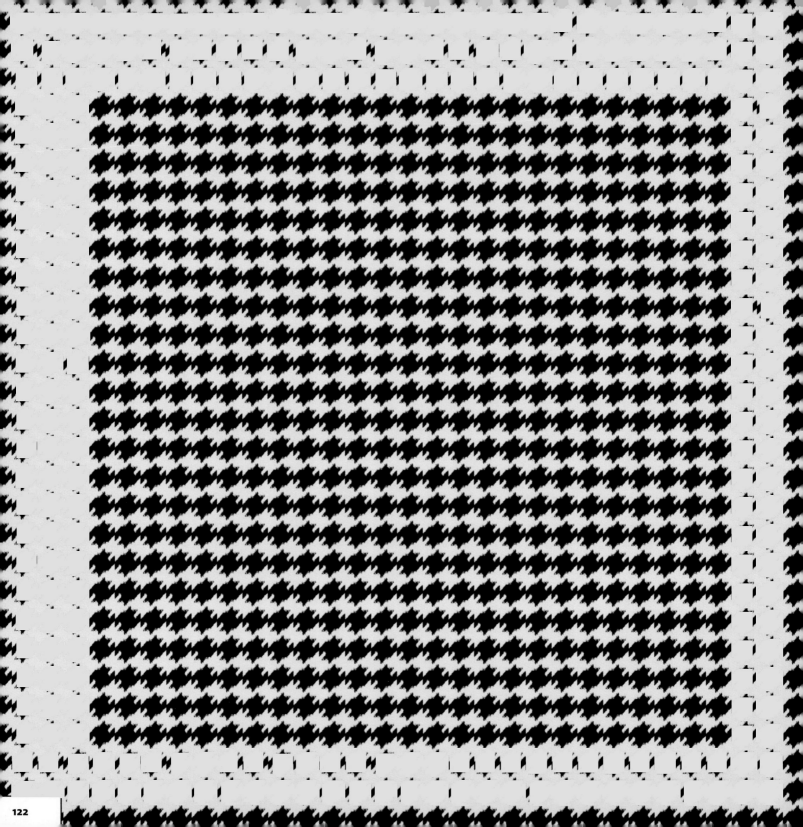

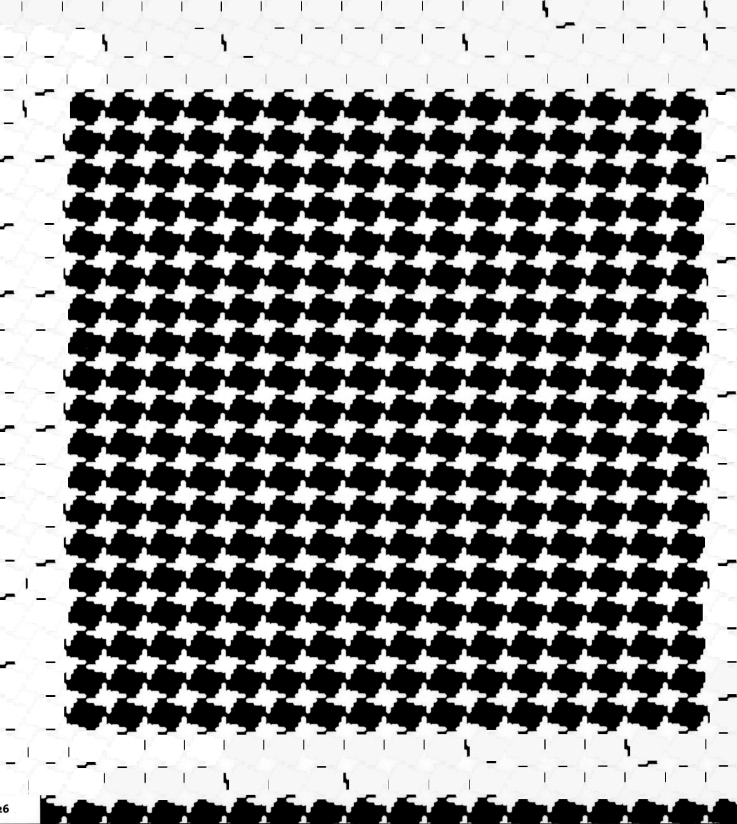

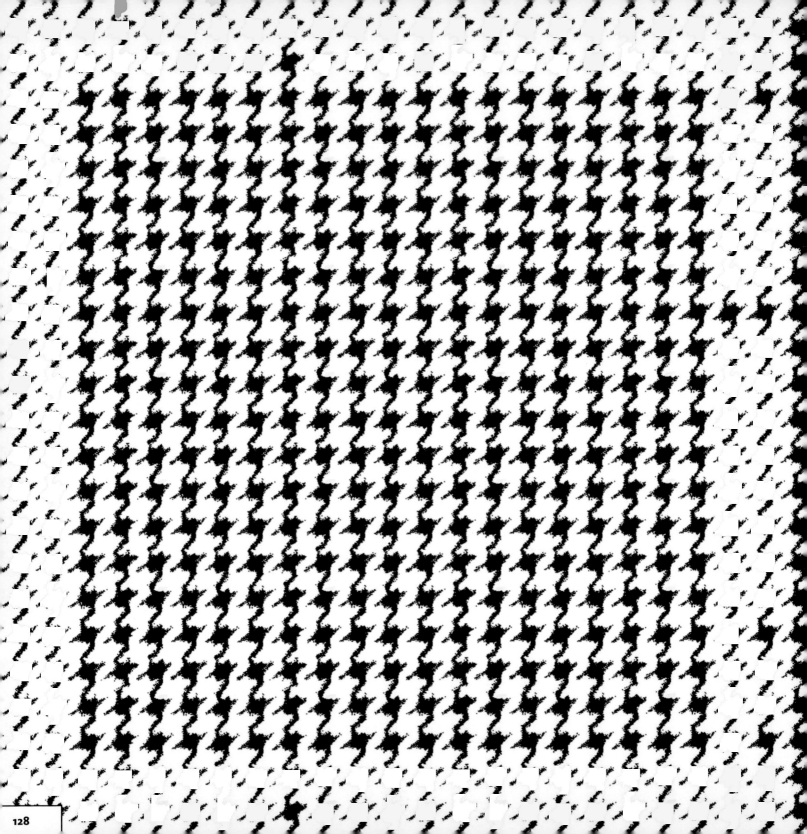

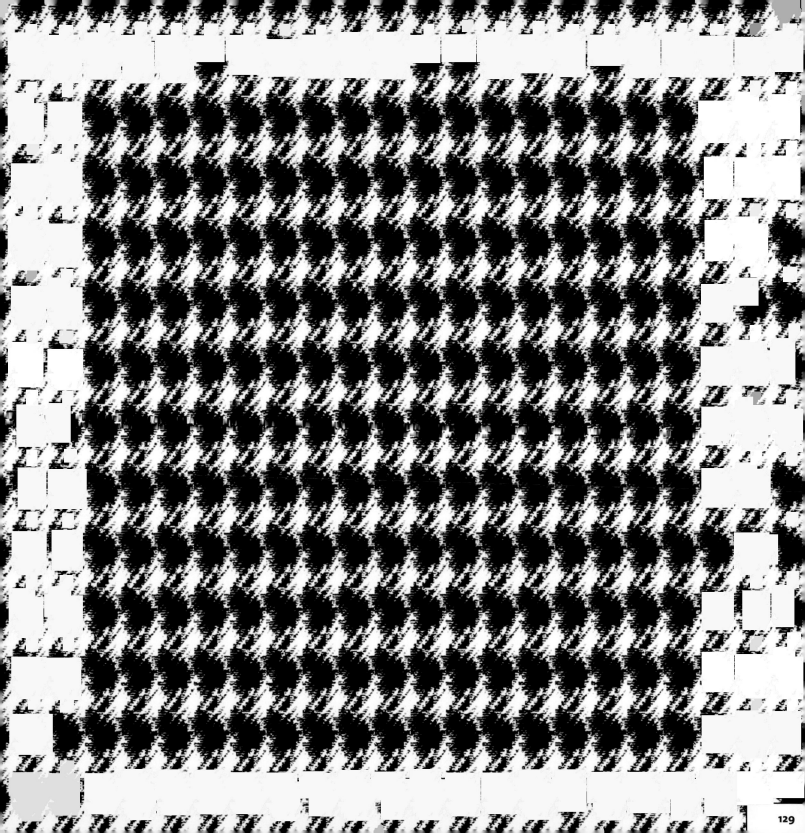

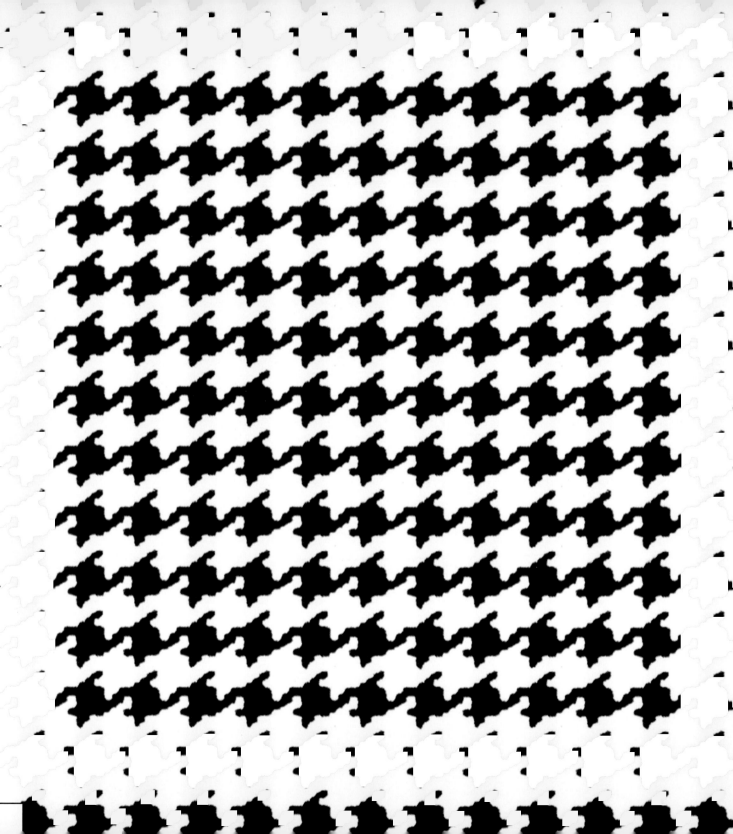

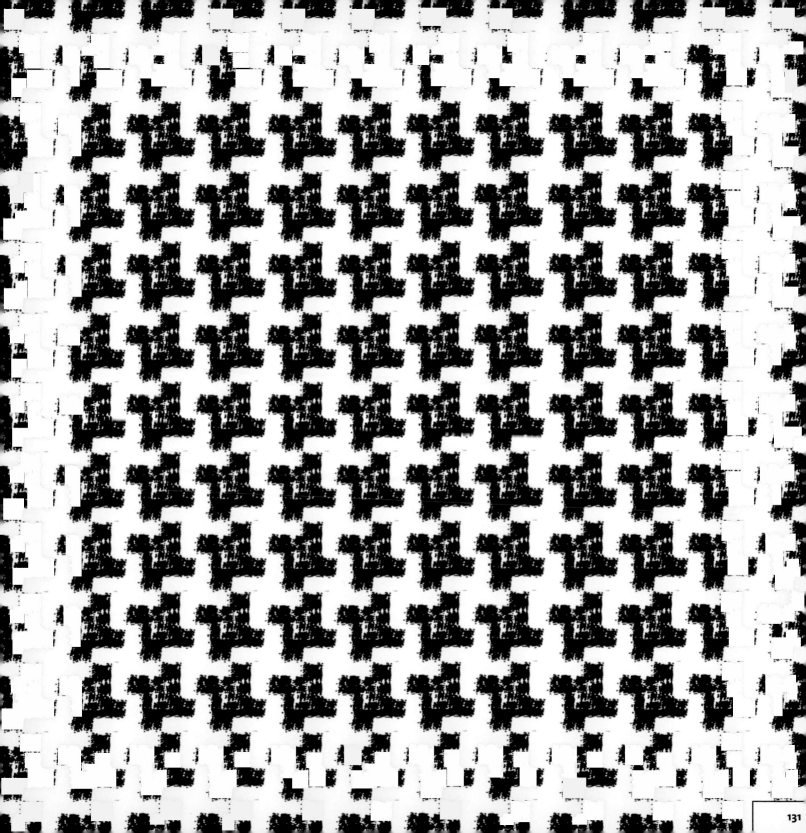

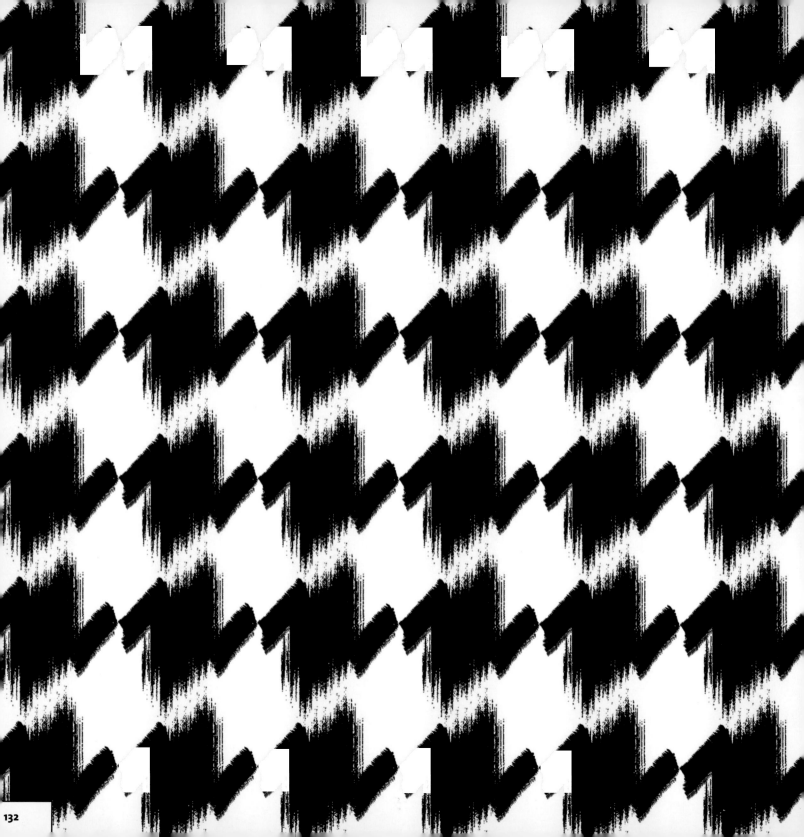

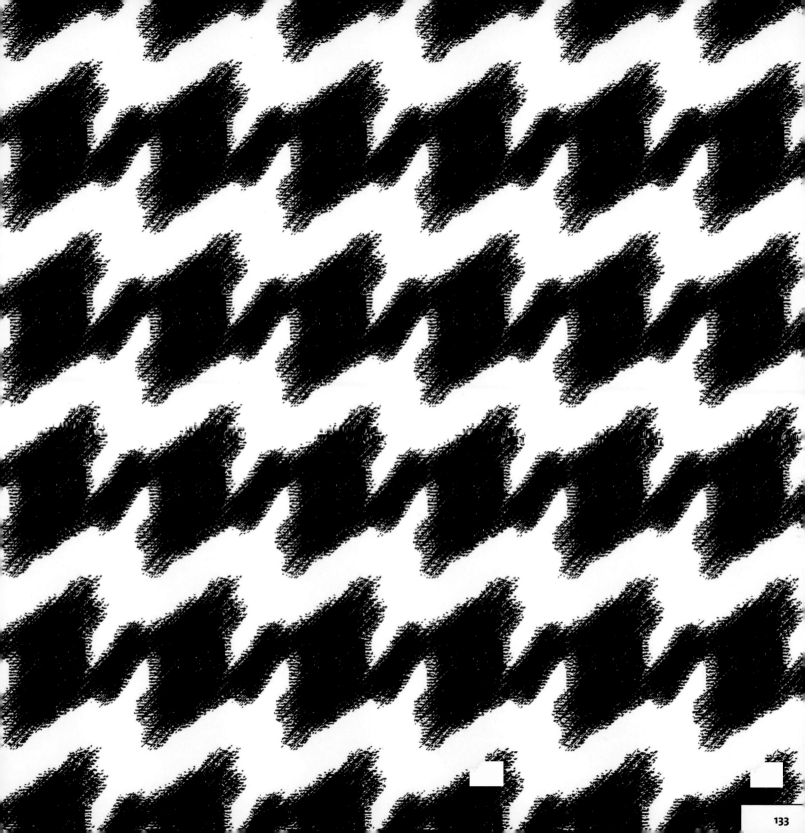

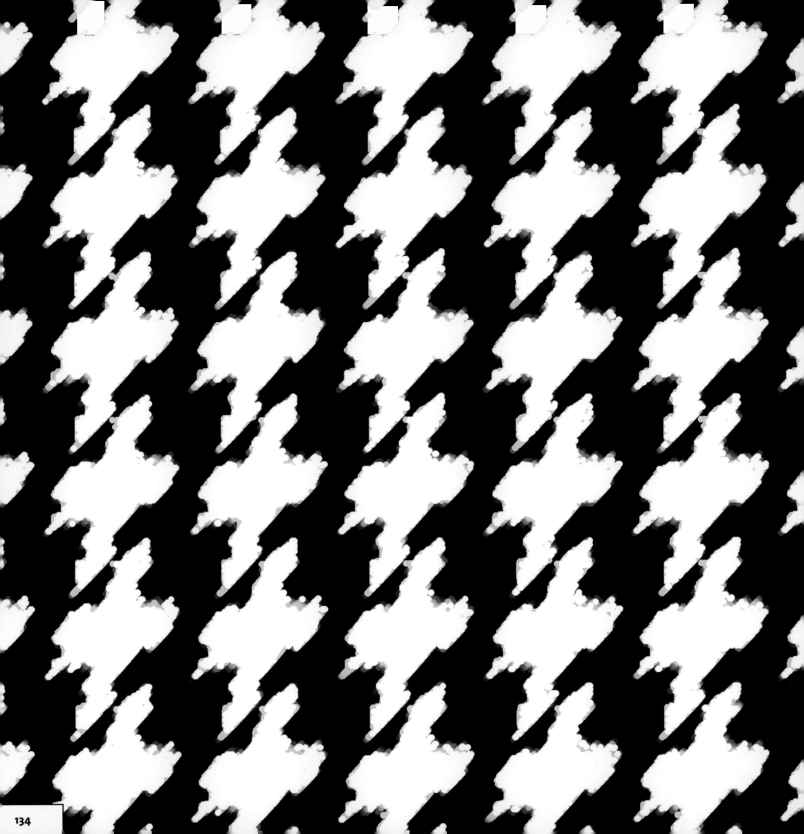

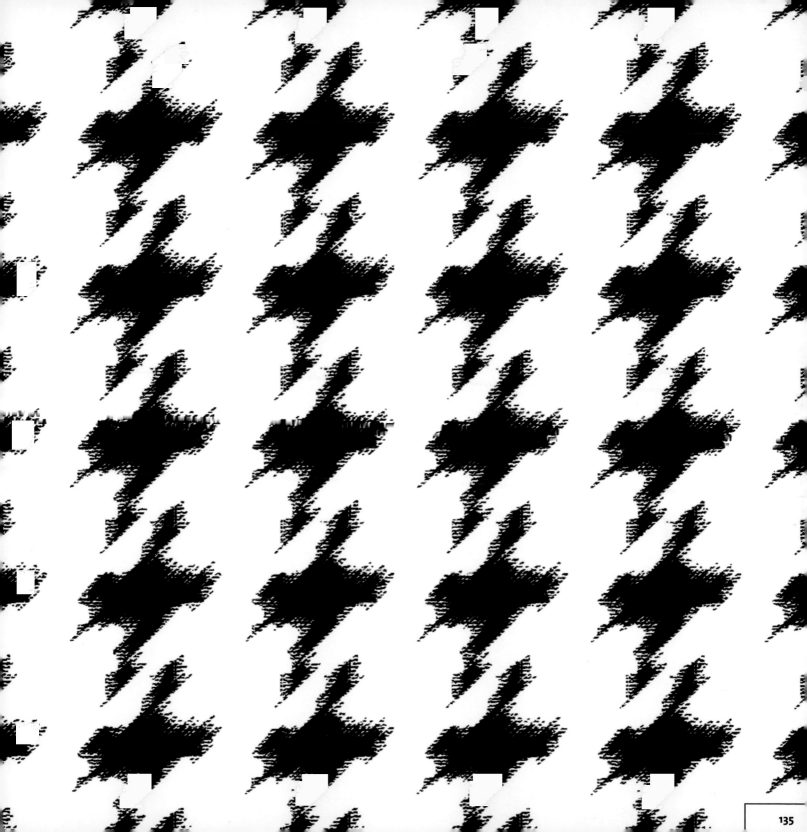

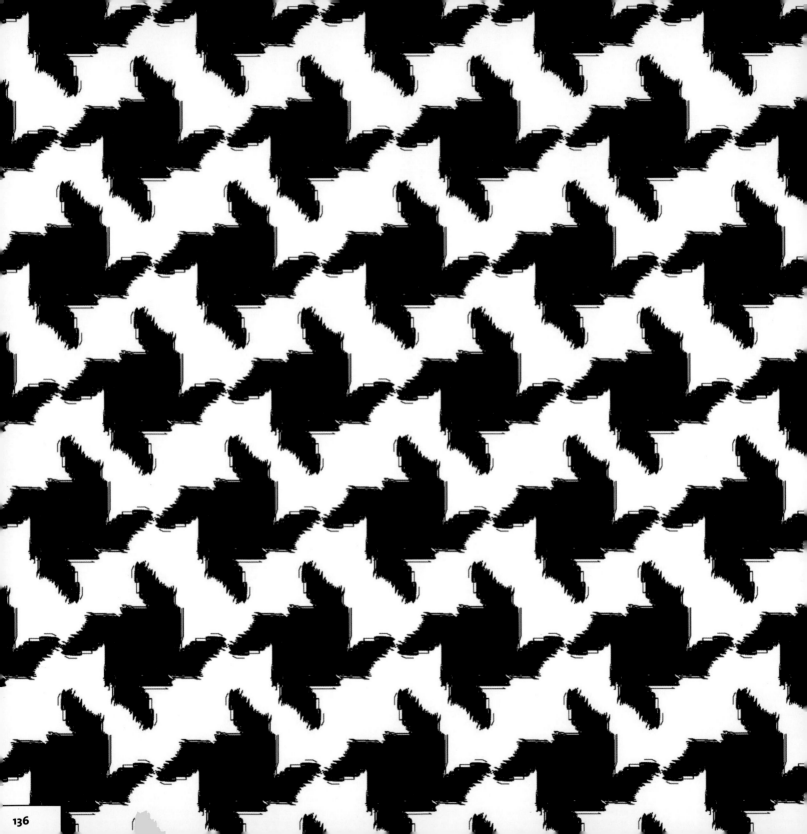

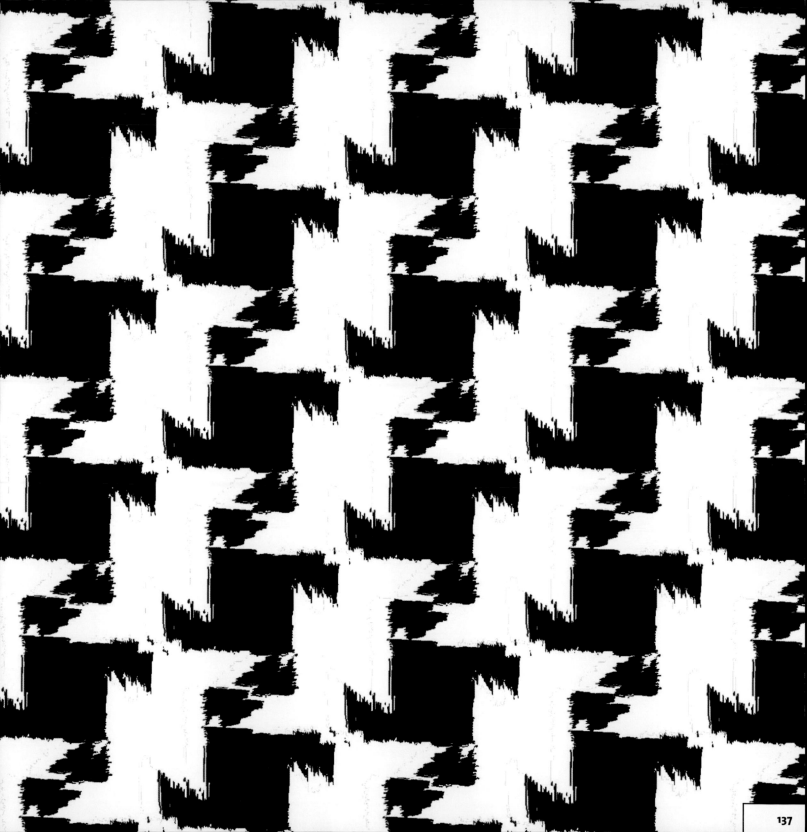

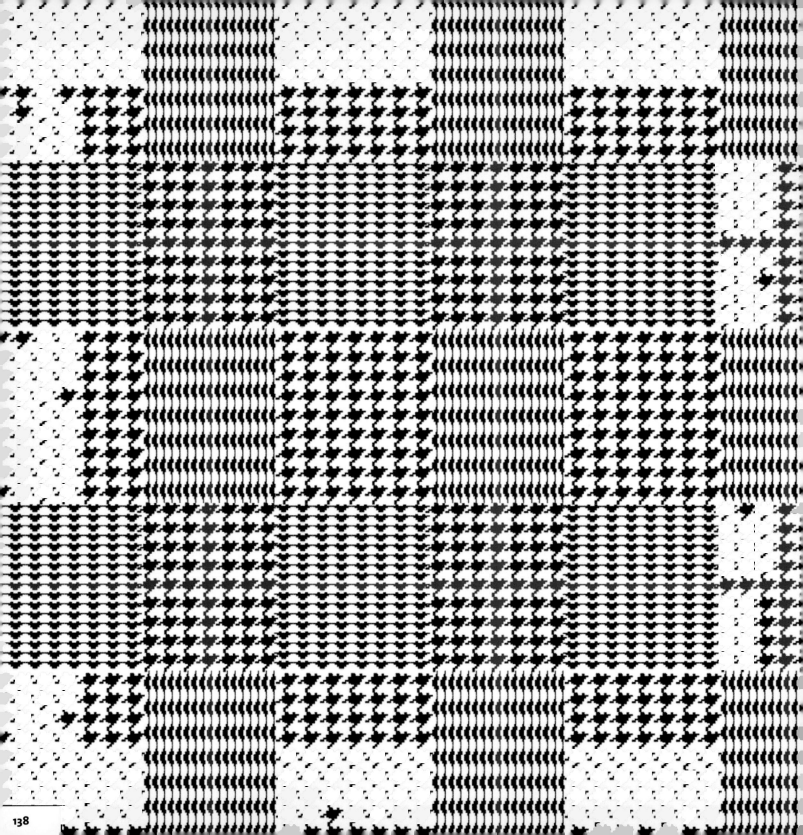

English

Prince of Wales Check

The Prince of Wales check was designed by King Edward VII while he was the Prince of Wales (1841 – 1901). His grandson, Edward (also Prince of Wales and later King Edward VIII), favoured the black and white Glen Urquhart check – one of several varieties of Glen checks. In popular usage, the term Prince of Wales often (mistakenly) refers to patterns from any of these three families of checks. All three are characterised by alternating checked patterns (often houndstooth alternating with guard's check) which, when combined, produce a larger checked pattern. Prince of Wales and Glen checks traditionally contain an additional overcheck in a contrasting colour, while Glen Urquhart checks do not.

In Great Britain, these checks are primarily used for more relaxed clothing to be worn at weekends In the rest of Europe and in America, they are more often used for suits and business attire.

Italiano

Principe di Galles

Il tessuto principe di Galles fu disegnato da Re Edoardo VII quando era ancora il Principe del Galles (1841 – 1901). Suo nipote Edoardo (anche lui prima Principe del Galles, poi Re Edoardo VIII) indossò volentieri questa fantasia Glen Urquhart nei colori bianco e nero, una delle molte varianti del Glen check. Nell'uso popolare il termine Principe di Galles è usato spesso ed erroneamente per indicare una di queste tre famiglie di disegni. Tutte e tre sono caratterizzate da motivi alternati (spesso *pied de poule* alternato a stoffa quadrettata) che, se combinati tra loro, danno luogo a un motivo più grande. Il Principe di Galles e i Glen check in genere presentano un disegno sovrapposto in un altro colore, mentre i Glen Urquhart no.

In Gran Bretagna è usato soprattutto per la produzione di capi di abbigliamento sportivi, da indossare nel tempo libero. Nel resto dell'Europa e in America, invece, viene usato principalmente per gli abiti degli uomini d'affari.

Deutsch

»Prince of Wales« Karo

Das »Prince of Wales« Karo wurde von König Eduard VII entworfen während er der Fürst von Wales (Prince of Wales) (1841 – 1901) war. Sein Enkelsohn, Eduard (ebenfalls Fürst von Wales und späterer König Eduard VIII), bevorzugte das schwarz-weiße »Glen Urquhart« Karo – eines von mehreren Variationen der »Glen« Karomuster. Umgangsprachlich wird der Begriff »Prince of Wales« oft (irrtümlich) für die Beschreibung von Mustern von einer der drei Familien dieser Karomuster benutzt. All drei werden von abwechselnd karierten Mustern charakterisiert (oftmals Pepita im Wechsel mit »Guard's« Karo), die, wenn diese kombiniert werden, ein größeres Karomuster bilden. Die »Prince of Wales« und »Glen« Karomuster beinhalten traditionell ein zusätzliches Overcheck in einer kontrastierenden Farbe, während »Glen Urquart« Karos dies nicht aufweisen.

In Großbritannien werden diese Karomusters hauptsächlich für Freizeitkleidung benutzt, die am Wochenende getragen wird. Im Rest von Europa und in Amerika werden diese häufiger für Anzüge und Geschäftskleidung verwendet.

Español

Cuadro príncipe de Gales

El rey Eduardo VII diseñó los cuadros príncipe de Gales durante su principado (1841-1901). Su nieto Eduardo (también príncipe de Gales y posteriormente el rey Eduardo VIII) prefería los cuadros Glen Urquhart en blanco y negro, una de las muchas variedades de los cuadros Glen. Popularmente, el término *príncipe de Gales* suele referirse (equivocadamente) al estampado de cualquiera de estas tres familias de cuadros. Los tres se distinguen por la alternancia de estampados de cuadros (a veces en combinación con pata de gallo) que, al combinarse, crean un estampado a cuadros de mayor tamaño. Por tradición, los cuadros príncipe de Gales y Glen incorporan un relieve en un color contrastante, al contrario que los Glen Urquhart.

En Gran Bretaña, este tipo de cuadros se utilizan sobre todo para confeccionar prendas deportivas para el fin de semana. En cambio, en el resto de Europa y Estados Unidos se reservan para los trajes y la ropa formal.

Français

Le prince-de-Galles

Le prince-de-Galles a été conçu par le roi Édouard VII lorsqu'il était prince de Galles (1841 – 1901). En français, le terme « prince-de-Galles » sert á désigner une gamme de motifs apparentés qui peuvent avoir plusieurs noms différents en anglais : « Prince of Wales », « Glen Urquhard » et « Glen ». Même en anglais, le terme « Prince of Wales » est souvent utilisé (á tort) comme un terme générique pour désigner des étoffes semblables. Ces motifs sont tous caractérisés par une combinaison de petits motifs de carreaux en alternance qui, lorsqu'ils sont arrangés ensemble, produisent un motif á carreaux plus grand.

En Grande-Bretagne, ces carreaux sont surtout utilisés pour des vêtements plus décontractés qu'on porte le week-end. Dans le reste de l'Europe et en Amérique, ils sont surtout utilisés pour les costumes et les complets.

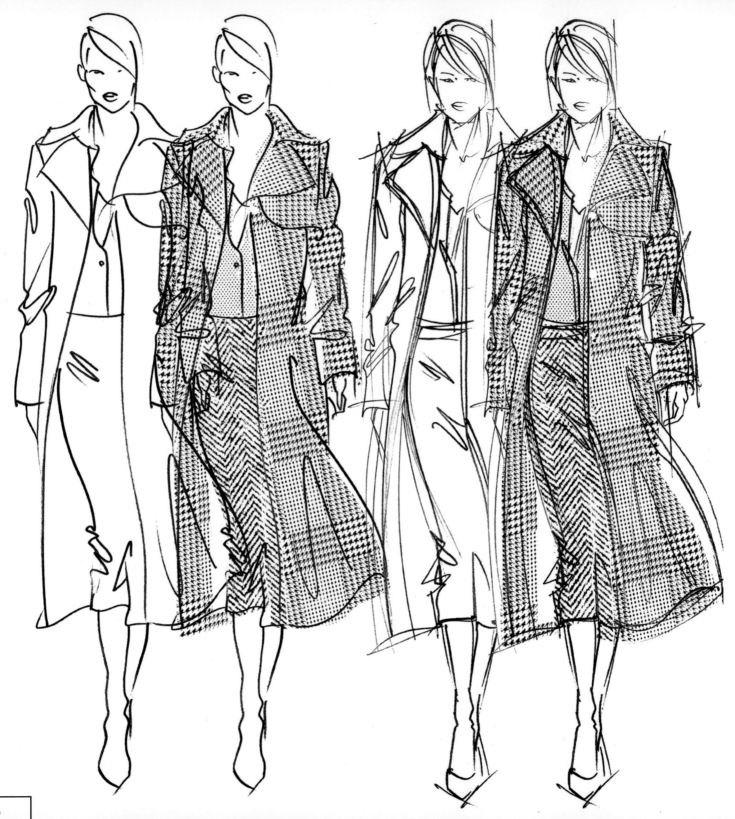

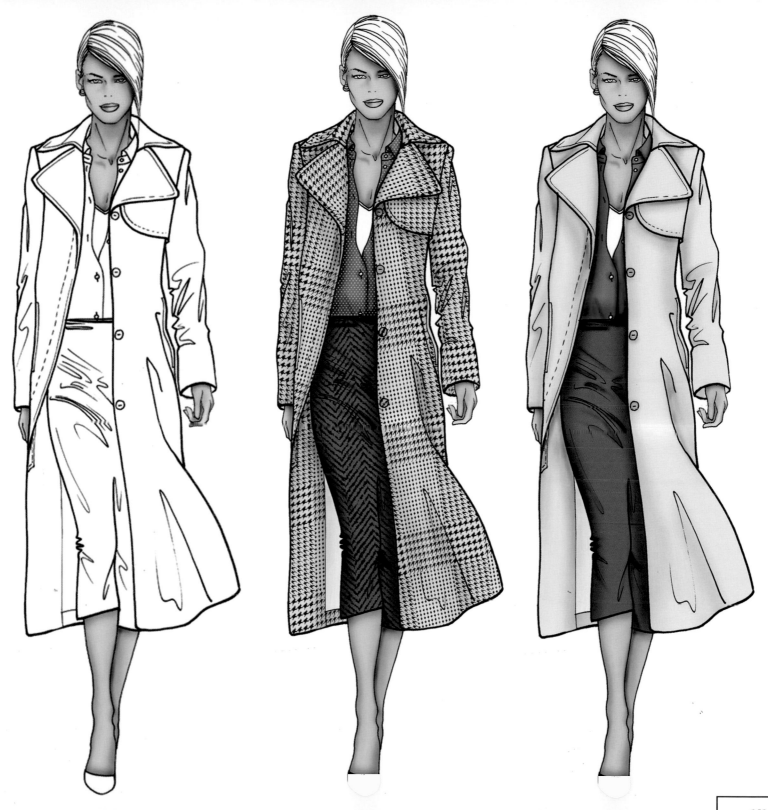

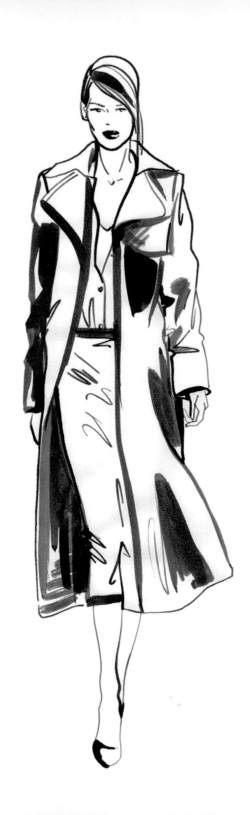
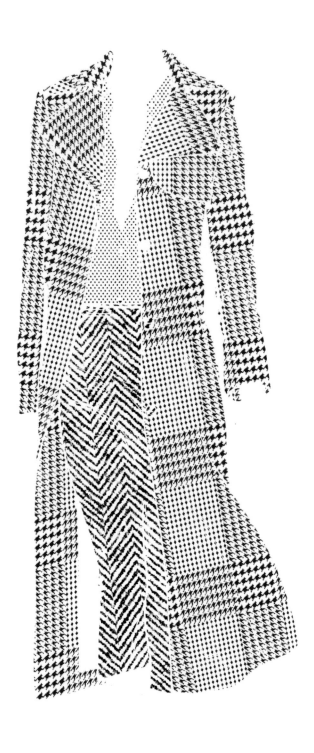

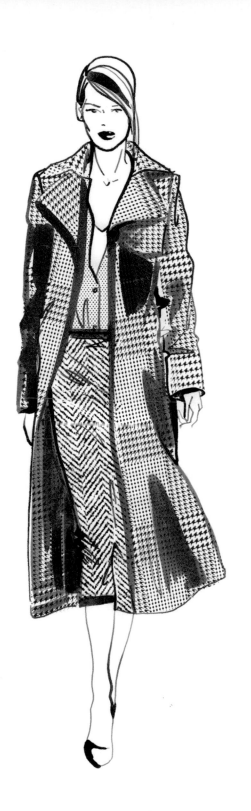
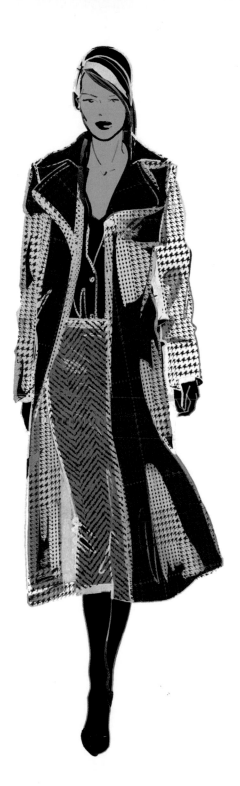

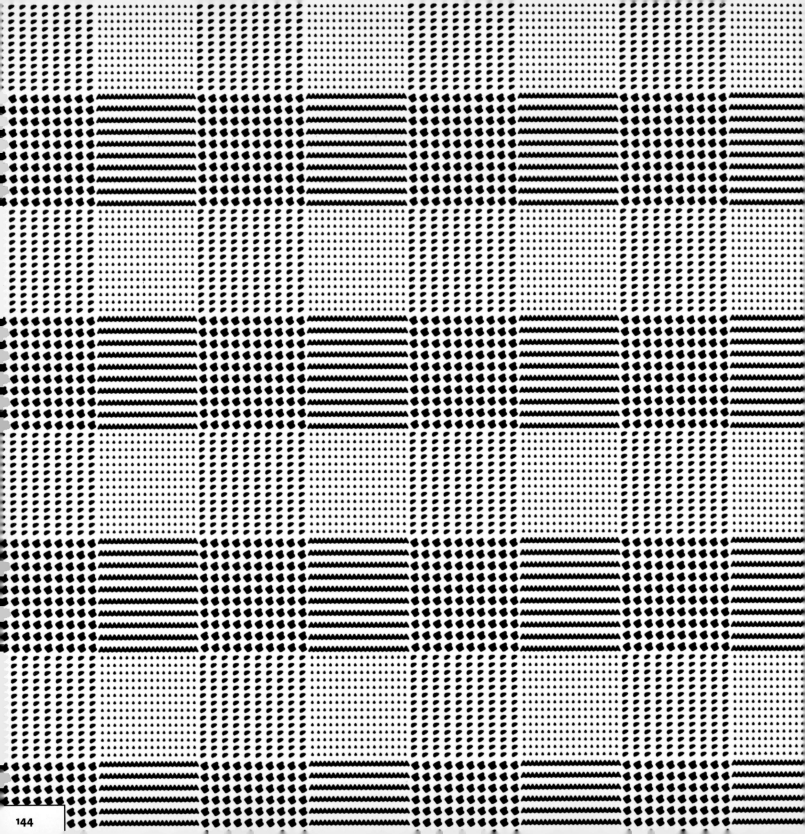

144

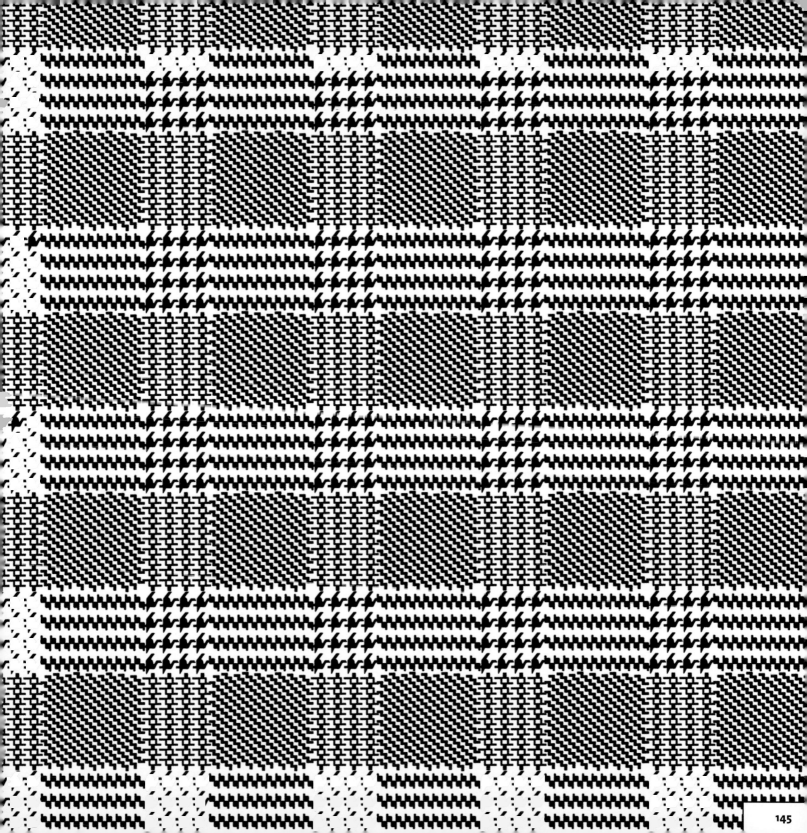

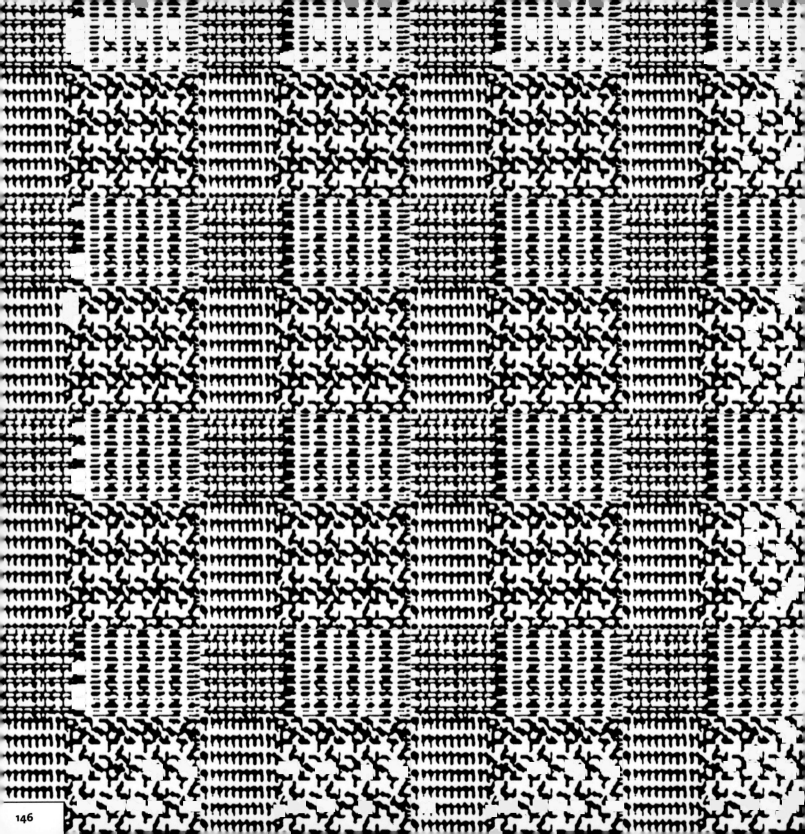

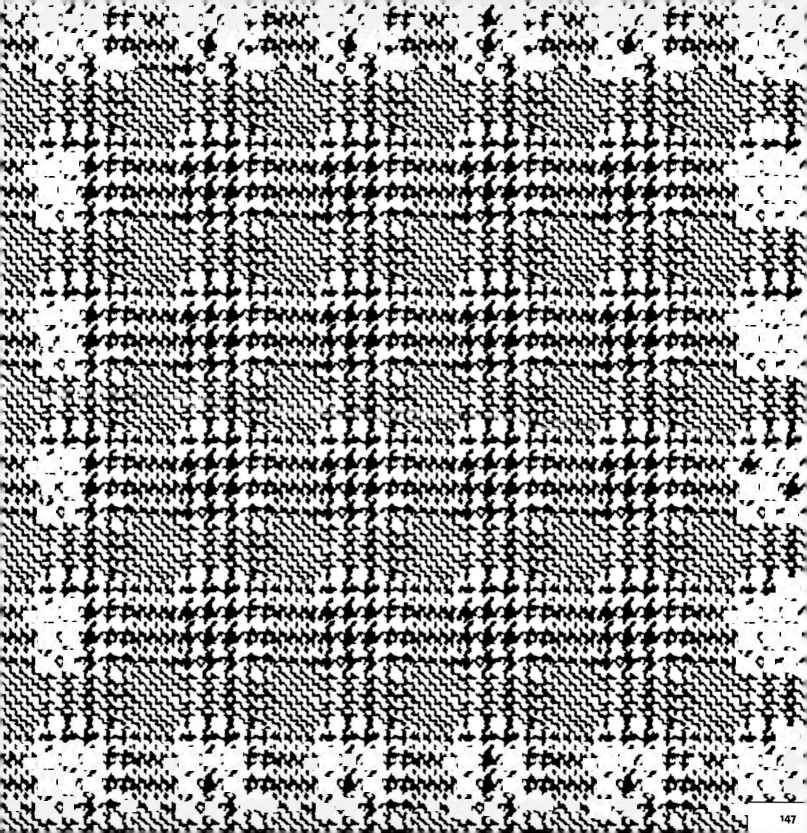

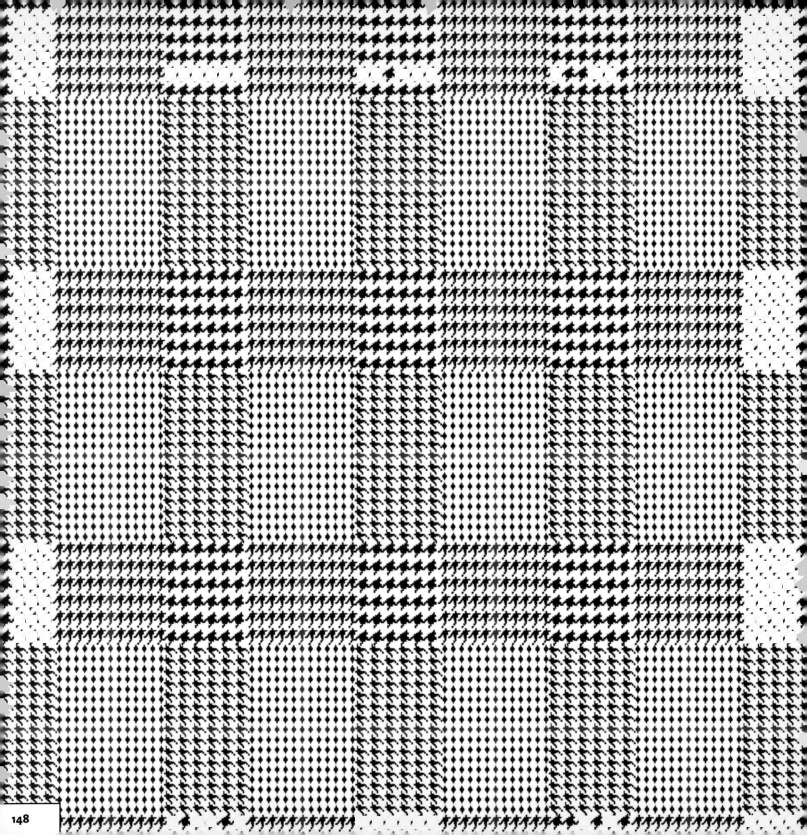

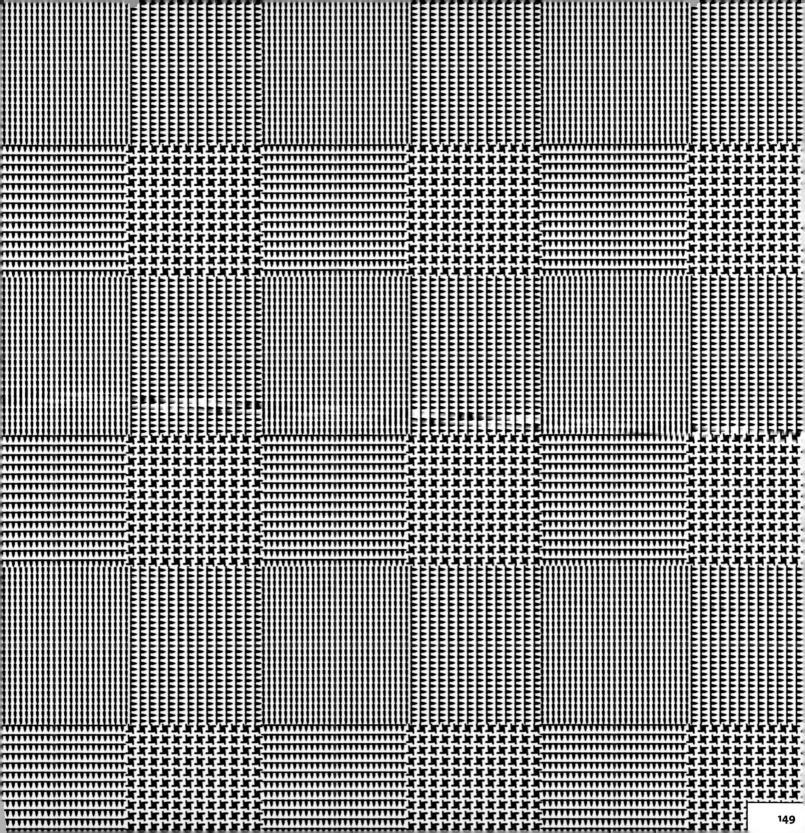

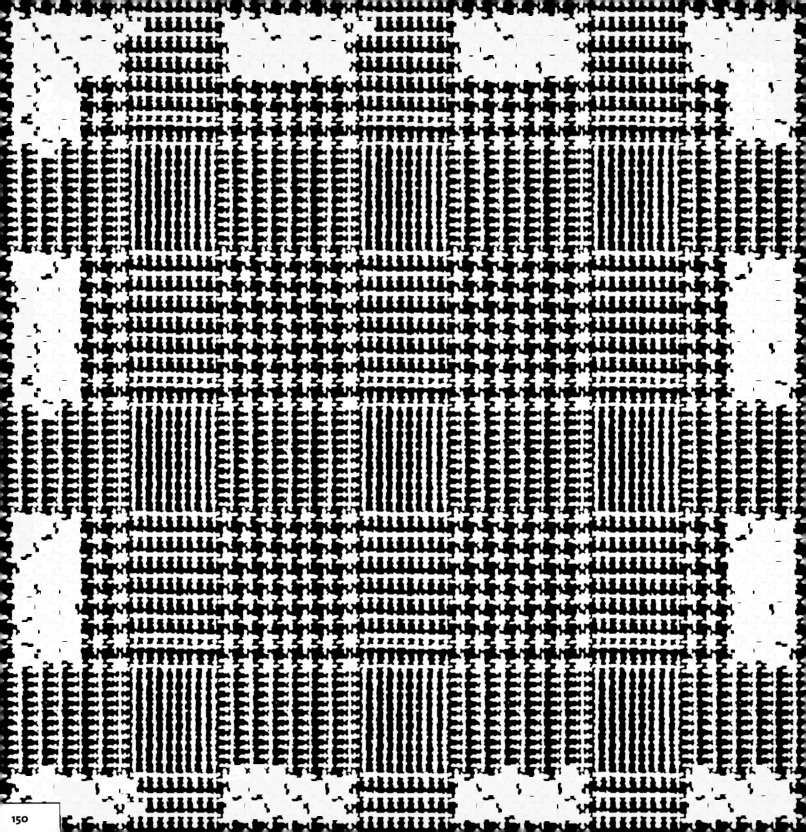

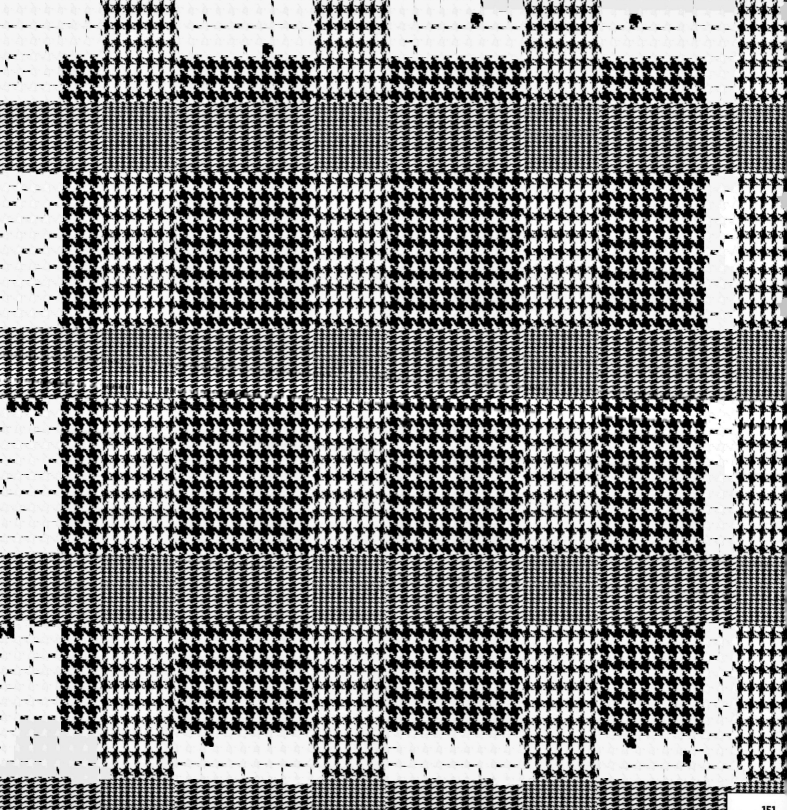

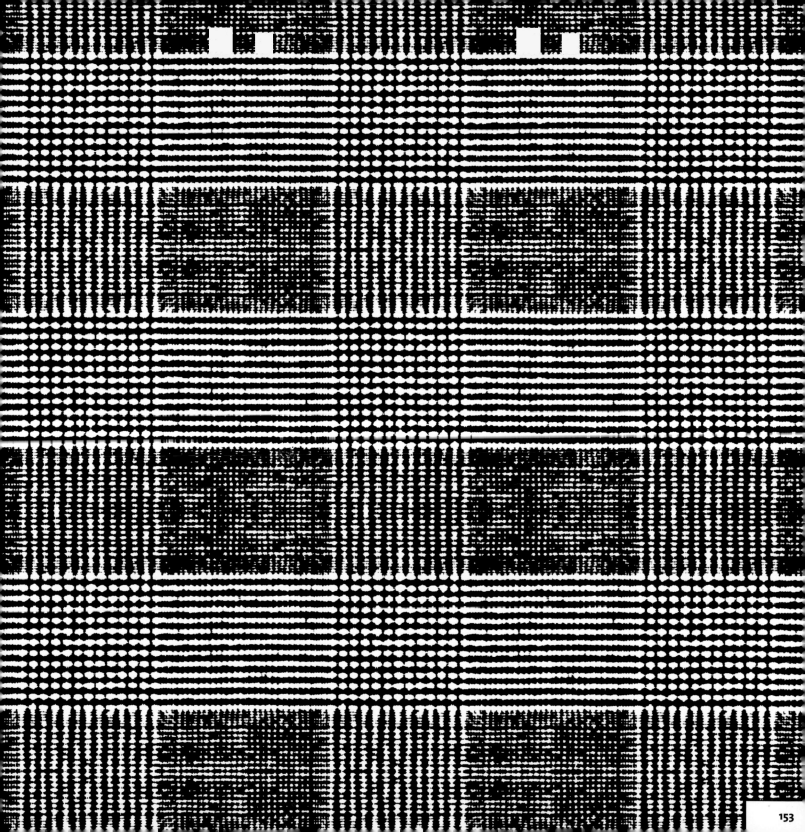

153

English

Chalk Stripe and Pinstripe

Chalk Stripe and Pinstripe are the two most common terms used to refer to a wide range of striped fabrics. These usually consist of a dark background with fine vertical lines in white or a light colour. The width of the stripe determines the fabric type: hairline is the narrowest stripe, then pinstripe, pencil stripe and chalk stripe is the widest. Variations include bead stripe (a broken line) and rope stripe (close, parallel, slanted lines). However, in most cases, the more general terms "chalk stripe" and "pinstripe" suffice.

Chalk and pinstripes have been popular since the 1930s when they were made popular by King Edward VIII of England. In the 1960s and 70s, cloth makers experimented with nontraditional colour combinations, but the classic dark grey fabric with a white stripe remains the most popular variation. Originally used to make men's suits, these fabrics are now also used for women's suits, skirts and trousers.

Italiano

Gessato

Il termine gessato viene usato per definire un'ampia gamma di tessuto a righine. In origine si trattava di un tessuto di colore scuro attraversato da sottilissime righe verticali di colore bianco o chiare. L'ampiezza delle righe è assai varia: si passa dalla riga sottilissima, a quella che ha lo spessore di un tratto di matita (in inglese *pencil stripe*), via via fino al cosiddetto *chalk stripe*, che è la riga più ampia. Le variazioni vanno dalla linea interrotta alle molte linee vicine e parallele.

A renderlo popolare fin dagli anni Trenta fu l'ex Principe di Galles, Edoardo VIII d'Inghilterra. Negli anni Sessanta e Settanta le marche più importanti di abbigliamento sperimentarono anche colori non tradizionali, ma il tessuto classico grigio scuro con le righe bianche rimane la variante più popolare. Utilizzato in origine per la confezione di completi e abiti maschili, viene attualmente realizzato anche in varianti di colore differenti dall'originale e utilizzato anche per abiti, gonne e pantaloni femminili.

CHALK STRIPE AND PINSTRIPE

GESSATO

KREIDE- UND NADELSTREIFEN

MILRAYAS Y RAYA DIPLOMÁTICA

LA RAYURE TENNIS ET LE MILLE-RAIES

Deutsch

Kreidestreifen und Nadelstreifen

Kreidestreifen und Nadelstreifen sind die zwei am häufigsten verwendeten Begriffe, die für die Bezeichnung einer breiten Palette von gestreiften Stoffen dienen. Diese Stoffe bestehen normalerweise aus einem dunklen Hintergrund mit dünnen vertikalen Linien in einer weißen oder hellen Farbe. Die Breite des Streifens bestimmt den Stofftyp. Die Breite der Streifen verlaufen von einem äußerst feinen Streifen über den Nadelstreifen bis hin zum breitesten Streifen, dem Kreidestreifen. Zu den Variationen gehören unterbrochene Linien und eng zusammenliegende, parallel verlaufende, schrage Linien. In den meisten Fällen sind die allgemeinen Begriffe »Kreidestreifen« und »Nadelstreifen« ausreichend.

Kreide- und Nadelstreifen sind seit den 30ern beliebt, und König Eduard VIII von England machte diese populär. In den 60ern und 70ern experimentierten Kleidungshersteller mit untraditionellen Farbkombinationen, aber der klassische dunkelgraue Stoff mit einem weißen Streifen bleibt die beliebteste Variante. Ursprünglich wurde dieser Stoff für die Herstellung von Herrenanzügen verwendet und wird jetzt ebenfalls für die Produktion von Damenanzügen, Röcken und Hosen benutzt.

Español

Milrayas y raya diplomática

Milrayas y *raya diplomática* son los dos términos más habituales para referirse a una gran variedad de tejidos en forma de listas. En general, consisten en un fondo oscuro cruzado por finas rayas verticales blancas o de un color claro. La anchura de las rayas, que pueden ser tan finas como el cabello de ángel y tan gruesas como el trazo de una tiza de sastre, determina el tipo de tejido. Las rayas también pueden presentar variaciones en forma de línea discontinua o de líneas juntas, paralelas y oblicuas.

El milrayas y la raya diplomática se dieron a conocer en la década de 1930, cuando el rey Eduardo VIII de Inglaterra las puso de moda. En los años sesenta y setenta, los fabricantes probaron combinaciones cromáticas poco tradicionales, aunque el clásico fondo gris con una raya blanca sigue siendo la variación más conocida. Utilizados antiguamente para confeccionar trajes masculinos, hoy también son habituales en trajes de chaqueta, faldas y pantalones de señora.

Français

La rayure tennis et le mille-raies

La rayure tennis et le mille-raies sont les deux termes les plus courants pour décrire une grande variété de tissus rayés. Ils consistent habituellement en un fond de couleur foncée avec une fine ligne verticale de couleur pâle. La largeur de la ligne détermine le type de tissu, la raie la plus fine produit le mille-raies et la plus large, la rayure tennis. Les variantes comprennent la rayure perle (une ligne brisée) et la rayure corde (des lignes obliques parallèles et serrées). Toutefois, dans la plupart des cas, les termes généraux «la rayure tennis » et « le mille-raies » suffisent.

La rayure tennis et le mille-raies sont populaires depuis les années 1930 lorsqu'ils ont été popularisés par le roi Édouard VIII d'Angleterre. Dans les années 1960 et 1970, les drapiers ont expérimenté avec des combinaisons de couleurs non traditionnelles, mais le tissu gris classique avec une raie blanche demeure la variante la plus populaire. Utilisées à l'origine pour confectionner les costumes pour homme, ces étoffes servent également aujourd'hui pour les tailleurs, les jupes et les pantalons féminins.

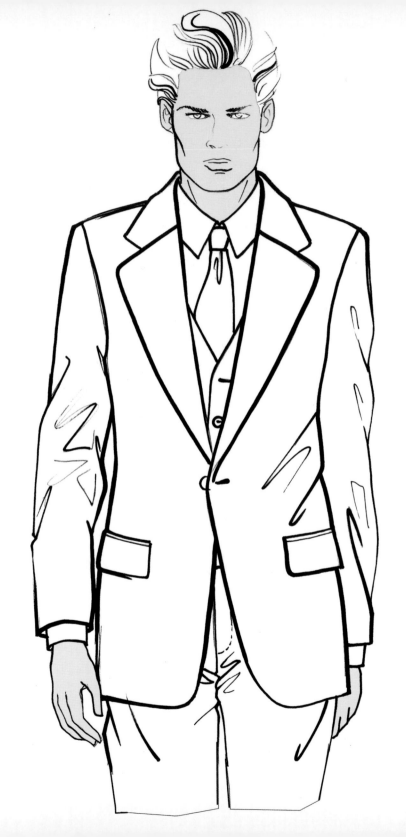

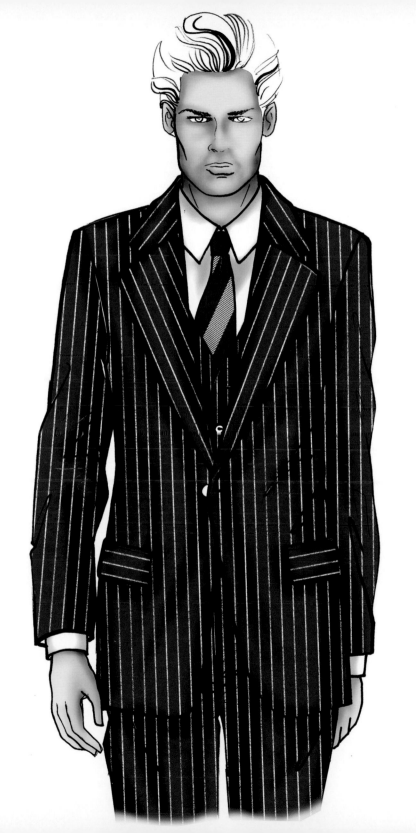

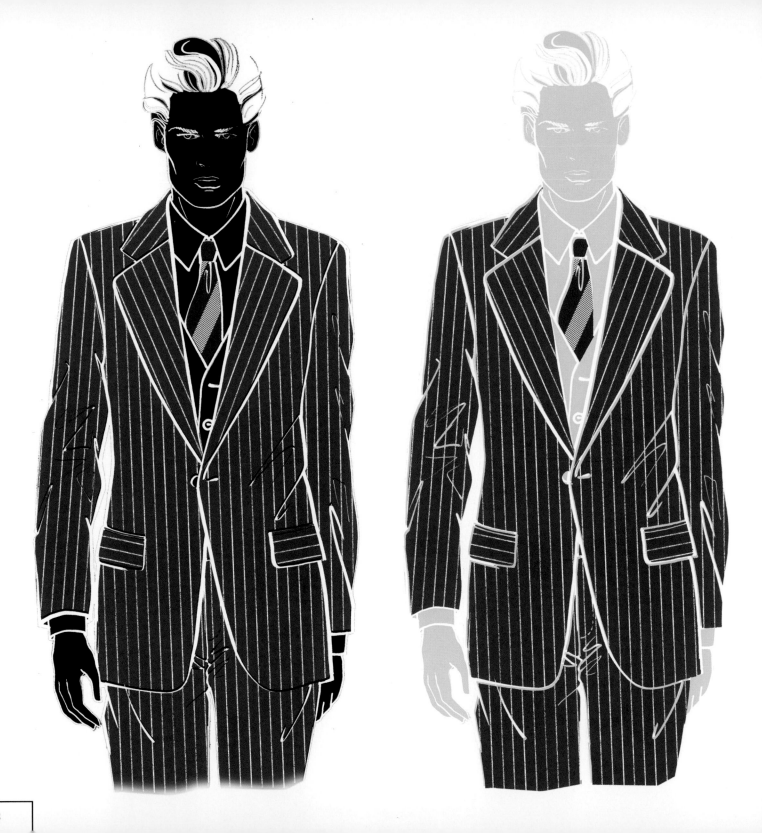

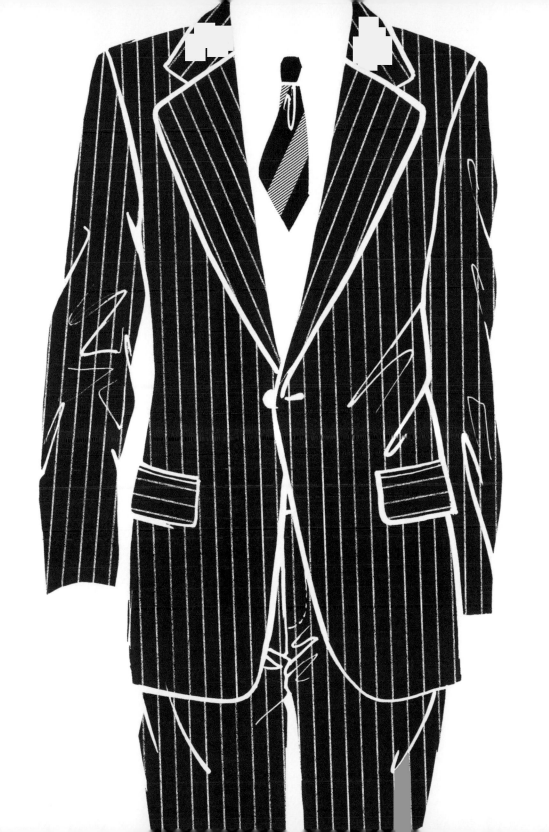

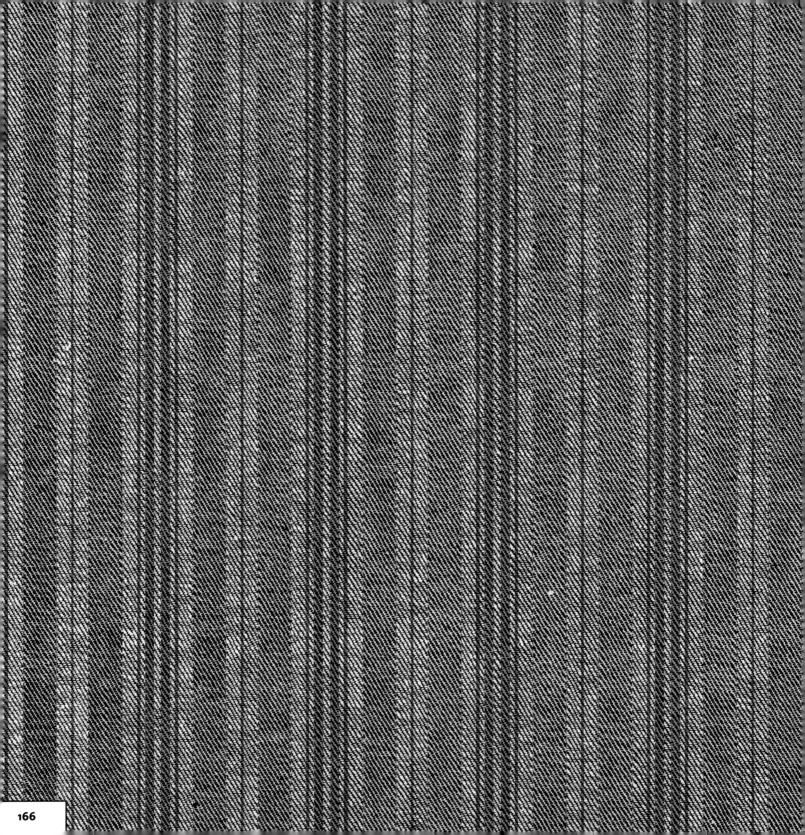

STRIPES
AND CHECKS

SCACCHI,
QUADRETTI E VICHY

STREIFEN
UND KAROS

RAYAS Y CUADROS

LES RAYURES
ET LES CARREAUX

English

Stripes and Checks

Fabrics woven with stripes and checks are available in countless patterns, colours and colour combinations. Because of the wide variety available, these fabrics are suitable for any season and often give a sporty or rustic look. Checked and striped fabrics are widely used for both men's and women's clothing as well as for household linens and upholstery.

Italiano

Scacchi, quadretti e Vichy

Disegni composti da quadri e righe, variabili per dimensioni e colore, utilizzati nella realizzazione di innumerevoli tipologie di tessuti. Adatti a ogni stagione, conferiscono spesso al tessuto un aspetto country o sportivo. I tessuti a righe e a quadretti sono molto utilizzati per camicie da uomo e da donna, per la biancheria per la casa e in tappezzeria.

Deutsch

Streifen und Karos

Stoffe, die mit Streifen und Karos gewebt werden, sind in unzähligen Mustern, Farben und Farbkombinationen erhältlich. Aufgrund der breiten Vielfalt, die verfügbar ist, sind diese Stoffe für jede Jahreszeit geeignet und haben oftmals einen sportliches oder rustikales Aussehen. Karierte und gestreifte Stoffe sind sowohl für Herren- als auch Damenkleidung weit verbreitet und werden ebenfalls für Haushaltsleinen und Bezüge verwendet.

Español

Rayas y cuadros

Hay tejidos de cuadros y rayas de todas las formas, colores y combinaciones cromáticas posibles. Debido a la gran variedad, estos tejidos son aptos para todas las estaciones del año y suelen transmitir un estilo deportivo o rústico. Los tejidos de cuadros y rayas se utilizan para confeccionar prendas masculinas y femeninas por igual, además de ropa de casa y tapizados.

Français

Les rayures et les carreaux

Les tissus à rayures et à carreaux existent en une multitude de motifs, de teintes et de combinaisons de couleurs. En raison de cette grande variété, ces tissus conviennent à toutes les saisons et donnent souvent une apparence sport ou rustique. Les tissus à carreaux et à rayures sont largement utilisés tant pour les vêtements masculins et féminins que pour le linge de maison et comme tissu d'ameublement.

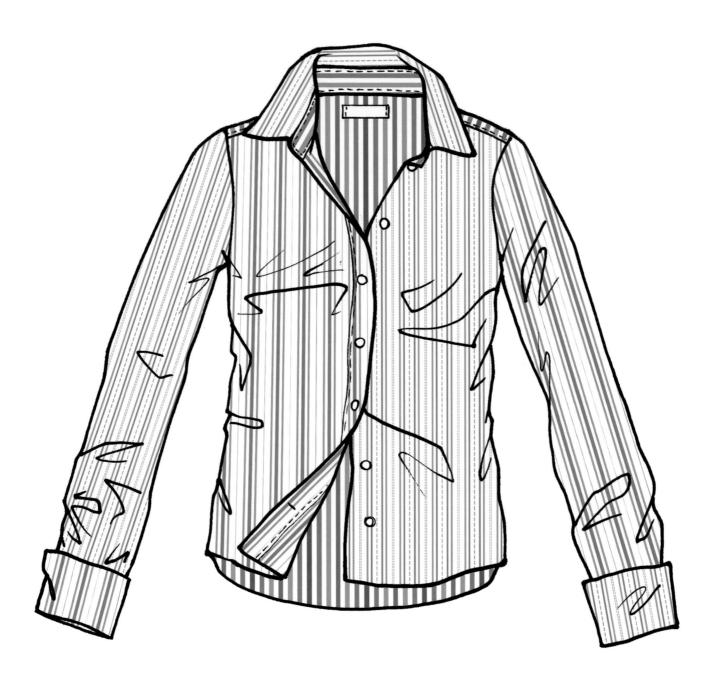

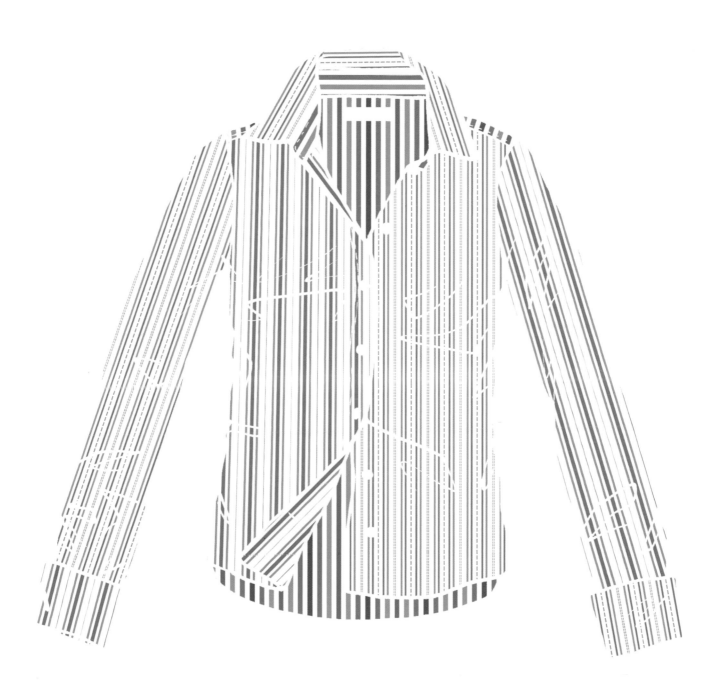

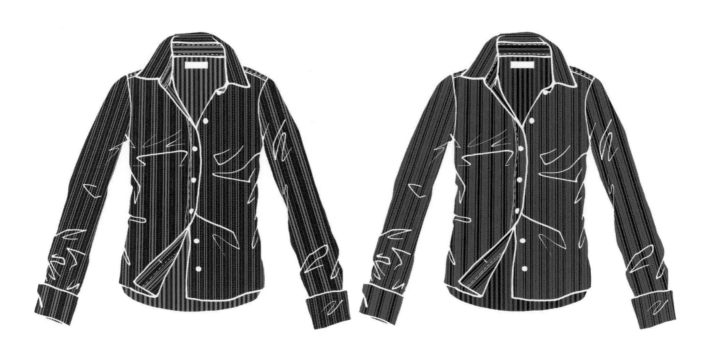

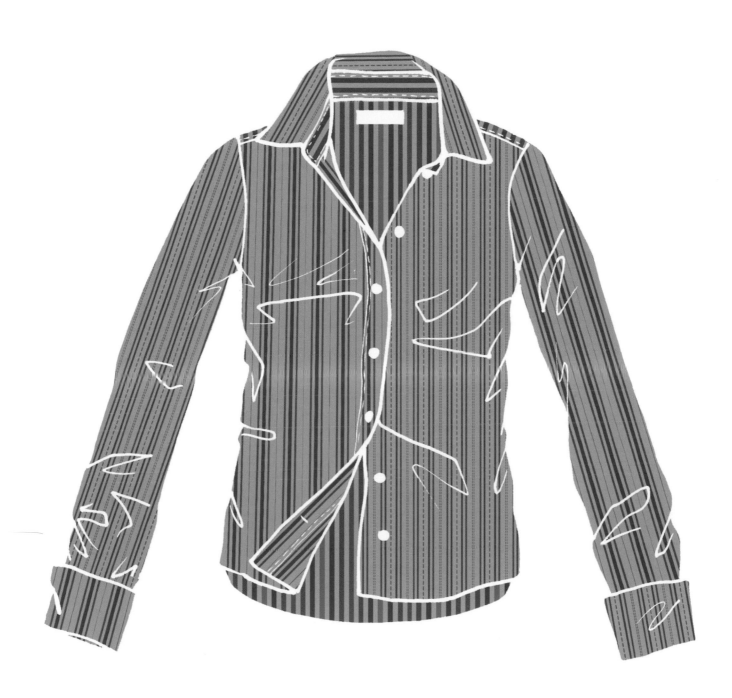

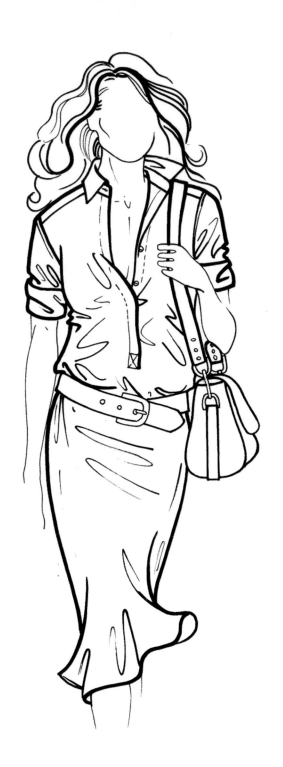
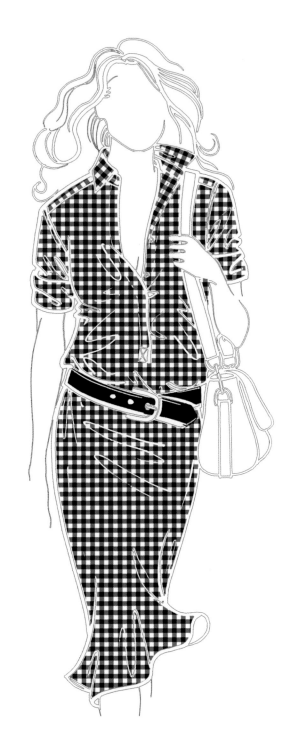

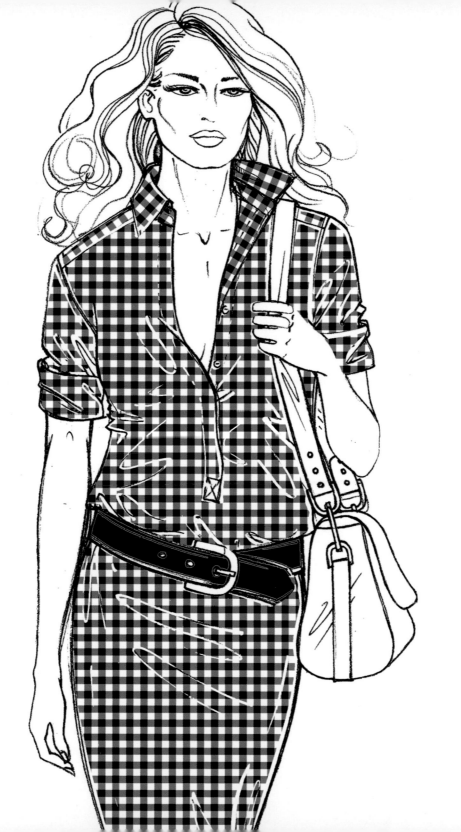

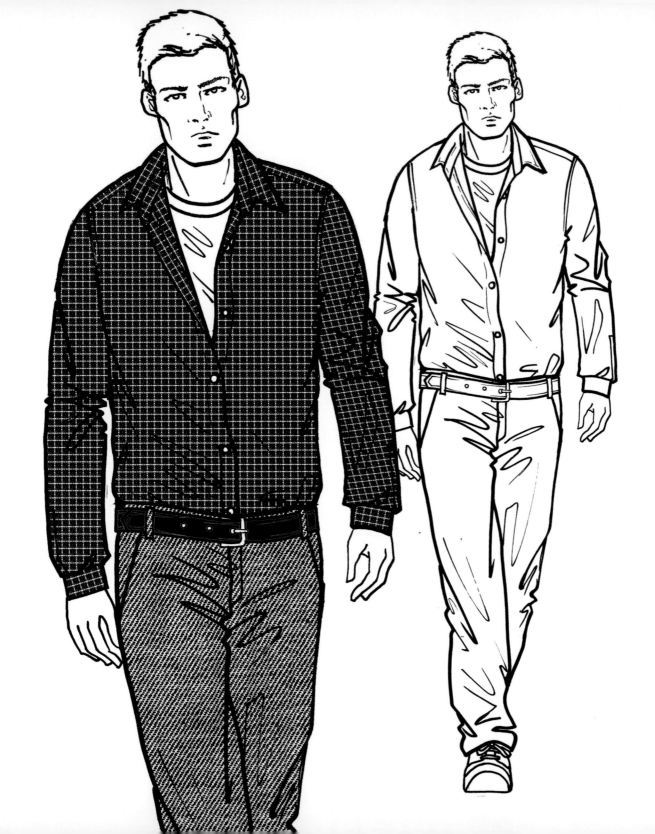

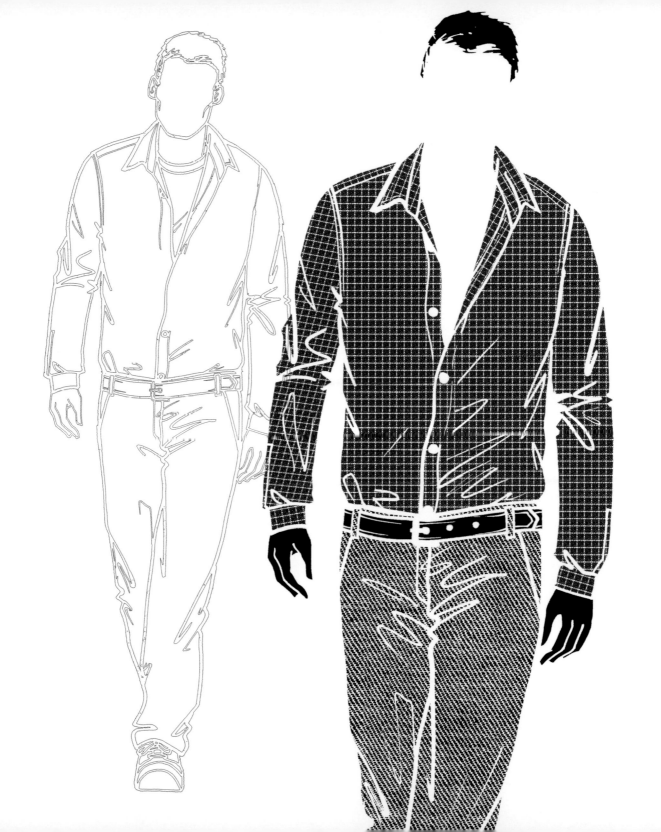

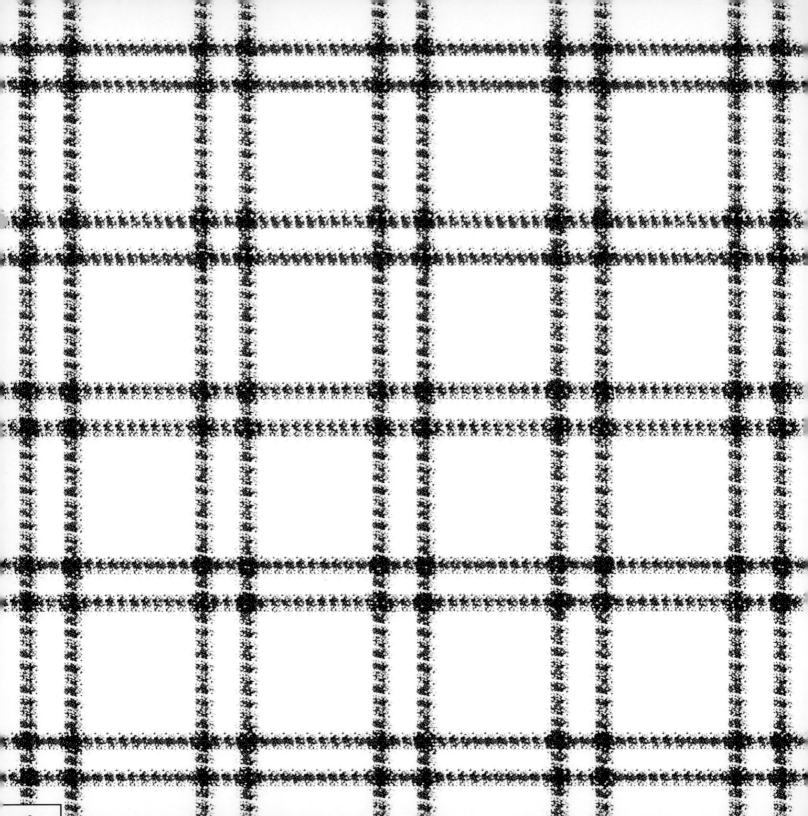

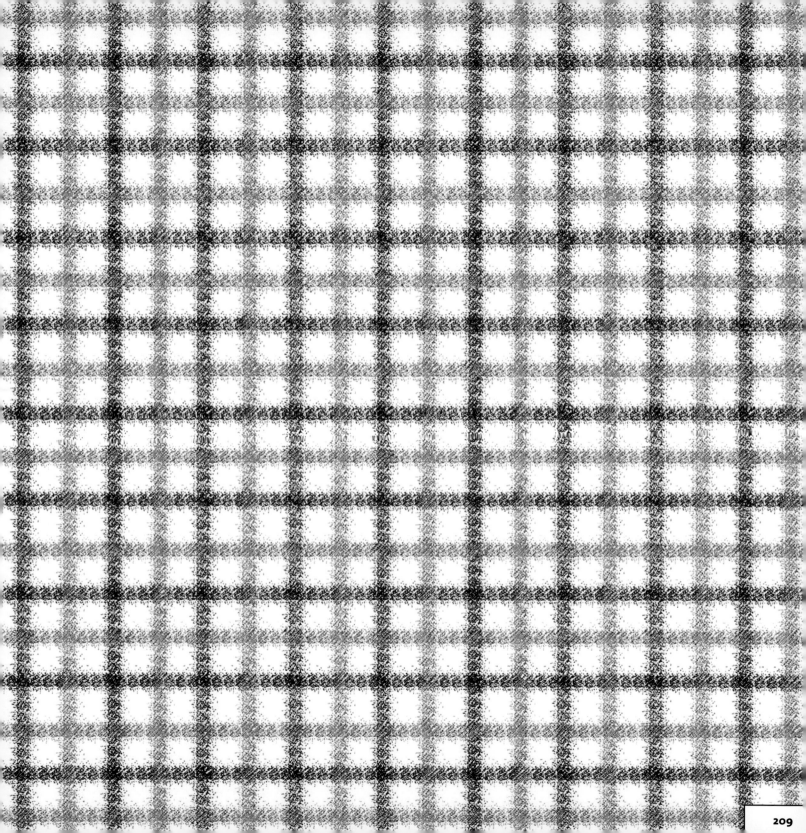

211

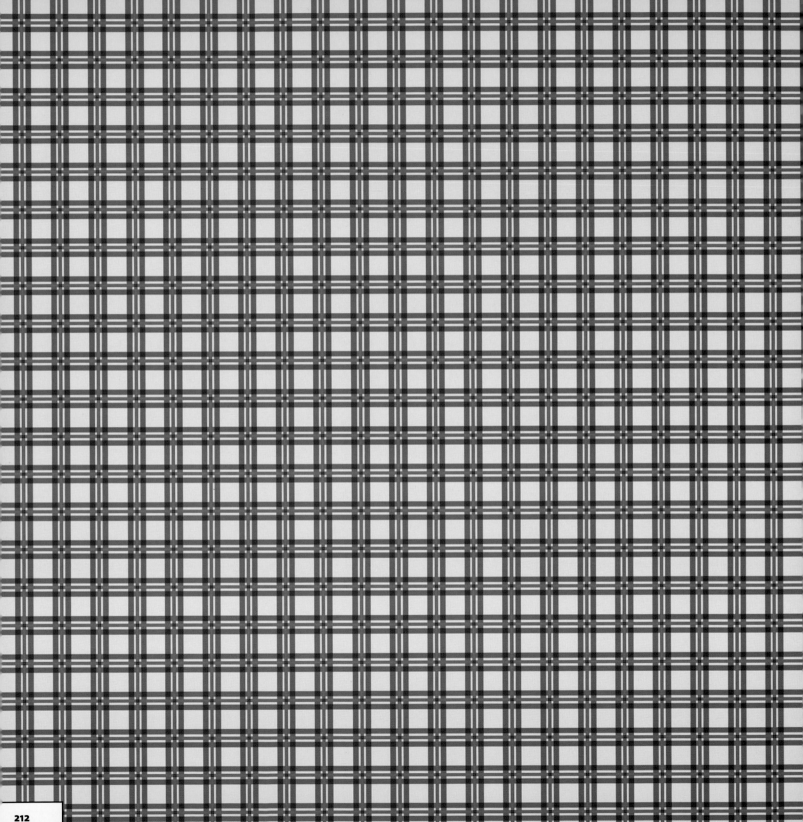

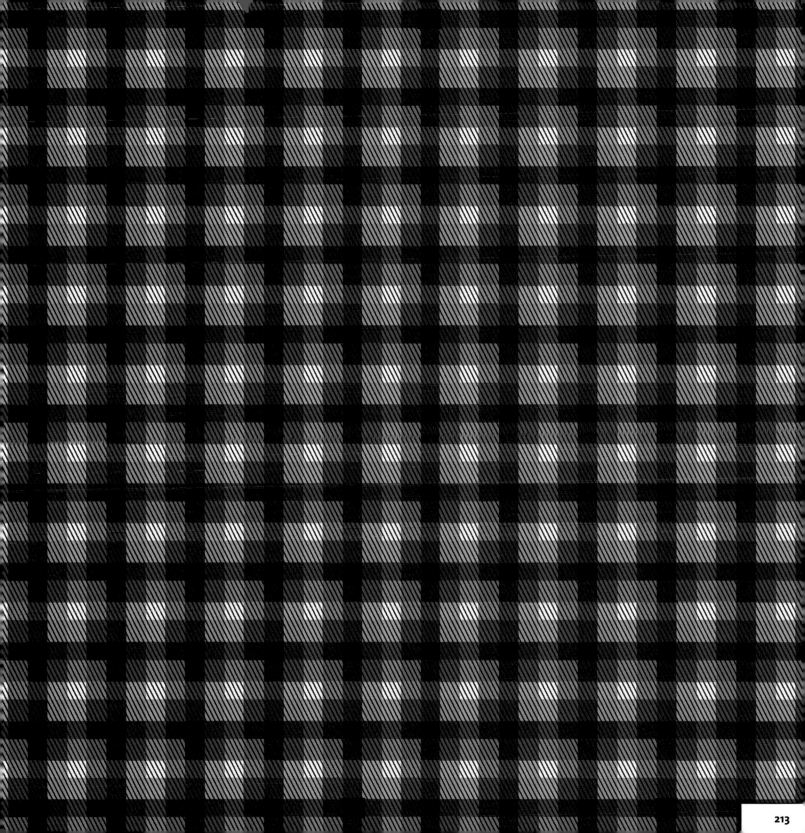

213

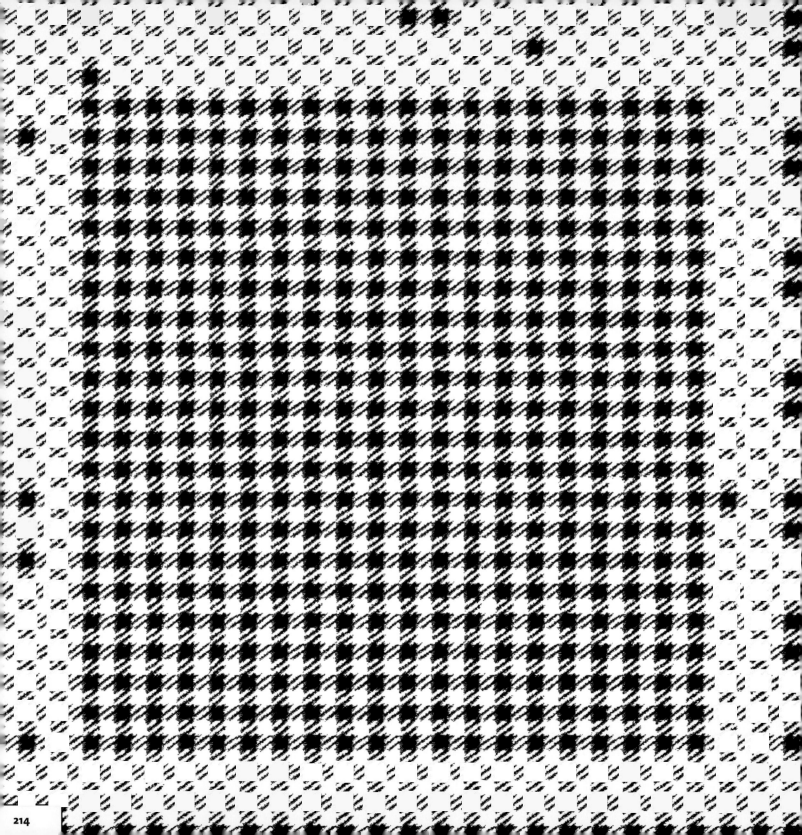

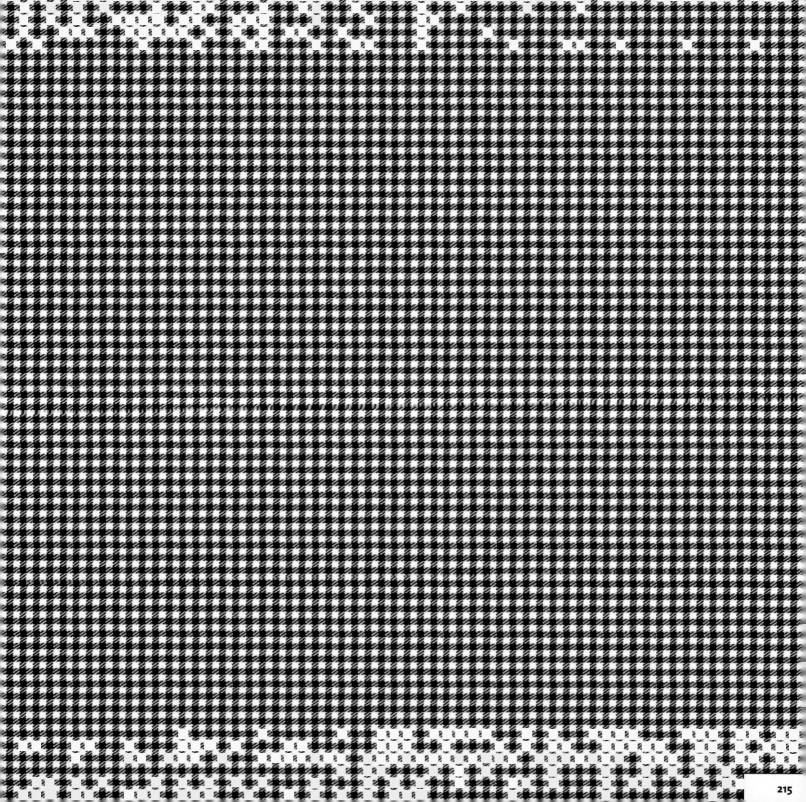

215

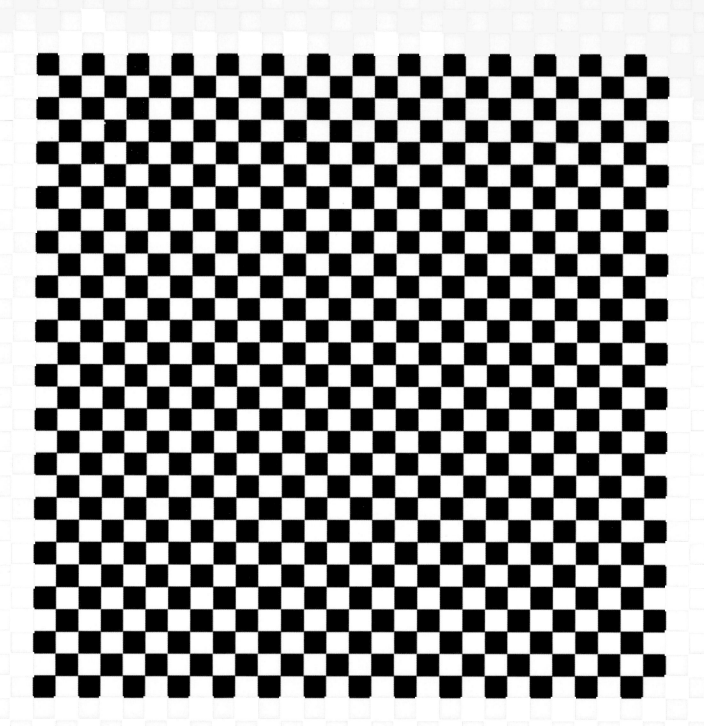

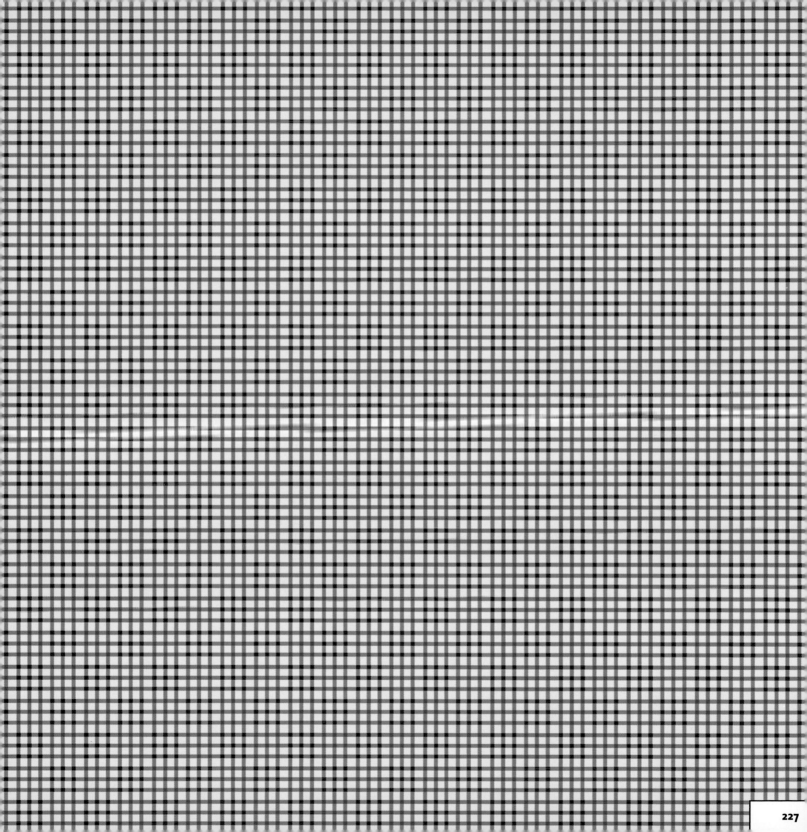

227

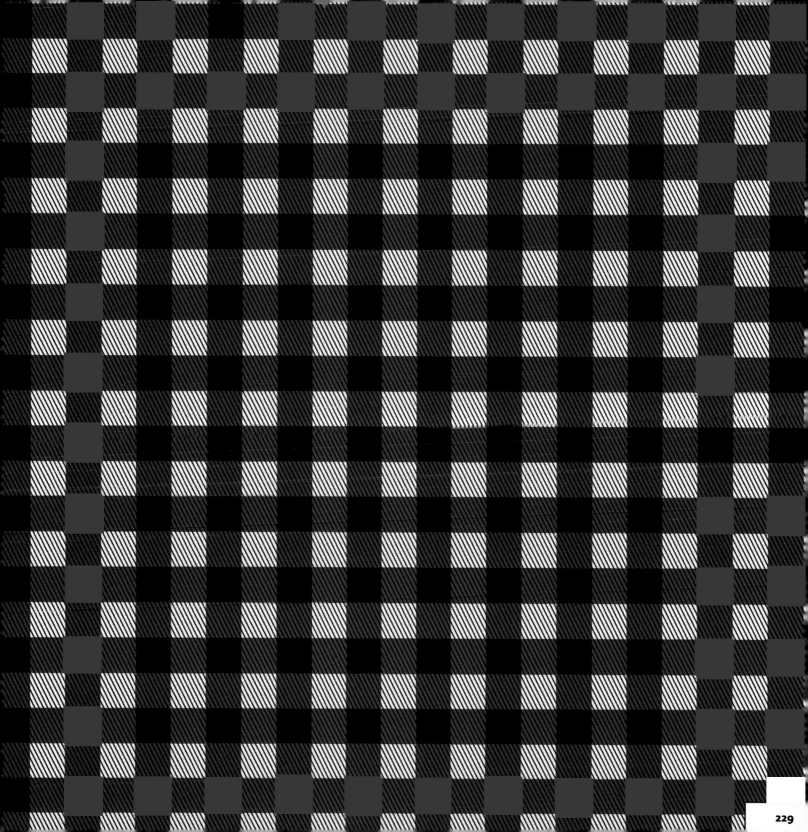

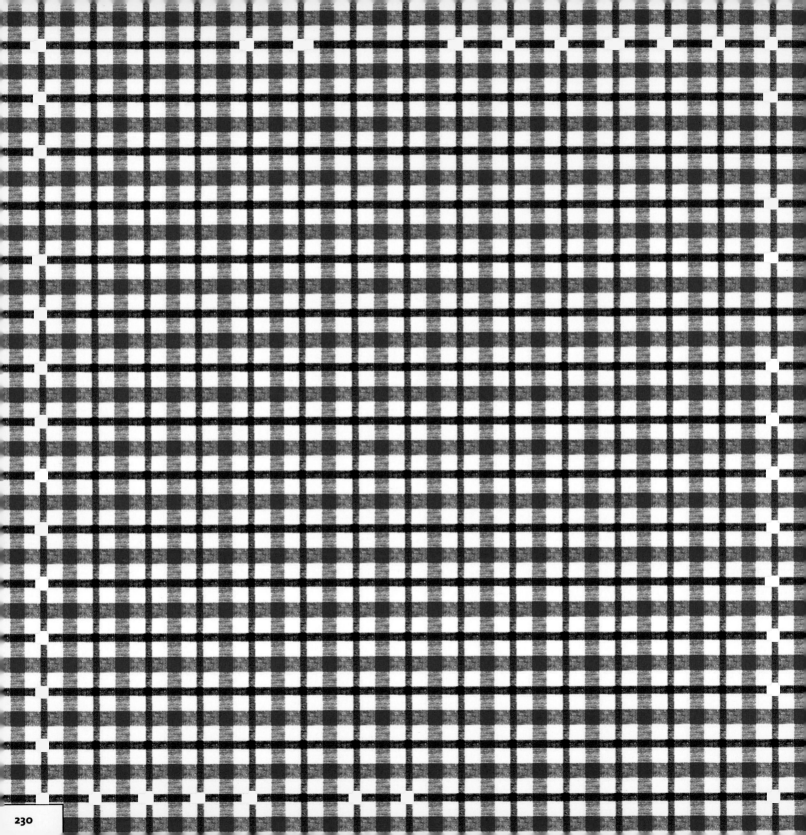

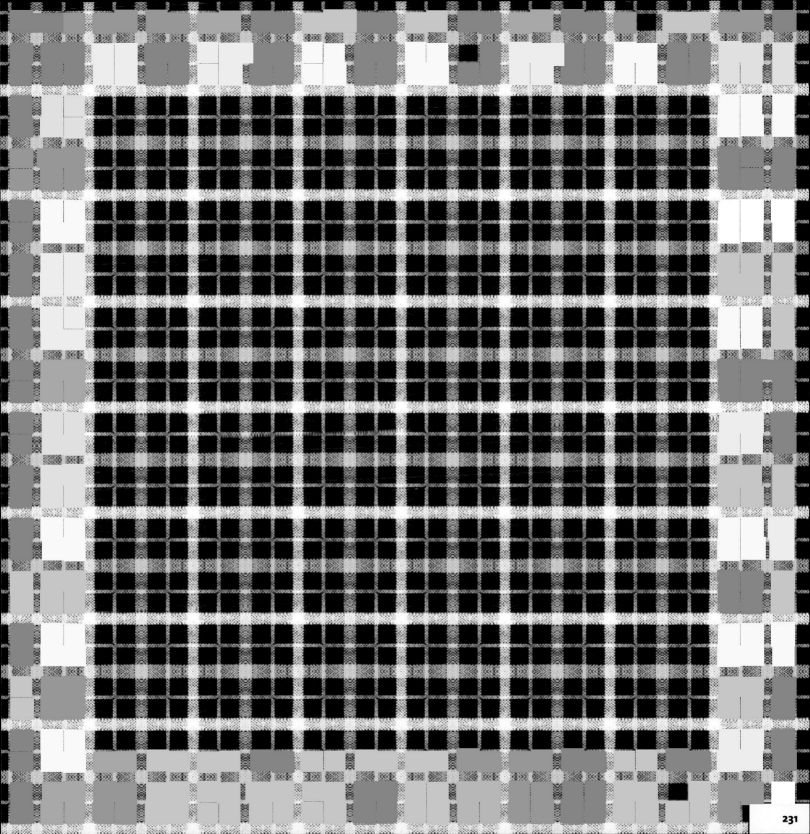

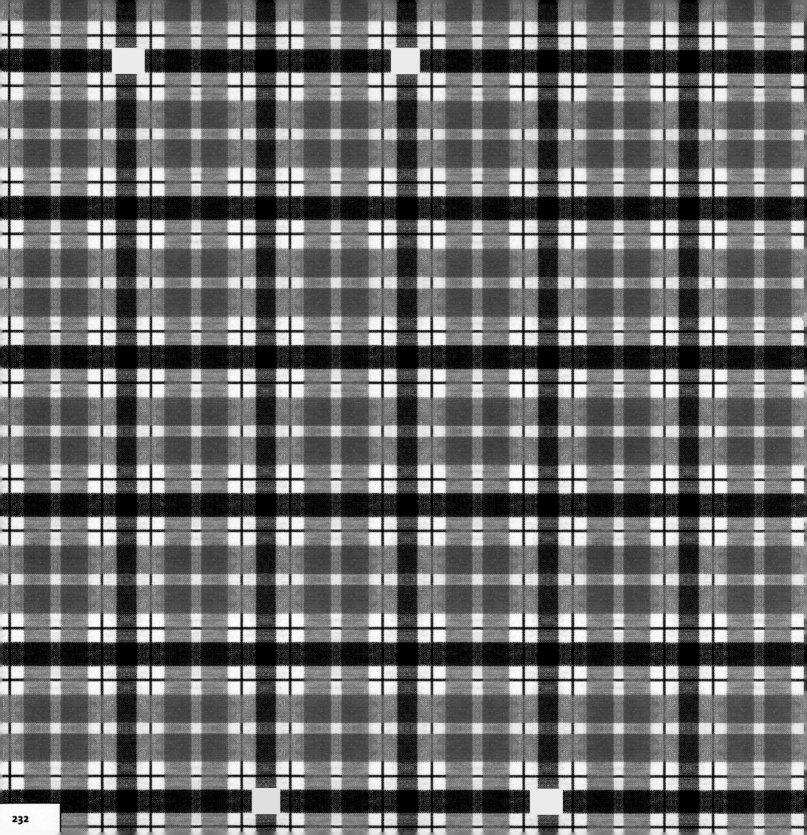

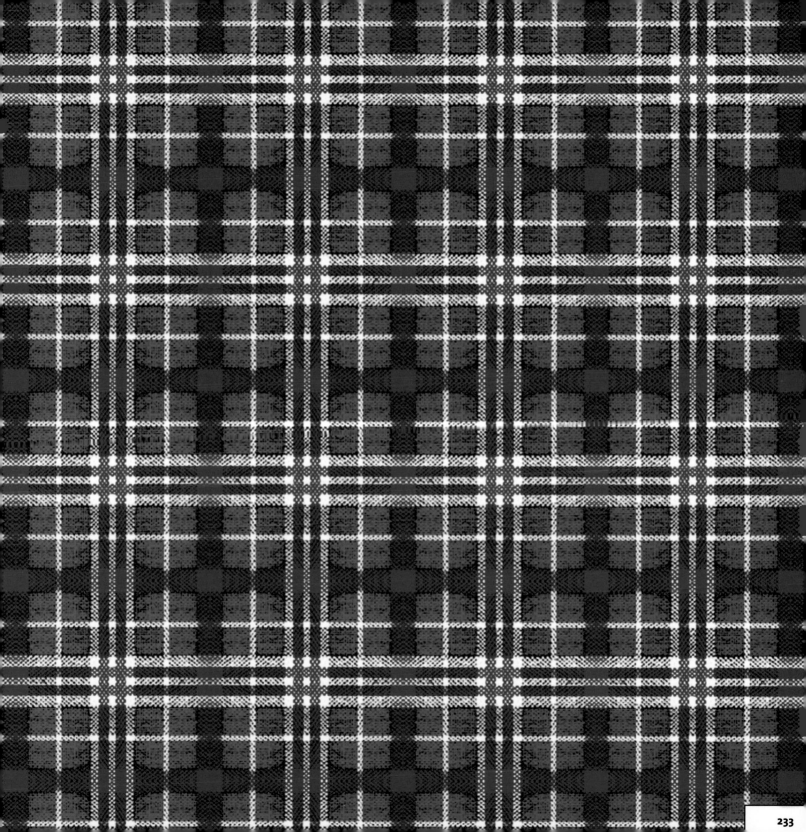

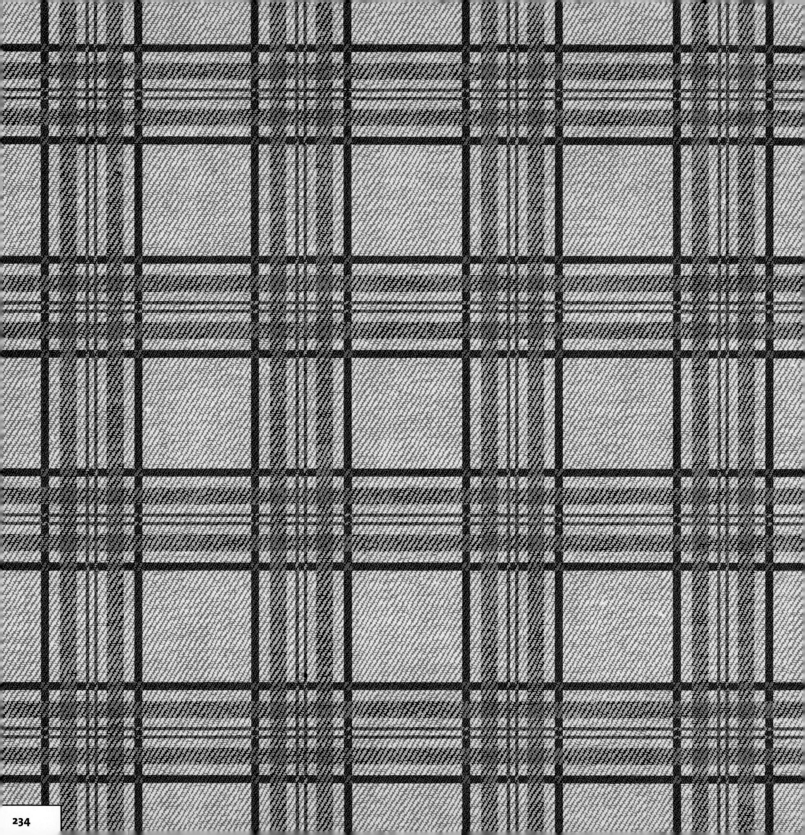

TARTAN / PLAID

TARTAN O SCOZZESE

SCHOTTENMUSTER / PLAID

TARTÁN / CUADROS ESCOCESES

LES TARTANS ET TISSUS ÉCOSSAIS

English

Tartan / Plaid

A woollen fabric of Scottish origin with a thick weft, characterized by check pattern made up of differently sized and coloured stripes that intersect to produce a window pane effect. An almost limitless range of patterns can be created by varying the size, colour and number of stripes and how they intersect. Historically, these patterns were used to identify the different Scottish Highland clans who wore them, but most tartans today are not related to a specific clan or region. In the middle of the 19th century, the frequent visits that Queen Victoria made to her Scottish residence of Balmoral contributed to a growth in the popularity of this fabric in fashion design. After World War II, the use of tartan patterns in kilts and skirts grew in popularity. In more recent years, tartan has also been used by fashion designers to give an original and unexpected quality to clothes – often with the help of unusual ruches, flounces and ruffles or by employing innovative cuts and forms.

Italiano

Tartan o scozzese

Tessuto di lana a trama fitta, di origine scozzese, caratterizzato dal disegno variamente quadrettato, costituito da strisce colorate di varie misure e tinta variabile che, intersecandosi in orizzontale e in verticale, creano motivi a riquadri finestrati. I disegni, differenti per dimensioni, colore e numero di strisce, venivano usati in origine per identificare i vari clan scozzesi delle Highlands, ma oggi non è più così. Attorno alla metà dell'Ottocento le frequenti visite della regina Vittoria nella sua proprietà scozzese di Balmoral contribuirono a far nascere la moda di capi realizzati con questo tessuto. Dalla Seconda Guerra Mondiale in poi i kilt e le gonne in tartan diventarono d'uso comune. In tempi più recenti il tartan viene utilizzato dagli stilisti in modo più originale, per capi insoliti, non classici, spesso arricchiti da inconsuete *rouche*, *volant* e arricciature o impiegato in tagli e forme del tutto nuovi.

Deutsch

Schottenmuster / Plaid

Ein Wollstoff mit schottischem Ursprung mit einem dicken Schuss, der durch ein Karomuster charakterisiert wird. Er besteht aus unterschiedlich großen und farbigen Streifen, die sich kreuzen und wie ein Fenster wirken. Eine schier endlose Zahl von Mustern können erzeugt werden, indem die Größe, Farbe und Anzahl der Streifen variiert wird und ebenfalls die Art in der sich diese kreuzen. Früher wurden diese Muster als Identifikation der unterschiedlichen Klans der schottischen Highlands verwendet, die diese Stoffe trugen. Heute haben jedoch die meisten keine Verbindung mehr mit einem bestimmten Klan oder einer gewissen Region. In der Mitte des 19. Jahrhunderts trugen die häufigen Besuche von Königin Viktoria in ihrer schottischen Residenz Balmoral zur Zunahme der Beliebtheit dieses Stoffes im Modedesign bei. Nach dem zweiten Weltkrieg wurde die Verwendung von Schottenmuster in Kilts und Röcken zunehmend beliebt. In letzter Zeit wurde das Schottenmuster ebenfalls von Modeschöpfern verwendet, um ihrer Kleidung eine originelle und unerwartete Note zu verleihen – oftmals mit der Hilfe von ungewöhnlichen Rüschen, Besätzen oder mit der Verwendung von innovativen Schnitten und Formen.

Español

Tartán / Cuadros escoceses

Tejido de lana de origen escocés con una gruesa trama que se caracteriza por el estampado a cuadros obtenido mediante la intersección de rayas de distintos tamaños y colores. A través de la combinación del tamaño, el color y la cantidad de rayas, y su forma de cruzarse con el resto, puede obtenerse una gama casi infinita de estampados. Antiguamente, los diseños de los cuadros escoceses se utilizaban para identificar a los distintos clanes de las Tierras Altas que los llevaban, pero hoy en día la mayoría de los tartanes no guardan relación con ningún clan ni región de Escocia. A mediados del siglo XIX, las frecuentes visitas de la reina Victoria a la residencia escocesa de Balmoral contribuyeron a poner de moda este tejido. Después de la Segunda Guerra Mundial, se empezaron a llevar *kilts* y faldas confeccionadas con diseños inspirados en los tartanes. En fechas más recientes, los diseñadores han recurrido al tartán para dotar a sus prendas de un toque original e insólito, a menudo acompañado de encañonados de encaje, volantes y chorreras, o bien de cortes y siluetas vanguardistas.

Français

Les tartans et tissus écossais

Étoffe de laine d'origine écossaise à trame épaisse, caractérisée par un motif à carreaux fait de lignes de tailles et de couleurs différentes produisant un effet de carreau. Une gamme presque infinie de motifs peut être créée en variant la taille, la couleur et le nombre de lignes et la façon dont elles sont intersectées. Historiquement, ces motifs servaient à identifier les divers clans écossais qui les portaient, mais la plupart des tartans aujourd'hui ne sont pas liés à un clan ou une région en particulier. Au milieu du XIXe siècle, les visites fréquentes de la reine Victoria à sa résidence écossaise de Balmoral contribuèrent à l'accroissement de la popularité de cette étoffe dans les créations de mode. Après la Seconde Guerre mondiale, l'utilisation de motifs de tartans pour les kilts et les jupes a connu une popularité accrue. De nos jours, le tartan a également été utilisé par les couturiers pour donner aux vêtements une qualité originale et inhabituelle, souvent à l'aide de ruchés, volants et jabots inhabituels en employant des coupes et des formes innovantes.

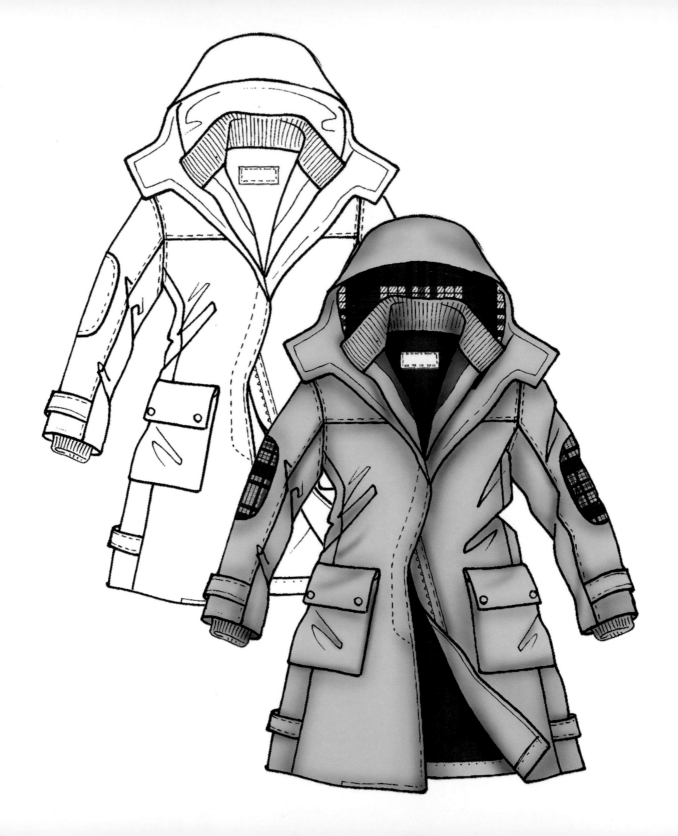

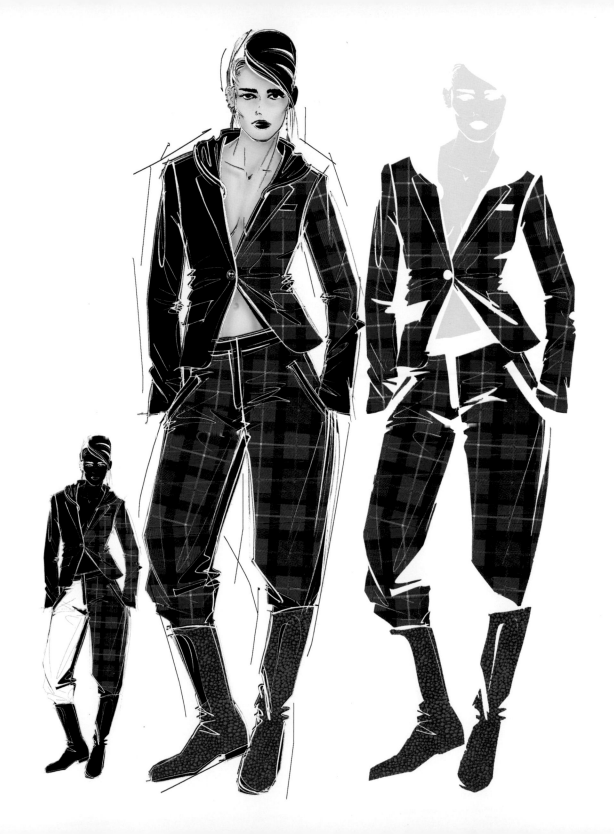

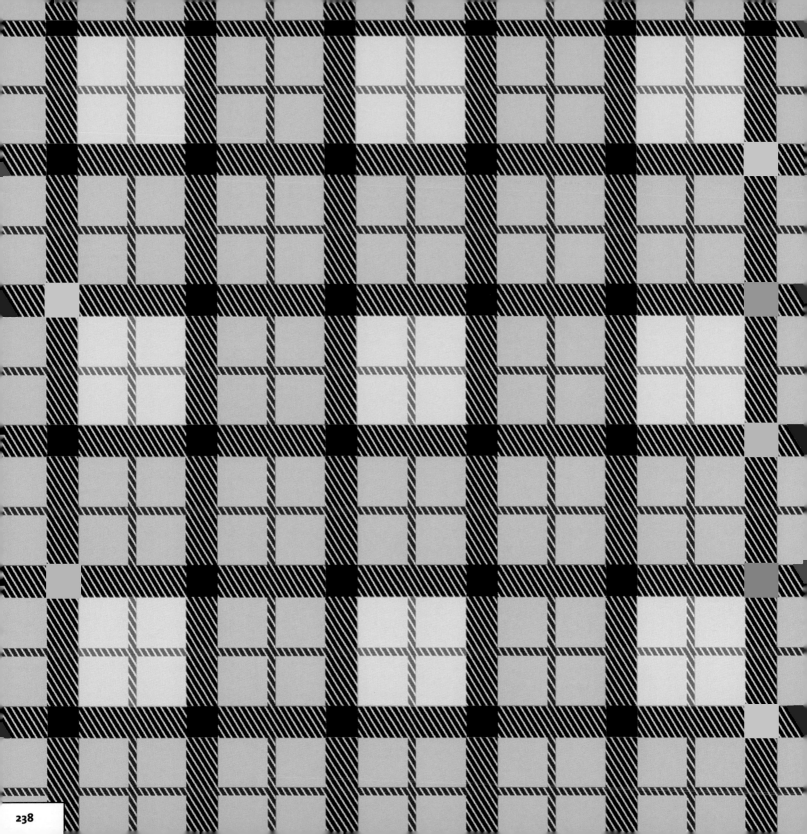

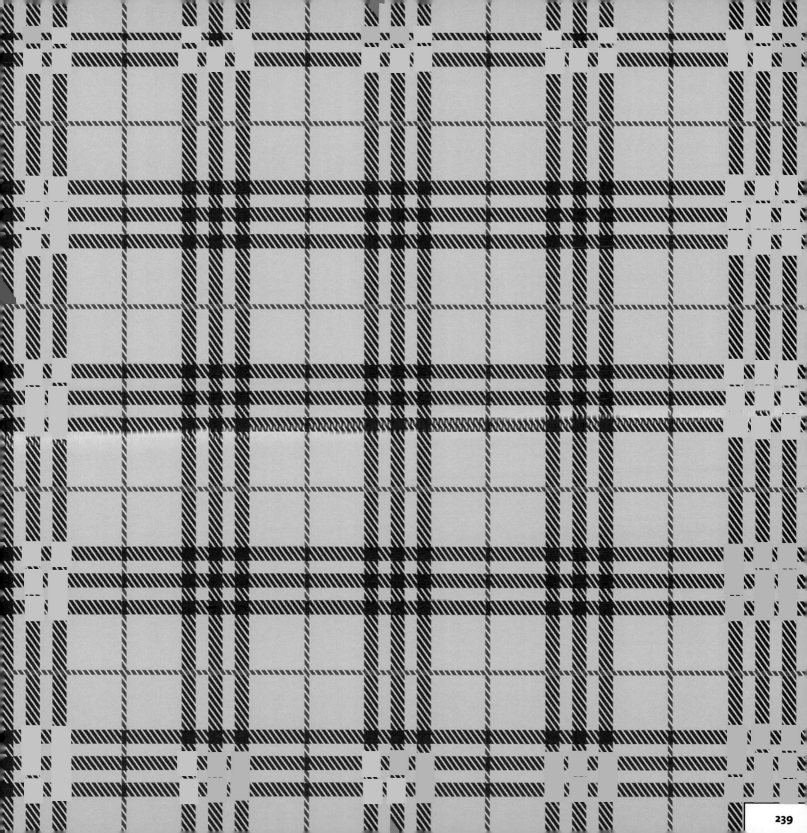

239

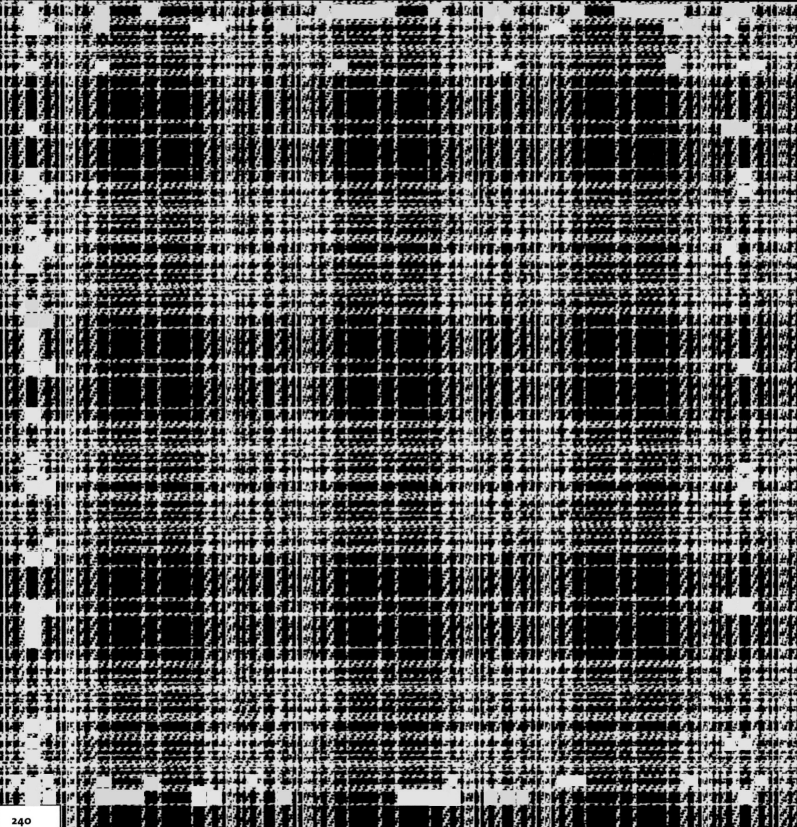

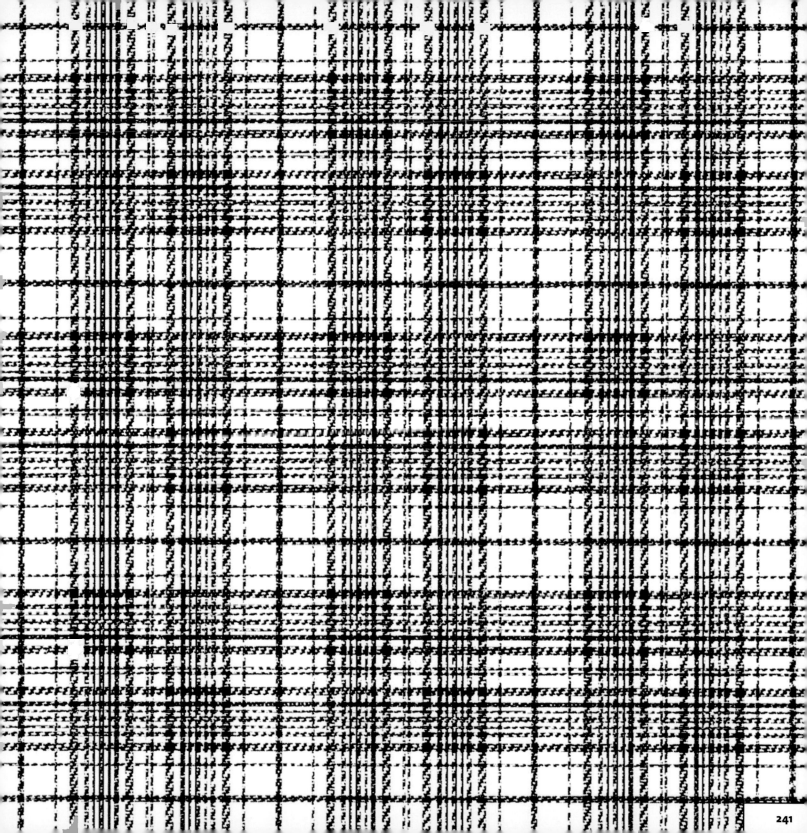

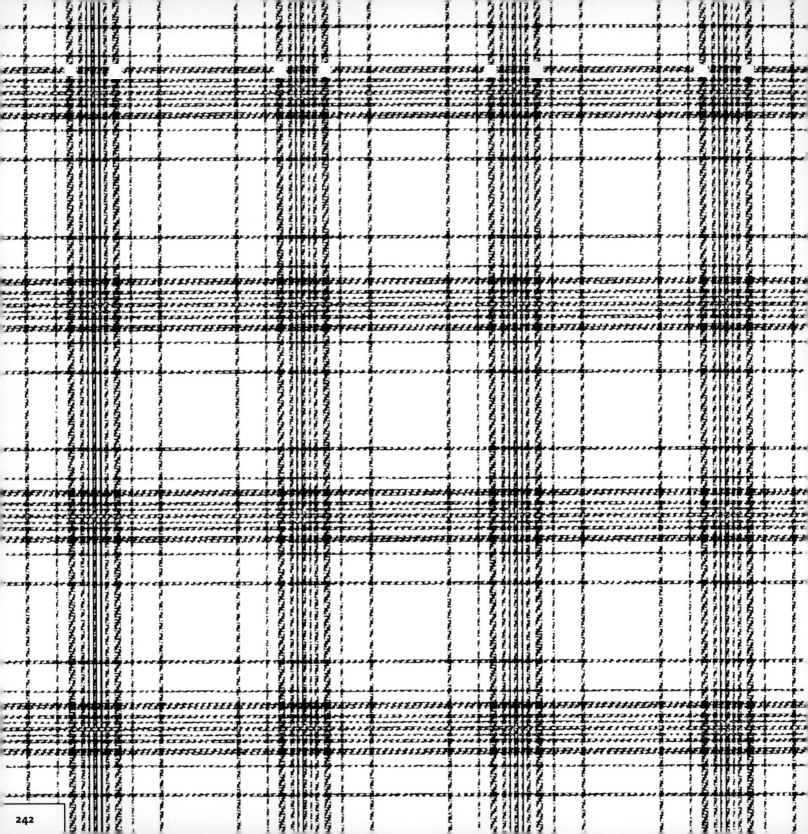

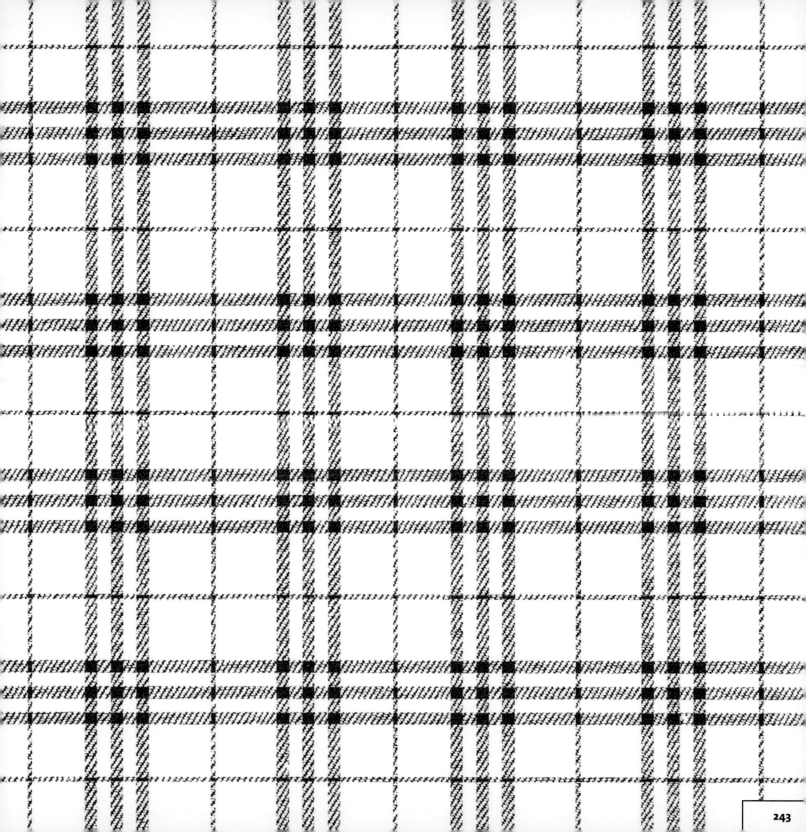

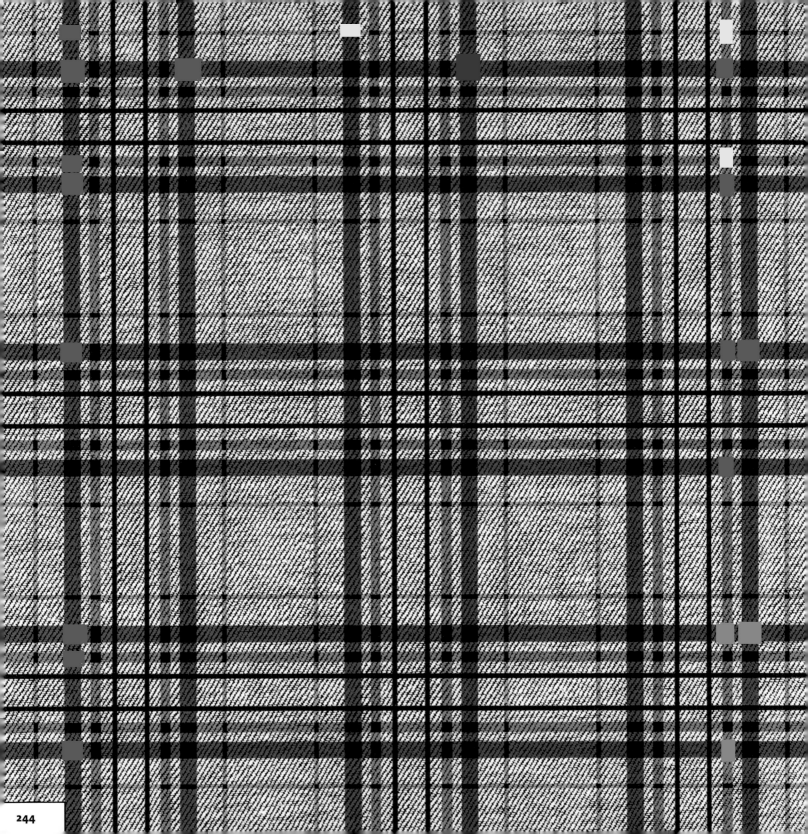

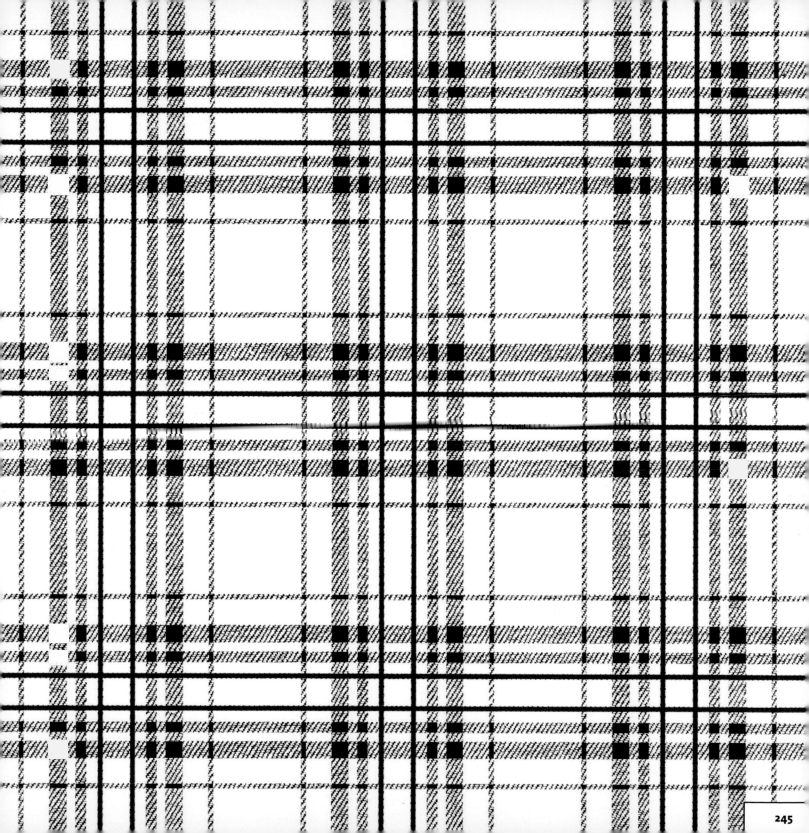

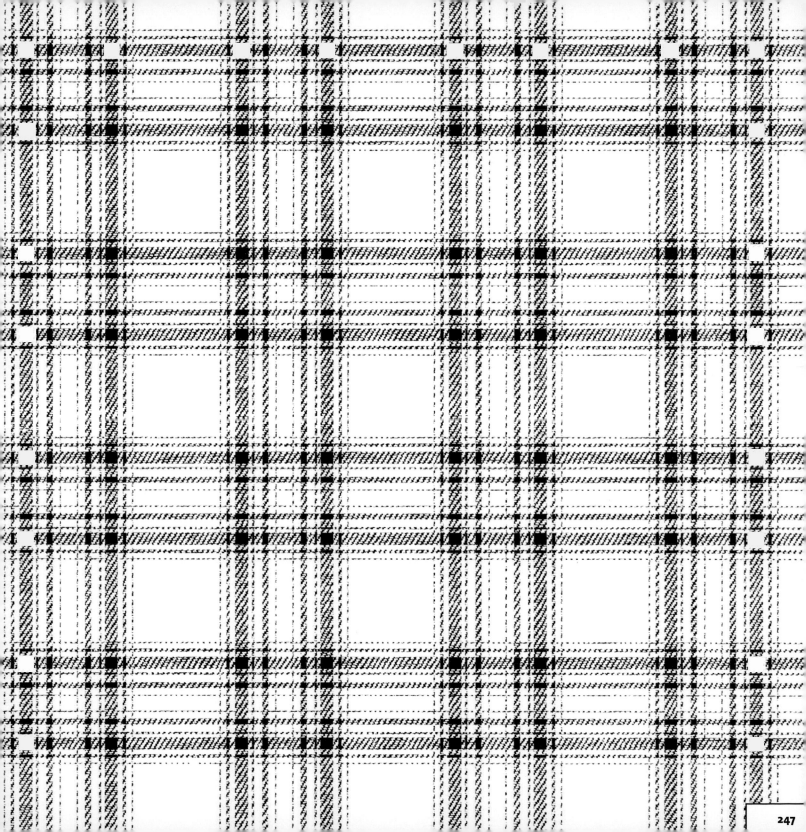

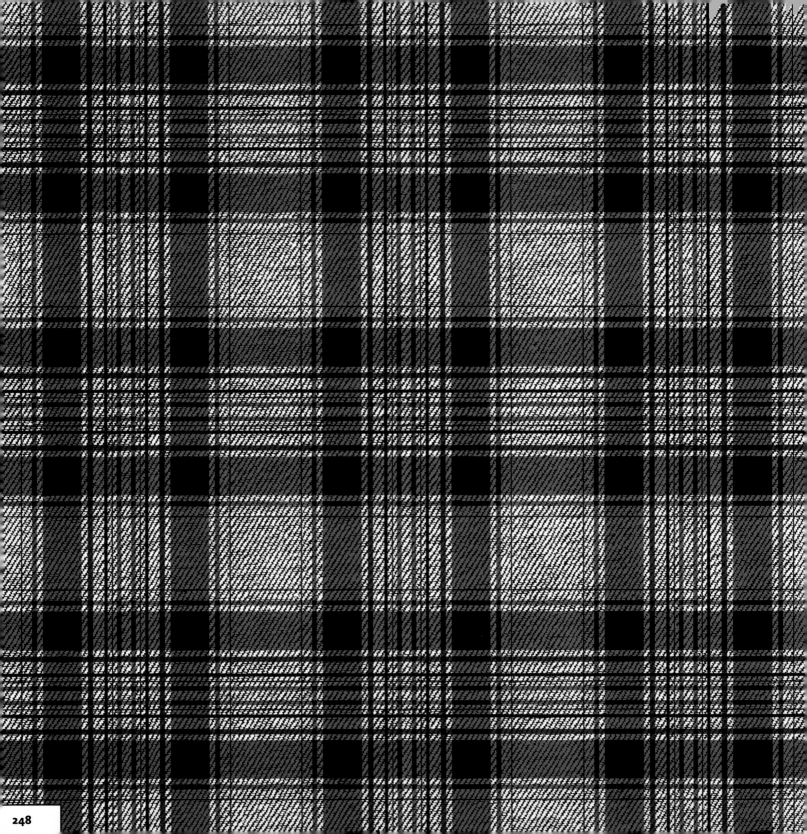

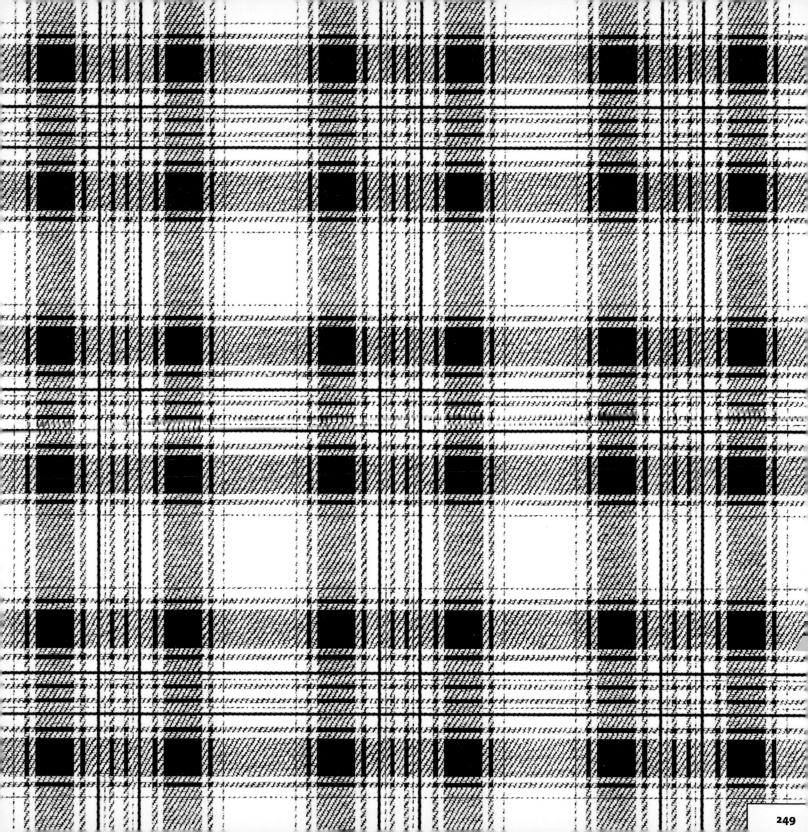

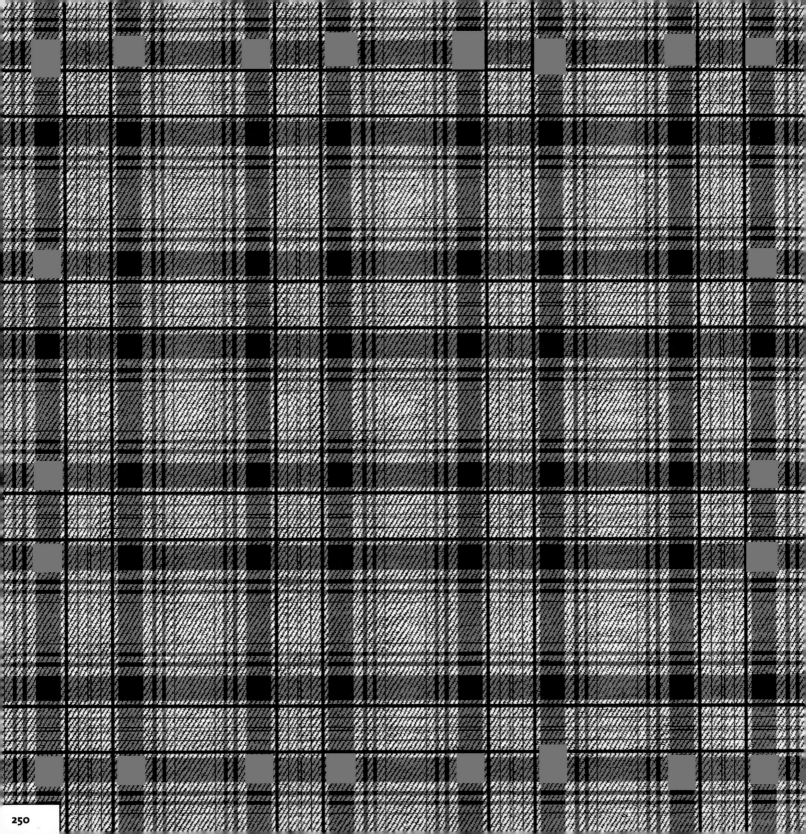

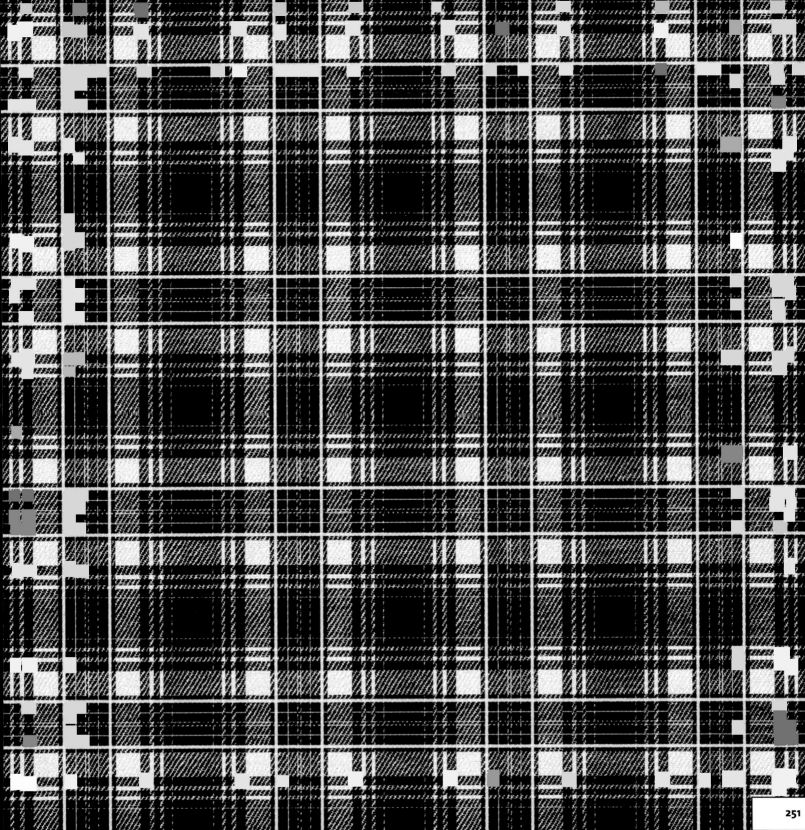

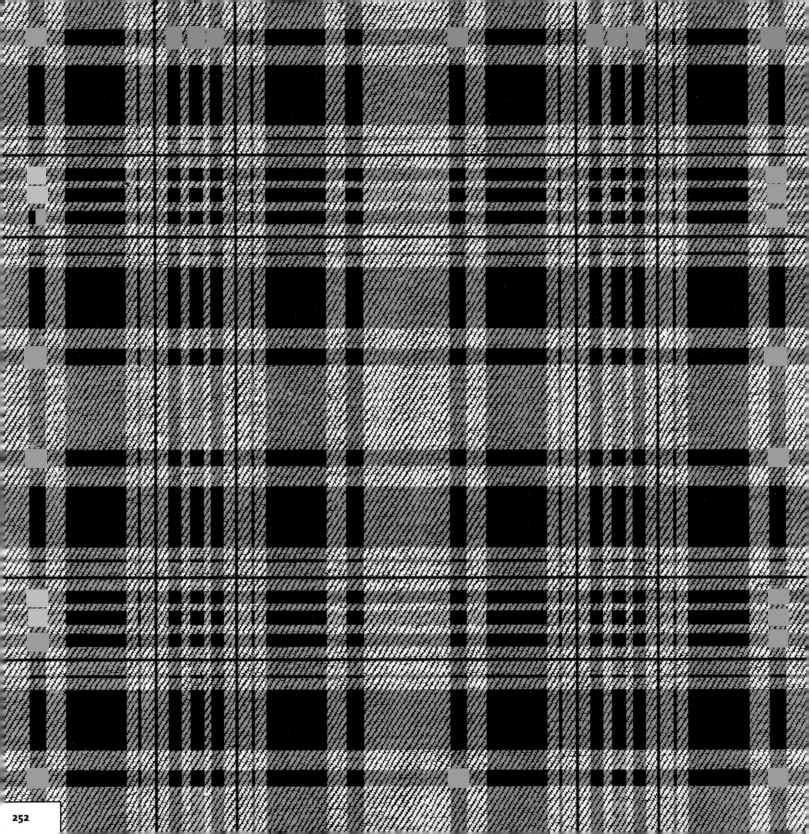

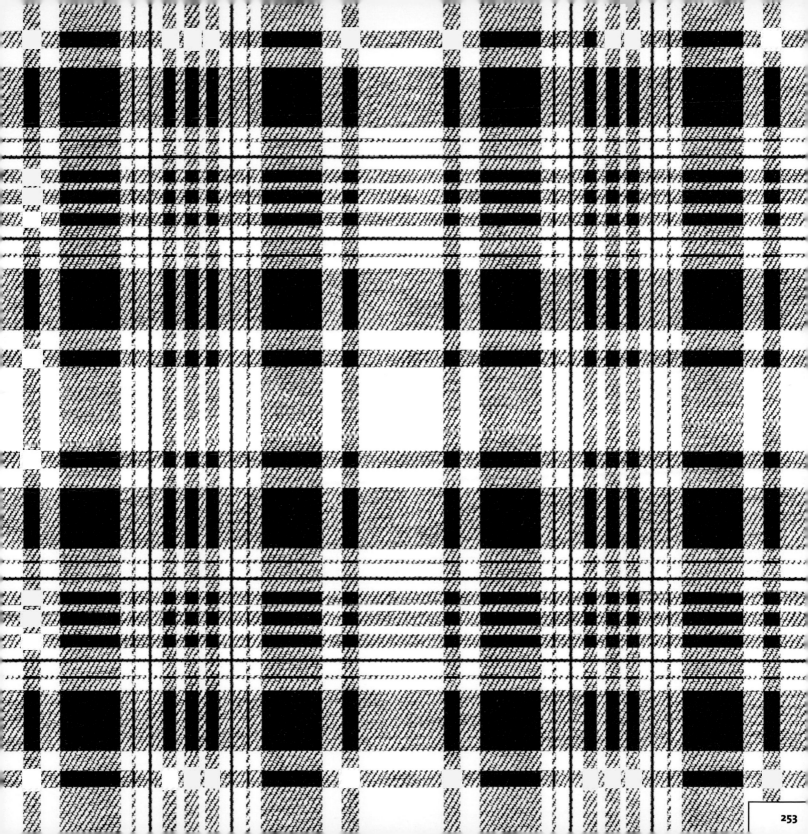

257

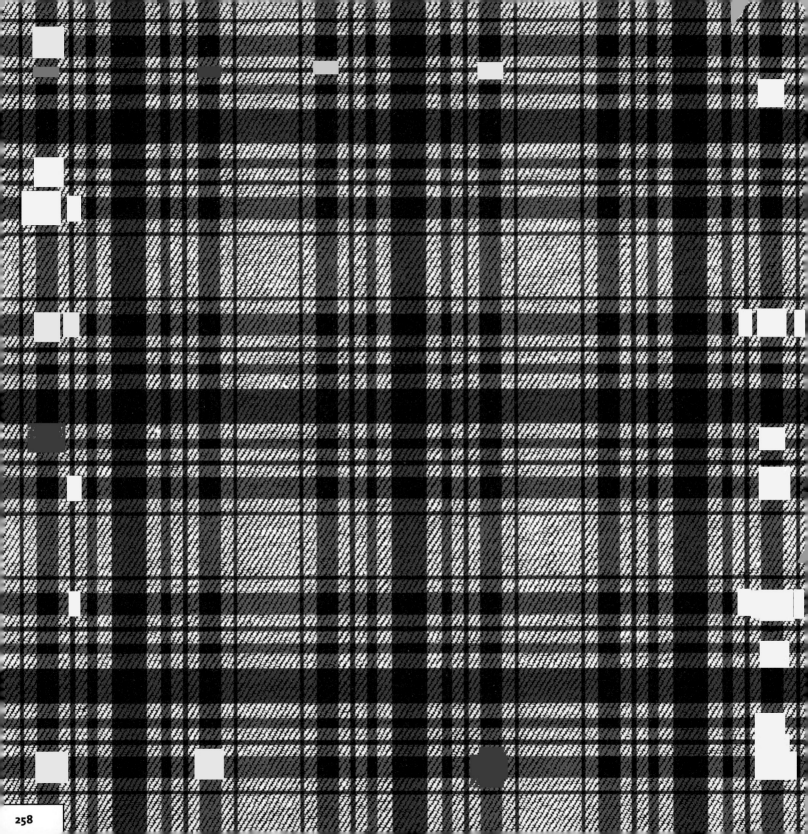

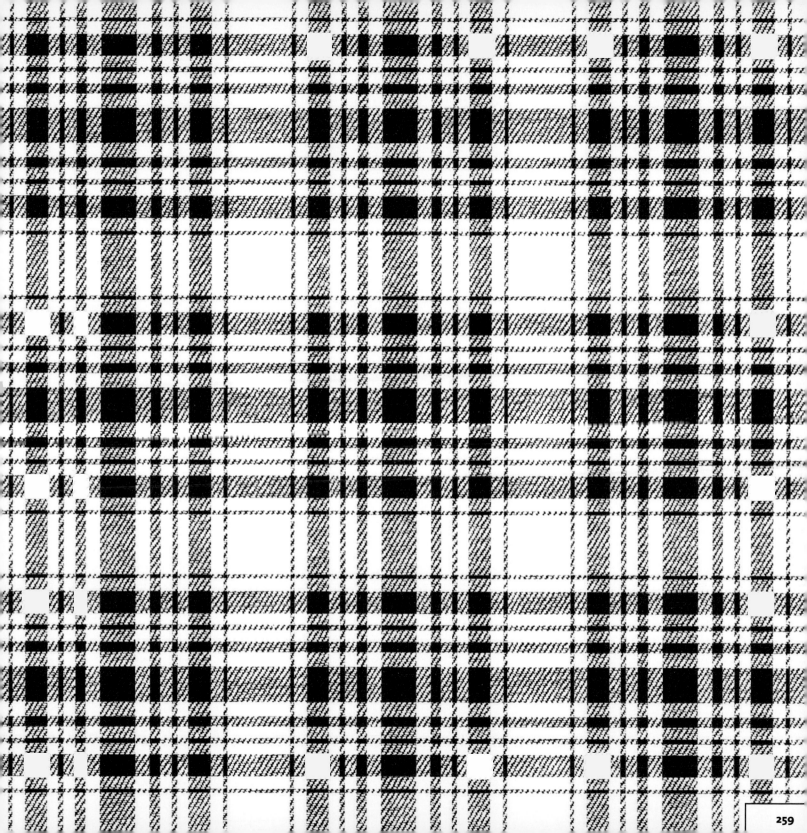

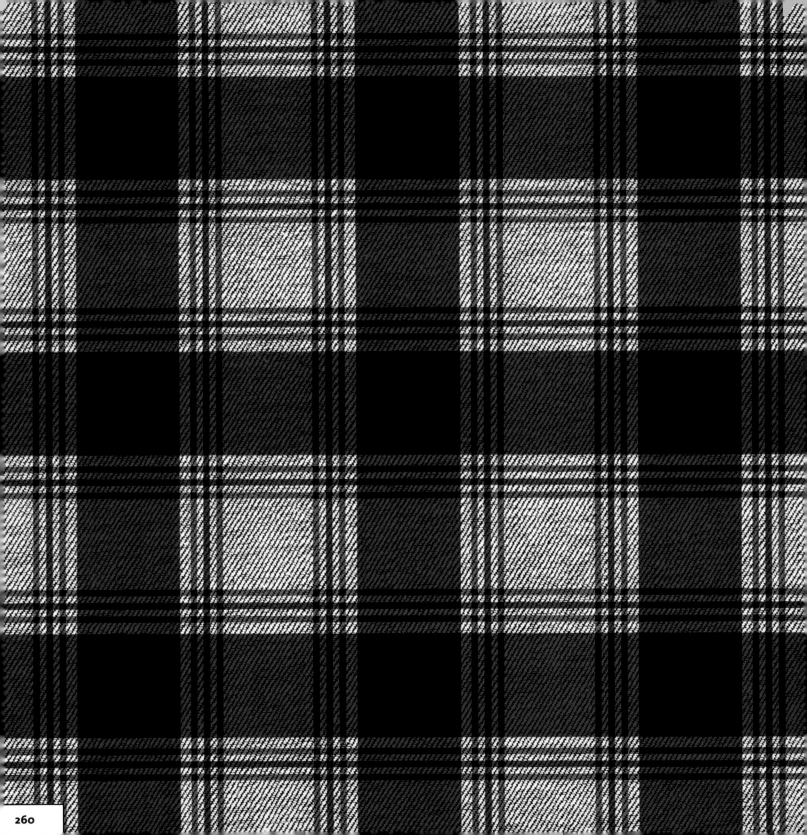

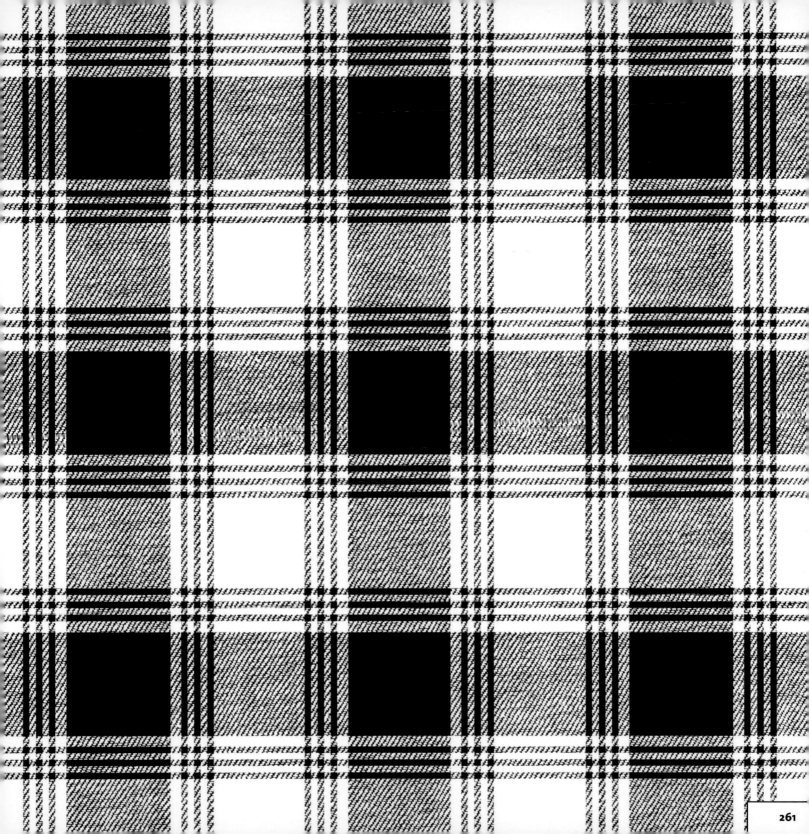

English

Shantung / Chantung

Shantung or chantung, named after a region in China, is a silk that is characterised by an uneven, knobbly surface. This is a result of the use of unrefined silk threads which are of uneven thickness and contain knobs and knots. Originally woven to be thin and soft, with a rather sparse weft, since the 20th century, it has been made heavier and more compact, often with the addition of rayon or cotton threads in mixed ratios. Traditionally employed for the making of eveningwear, it is no longer readily available in Europe or the Americas and can often only be found in the form of scarves, shawls and sarongs imported from Asia.

Italiano

Shantung

Lo shantung o *chan-tung*, prende il nome da una regione della Cina, è detto anche *doppione* ed è caratterizzato da una superficie irregolare e nodosa. È il risultato dell'uso di fili di seta non raffinata di differente spessore e che contengono dei nodi. In origine era un tessuto sottile e morbido e si tesseva in maniera rada. A partire dal XX secolo si è reso più pesante e più compatto, aggiungendo anche dei fili di cotone o di rayon. Tradizionalmente impiegato per la realizzazione di abiti da sera, è ormai difficile da reperire in Europa e in America. Si trova solo d'importazione orientale, sotto forma di sciarpe, scialli o pareo.

Deutsch

Shantungseide

Shantungseide (bzw. chantung) benannt nach einer Region in China, ist eine Seide, die von einer unebenen, knubbeligen Oberfläche gekennzeichnet wird. Dies kommt von der Verwendung von rohen Seidenfäden, die eine ungleiche Dicke haben und Knoten aufweisen. Ursprünglich wurde sie gewebt, sodass die Seide dünn und weich war und eine eher netzartige Struktur hatte. Seit dem 20. Jahrhundert wurde sie schwerer und kompakter hergestellt, wobei oftmals Rayon oder Baumwollgarn in bestimmten Mischverhältnissen hinzugefügt wurden. Traditionell wurde Shantungseide für die Fertigung von Abendkleidung verwendet, aber sie ist nicht mehr einfach in Europa oder Nord- und Südamerika erhältlich und ist jetzt nur in der Form von Tüchern, Schals und Sarongs zu finden, die aus Asien importiert werden.

Español

Shantung

El *shantung*, originario de la región china homónima, es un tejido de seda que se caracteriza por su superficie tosca y en relieve. Es el resultado de la utilización de hilos de seda sin refinar de grosor irregular que contienen protuberancias y nudos. Antiguamente elaborado para obtener un acabado fino y sedoso, con una trama relativamente espaciada, desde el siglo XX se fabrica de manera que quede más pesado y compacto, a menudo con la incorporación de hilos de rayón o algodón. Tradicionalmente utilizado para la confección de trajes de noche, actualmente en Europa y en el continente americano solo se encuentra en forma de pañuelos, chales y pareos importados de Asia.

Français

Le shantung ou shantoung

Le shantung ou shantoung, du nom de la région de Chine, est une soie qui se caractérise par sa surface noueuse et irrégulière. Il est le fruit de l'utilisation de fils de soie brute qui sont d'épaisseur irrégulière et qui contiennent des nœuds. Tissé à l'origine pour être mince et doux, avec une trame plutôt légère, depuis le XXᵉ siècle il a été rendu plus épais et plus compact, souvent par l'addition de fils de rayonne ou de coton en proportions mixtes. Traditionnellement employé pour la confection de tenues de soirée, il n'est plus disponible en Europe ou dans les Amériques et peut souvent se retrouver sous forme d'écharpes, de châles et de sarongs importés d'Asie.

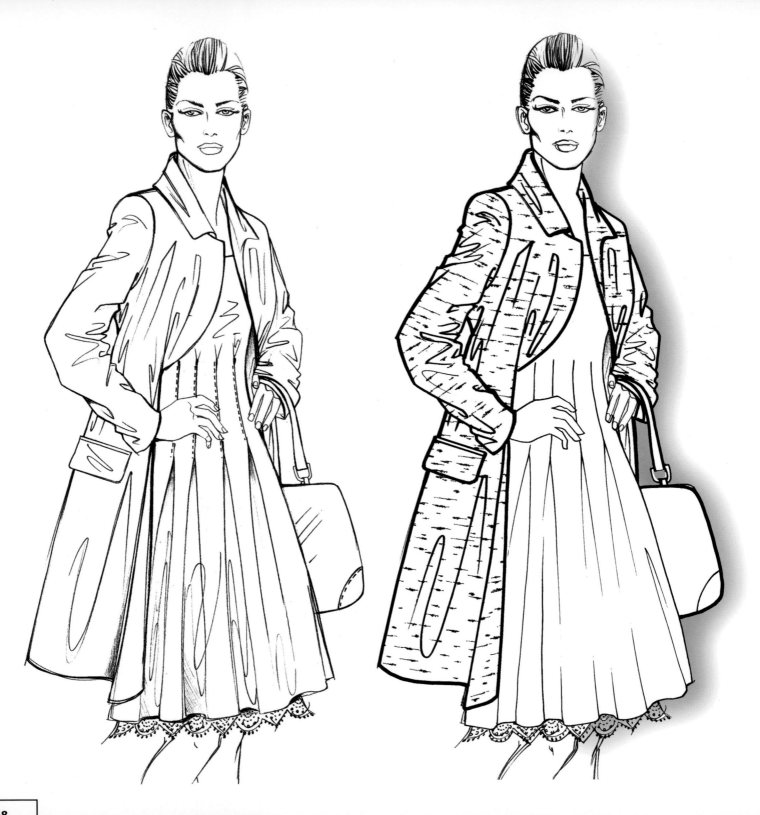

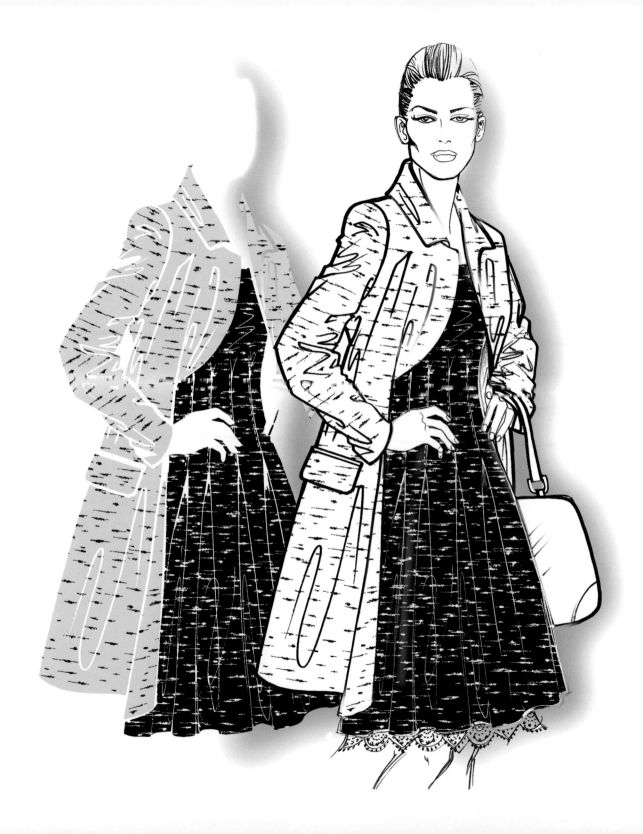

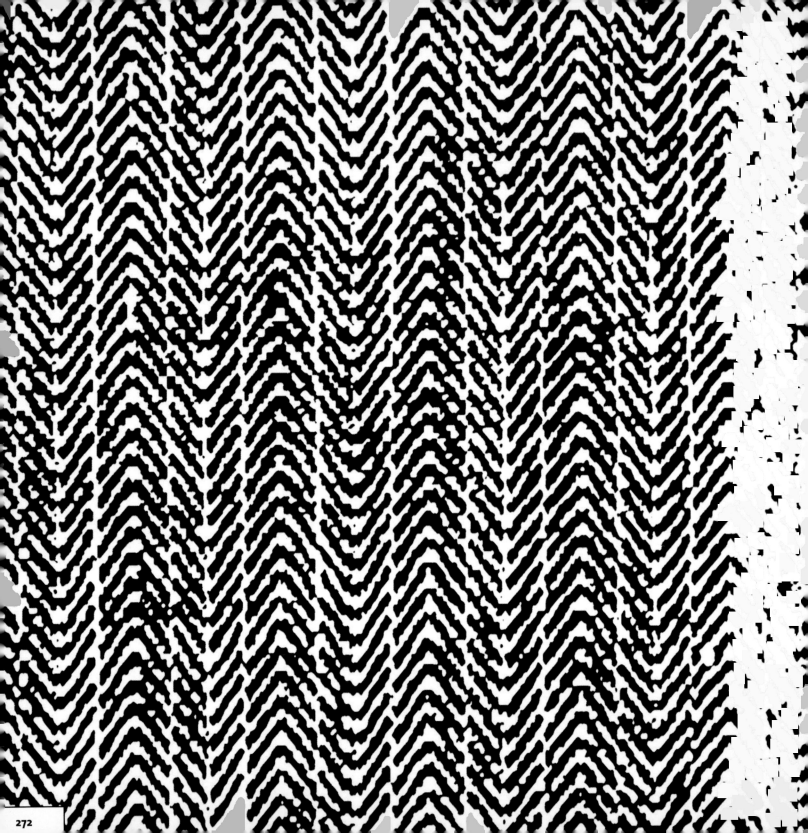

HERRINGBONE / CHEVRON

SPINATO / CHEVRON

FISCHGRÄTENSTOFF / CHEVRON-GEWEBE

TEJIDO DE ESPIGA / GALÓN

LES CHEVRONS

English

Herringbone / Chevron

Fabric with an alternating twill weave. The alternating weave creates a characteristic zigzag or chevron pattern which resembles the skeletal structure of a herring. Since the 19th century, it has been used for suits, jackets and outerwear for both men and women.

Italiano

Spinato / Chevron

Si tratta di un tessuto ad armatura a saia o levantina, che crea un disegno a zigzag caratteristico e ricorda la struttura della spina di un pesce. Usato a partire dal XIX secolo nella realizzazione di capispalla e completi sia maschili che femminili, è conosciuto anche con i nomi di *spina di pesce*, *rescato* o *chevron*.

Deutsch

Fischgrätenstoff / Chevron-Gewebe

Stoff mit einer abwechselnden Köperbindung. Die abwechselnde Webung erzeugt ein charakteristisches Zickzack- oder Chevronmuster, das der Skelettstruktur eines Herings ähnelt. Seit dem 19. Jahrhundert wird es für Anzüge, Jacken und Oberbekleidung für sowohl Damen als auch Herren verwendet.

Español

Tejido de espiga / Galón

Tejido de ligamento de sarga alterno. El ligamento alterno crea un característico estampado en forma de zigzag o galón que recuerda la estructura de una espiga. Desde el siglo XIX, se ha utilizado para confeccionar trajes, chaquetas y prendas de abrigo masculinas y femeninas.

Français

Les chevrons

Tissu avec une armure sergé alternée. L'armure alternée produit un effet de zigzag caractéristique qui évoque des chevrons. Depuis le XIXe siècle, on l'utilise pour les complets, les vestes et les vêtements d'extérieur pour homme et pour femme.

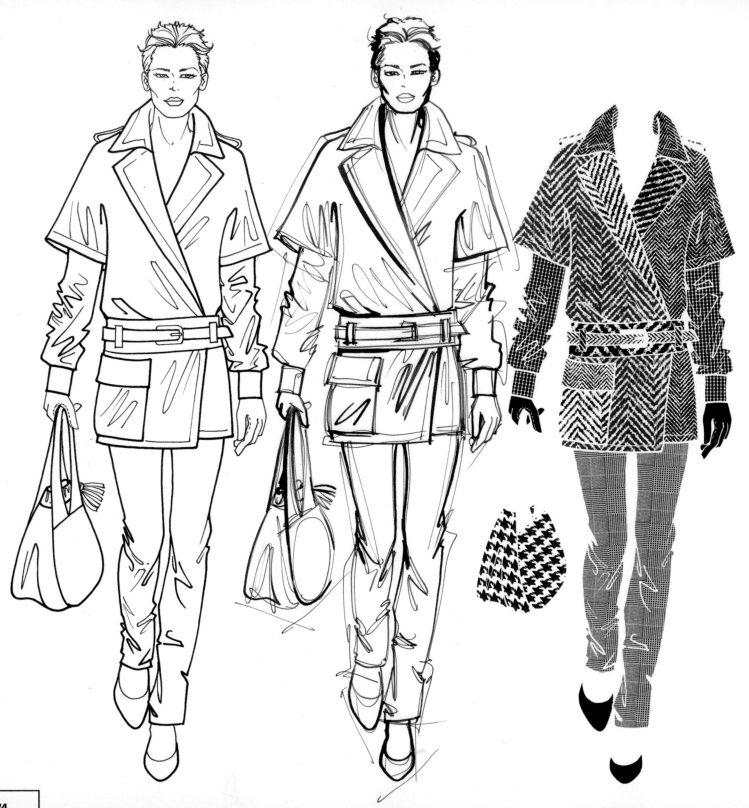

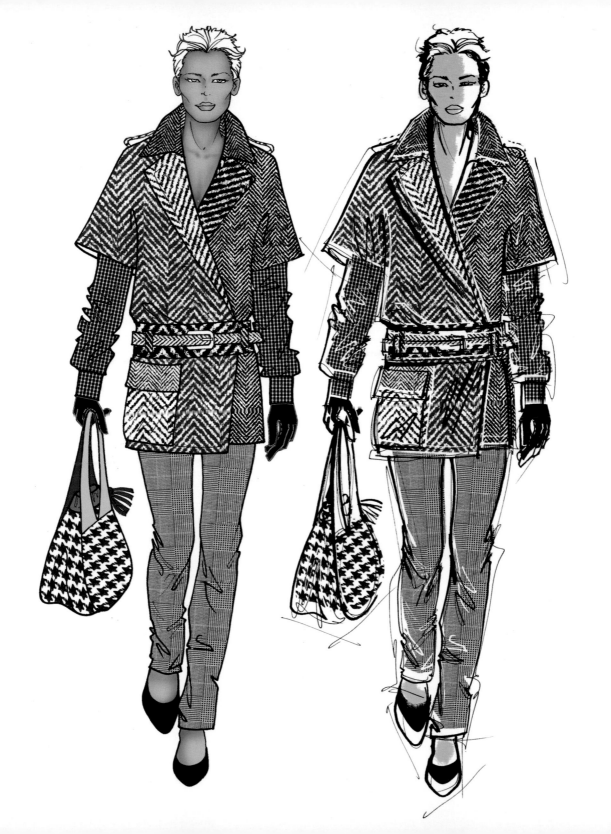

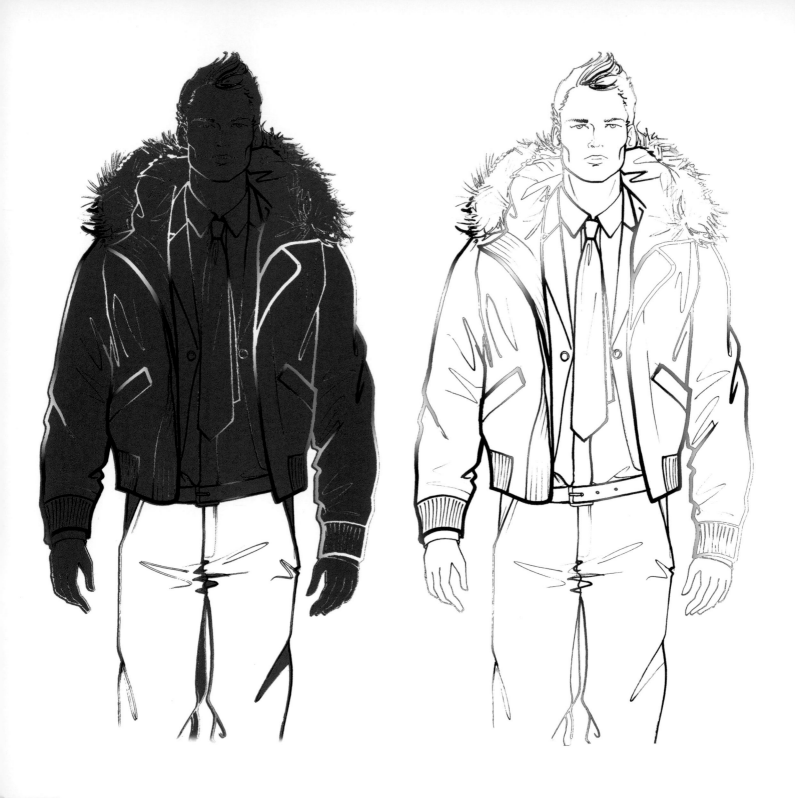

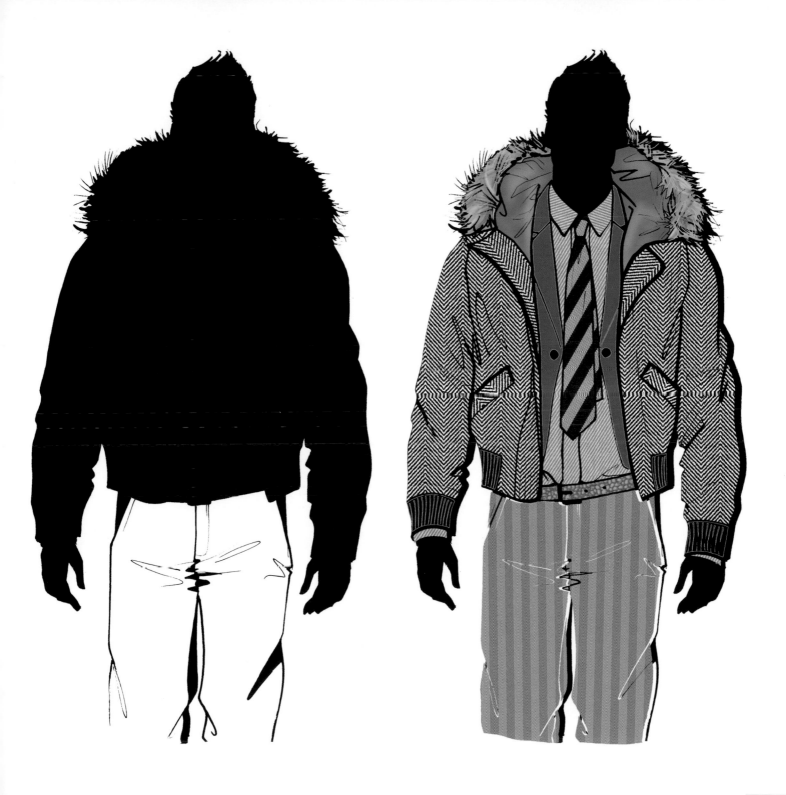

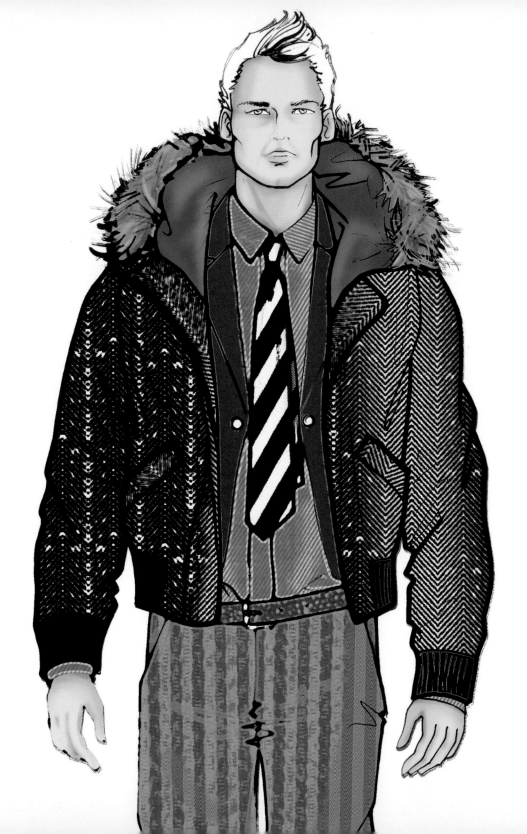

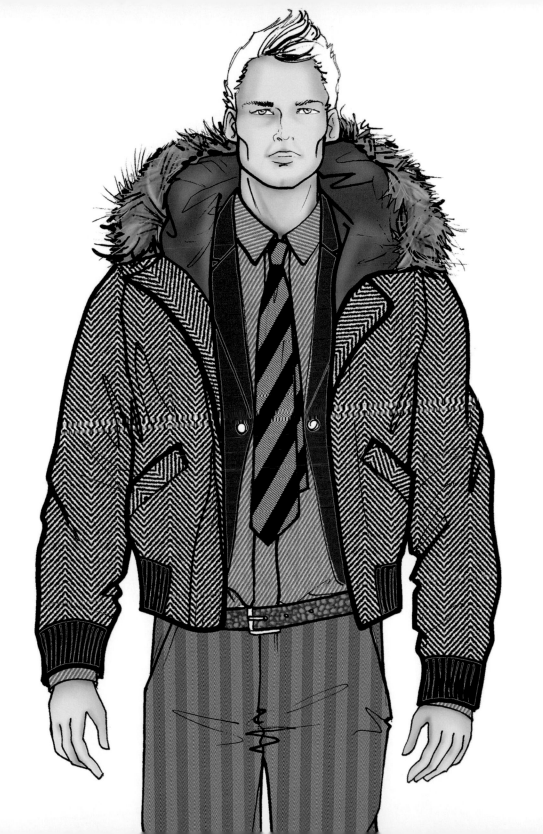

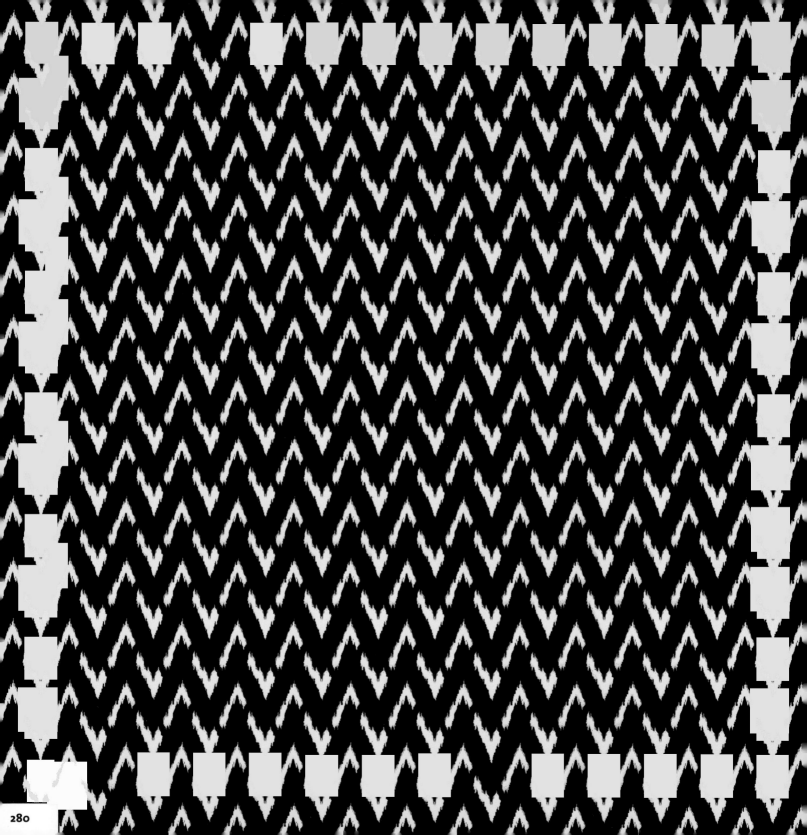

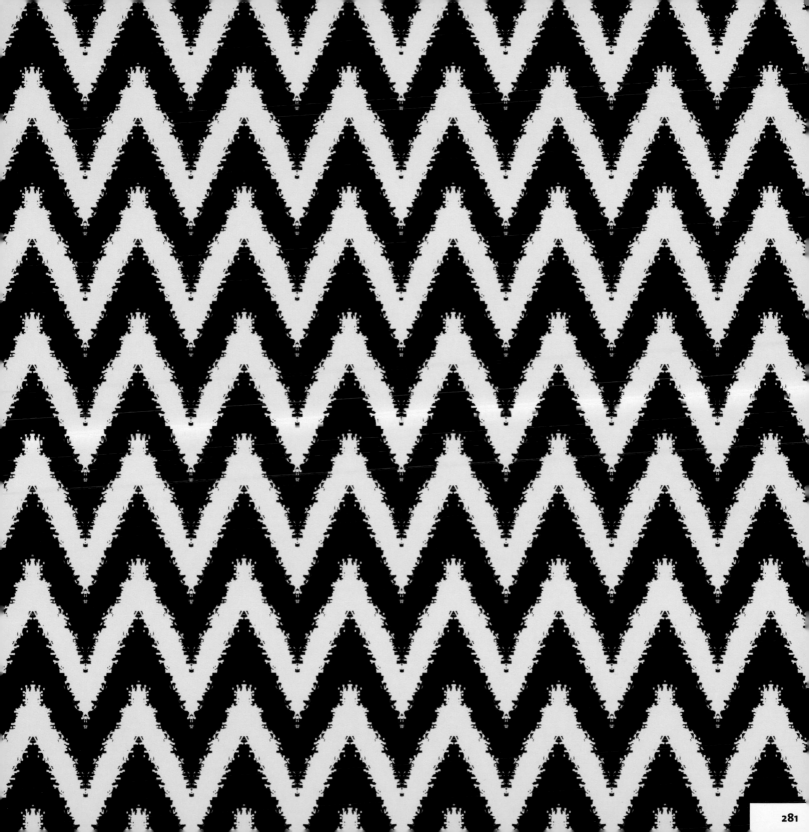

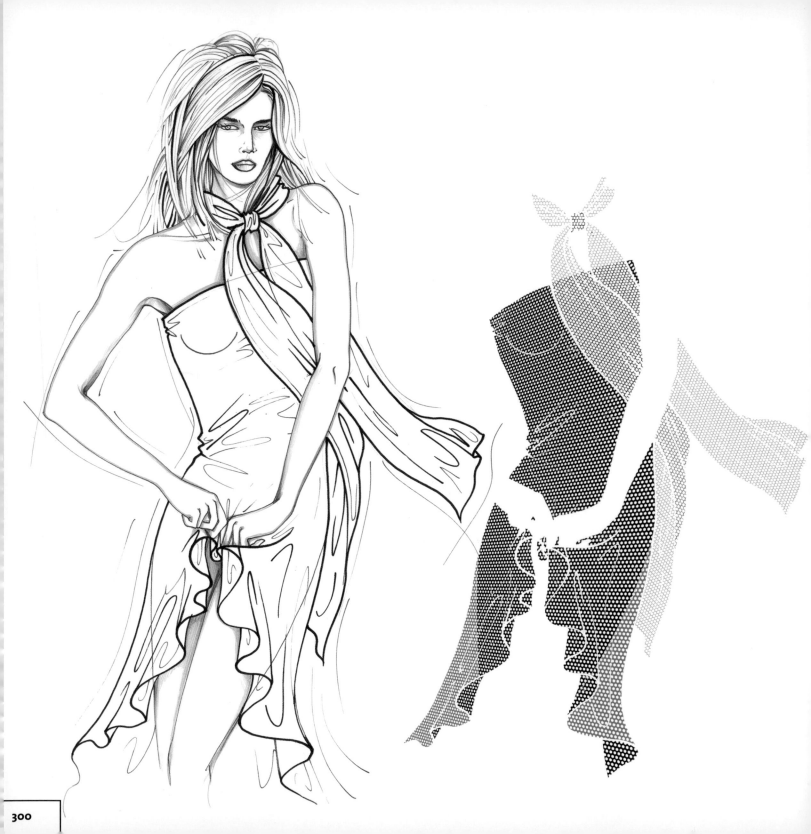

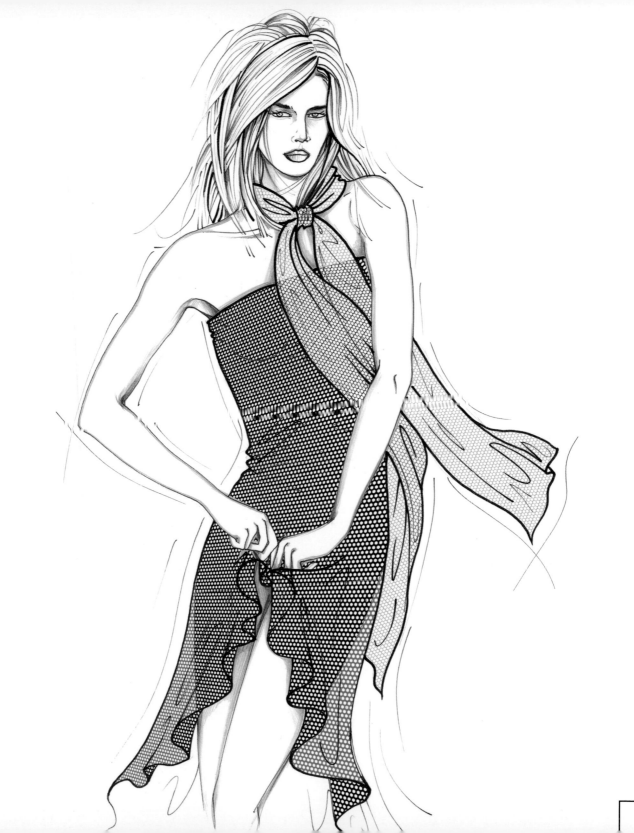

Tweed

The name appears to have been a misspelling of "tweel" or "tweeled" (the Scottish words for "twill" and "twilled") and has also been associated with the River Tweed in Scotland, a river important to the textile industry in Scotland in the 19th century. Tweed is a woollen fabric with a rough, uneven surface and a thick weft. Produced in a wide range of colours, often with a "heather" effect obtained by twisting differently coloured wools into a single multi-ply yarn. Originally made of pure wool, some modern tweeds are blended with cotton or synthetic fibres. Tweed is used widely in making men's and women's suits, jackets and outerwear.

One of the most famous names in tweeds is Harris. To be called a "Harris Tweed", the fabric must be made on the islands of the Outer Hebrides (off the coast of Scotland), must be hand-woven in the home of weavers and can only be made using 100 percent virgin wool that has been dyed, spun and finished on the islands. Ireland is also known for producing high-quality tweeds, particularly in the northern counties of Donegal and Tyrone. In England, the Linton Tweeds company has long been renown for the range of tweeds it has produced for designers and fashion houses such as Chanel, Schiaparelli, Balenciaga, Dior and Saint Laurent. Coco Chanel's name became associated with the fresh, modern look that she introduced to tweeds – "Chanel tweeds" were characterised by chunky, knobby textures and a fanciful use of colours.

Tweed

Il nome sembra derivare da una storpiatura, ovverosia del termine scozzese *tweel* o *tweeled* (varianti indigene di *twill* e *twilled* – tessuto in armatura a batavia) ed è stato anche associato al fiume Tweed che scorre sempre in Scozia e ha giocato un ruolo importante nell'industria tessile di questo paese. Si tratta di un tessuto in lana dalla superficie grezza e irregolare, a trama grossa. Prodotto in una vasta gamma di motivi colorati, ha spesso un effetto particolare, che ricorda i fiori dell'erica, ottenuto arricciando diverse lane in un solo filo. In origine era confezionato solo con fili di lana, oggi viene fabbricato anche in cotone o in fibre sintetiche. È impiegato spesso nella confezione di abiti da uomo e da donna e di capispalla.

Uno dei tipi più famosi di tweed è detto Harris. Si tratta di un tipo di tessuto prodotto nelle Ebridi esterne (isole situate di fronte alle coste della Scozia), tessuto a mano in casa e utilizzando solo lana vergine al 100% tinta, filata e rifinita su quelle isole. Anche l'Irlanda è famosa per la sua produzione di tweed di alta qualità, specialmente le contee settentrionali di Donegal e Tyrone. In Inghilterra l'azienda Linton Tweeds è assai rinomata e ha prodotto da sempre il tweed per stilisti e case di moda quali Chanel, Schiaparelli, Balenciaga, Dior e Saint Laurent. Il nome di Coco Chanel è associato al tocco fresco e moderno che questa stilista ha dato al tweed. I suoi tweed erano caratterizzati da una consistenza spessa e nodosa e dai colori inusuali e divertenti.

Tweed

Der Name scheint ein Schreibfehler von »tweel« oder »tweeled« zu sein (den schottischen Wörtern für die englischen Begriffe »twill« und »twilled«) und wird ebenfalls mit dem Fluss Tweed in Schottland in Verbindung gebracht. Dies ist ein Fluss, der eine wichtige Rolle für die Textilindustrie in Schottland im 19. Jahrhundert spielte. Tweed ist ein Wollstoff, der eine raue, ungleichmäßige Oberfläche mit einem dicken Schuss besitzt. Er wird in einer Reihe von Farben hergestellt und hat oftmals einen »Heide«-Effekt, der erzielt wird, indem unterschiedlich gefärbte Wolle in einem einzelnen mehrlagigem Garn gedreht werden. Ursprünglich wurde er aus reiner Wolle gemacht. Einige moderne Tweedarten enthalten Baumwolle oder synthetische Fasern. Tweed wird häufig bei der Herstellung von Herren- und Damenanzügen, Jacken und Oberbekleidung verwendet.

Einer der berühmtesten Namen in Bezug zu Tweed ist Harris. Um den Namen »Harris Tweed« zu tragen muss der Stoff auf den Inseln der äußeren Hebriden (vor der Küste Schottlands) hergestellt worden sein. Ferner muss er im Haus der Weber handgewebt werden und es darf nur hundertprozentige Schurwolle verwendet werden, die auf den Inseln gefärbt, gesponnen und veredelt wurde. Irland ist ebenfalls für die Fertigung hochwertiger Tweeds bekannt, insbesondere in den nördlichen Grafschaften Donegal und Tyrone. In England ist die Firma Linton Tweeds seit langem bekannt für ihre Palette von Tweedstoffen, die für Designer und Modehäuser wie Chanel, Schiaparelli, Balenciaga, Dior und Saint Laurent hergestellt werden. Der Name Coco Chanel wurde mit dem neuen, modernen Look assoziiert, den sie den Tweedstoffen verlieh – »Chanel Tweed« wurde von stämmigen, knotenartigen Texturen und einer ausgefallenen Verwendung von Farben charakterisiert.

Español

Tweed

Este término parece una forma ortográficamente incorrecta de *tweel* o *tweeled* (que en escocés se refieren al ligamento de sarga), aunque también suele asociarse al río escocés de Tweed, que fue muy importante para la industria textil de Escocia en el siglo XIX. El *tweed* es un tejido de lana que se caracteriza por la superficie tosca e irregular y el grosor de la trama. Se fabrica en una amplia gama de colores, a menudo con un efecto «brezo» que se obtiene retorciendo lanas de colores distintos en un único hilo de varias hebras. Fabricado con pura lana en sus orígenes, las versiones actuales se mezclan con algodón o fibras sintéticas. El *tweed* se utiliza habitualmente para confeccionar trajes, chaquetas y prendas de abrigo masculinas y femeninas.

Una de las variaciones más conocidas del *tweed* es el Harris. Para que pueda llamarse un *tweed* Harris, el tejido debe ser originario de las islas escocesas Hébridas Exteriores, haberse ligado a mano en casa del tejedor y elaborado con pura lana virgen teñida, cardada y acabada en las islas. Irlanda también es conocida por sus *tweeds* de calidad, sobre todo los condados de Donegal y Tyrone. En Inglaterra, la empresa Linton Tweeds cuenta con una larga tradición en la fabricación de este tipo de tejido para casas de moda como Chanel, Schiaparelli, Balenciaga, Dior y Saint Laurent. El nombre de Coco Chanel va asociado al toque fresco y moderno que la diseñadora dio a sus *tweeds*, que se caracterizaban por las texturas fornidas y protuberantes y el uso imaginativo del color.

Français

Le tweed

Le nom semble provenir d'une mauvaise orthographe de « *tweeled* » – le mot écossais pour « *twilled* » (sergé) – et il a aussi été associé au fleuve Tweed en Écosse, un cours d'eau important pour l'industrie textile dans l'Écosse du XIXe siècle. Le tweed est une étoffe de laine qui possède une surface rude et inégale et une trame épaisse. Produit dans une vaste gamme de couleurs, souvent avec un effet de « bruyère » obtenu en tordant des fils de laine de couleurs différentes en un seul brin. Fait à l'origine de laine pure, certains tweeds modernes sont le résultat d'un mélange de laine et de coton ou de fibres synthétiques. Le tweed sert principalement à la confection de complets, de tailleurs, de vestes et de vêtements d'extérieur.

L'un des noms les plus célèbres pour le tweed est Harris. Pour porter le nom « Harris tweed », le tissu doit être produit dans les Hébrides occidentales (près des côtes de l'Écosse), il doit être tissé à la main au domicile d'un tisserand et doit être fait de laine vierge à 100 % qui a été teinte, filée et finie dans ces îles. L'Irlande est également connue pour sa production de tweeds de grande qualité, particulièrement au nord, dans les comtés de Donegal et Tyrone. En Angleterre, la société Linton Tweeds jouit d'une longue réputation pour la variété de tweeds qu'elle a produite pour les couturiers et les maisons comme Chanel, Schiaparelli, Balenciaga, Dior et Saint Laurent. On a associé le nom de Coco Chanel au style frais et moderne qu'elle a donné aux tweeds ; les « tweeds Channel » se caractérisaient par leur texture grosse et noueuse, ainsi que par leur utilisation imaginative des couleurs.

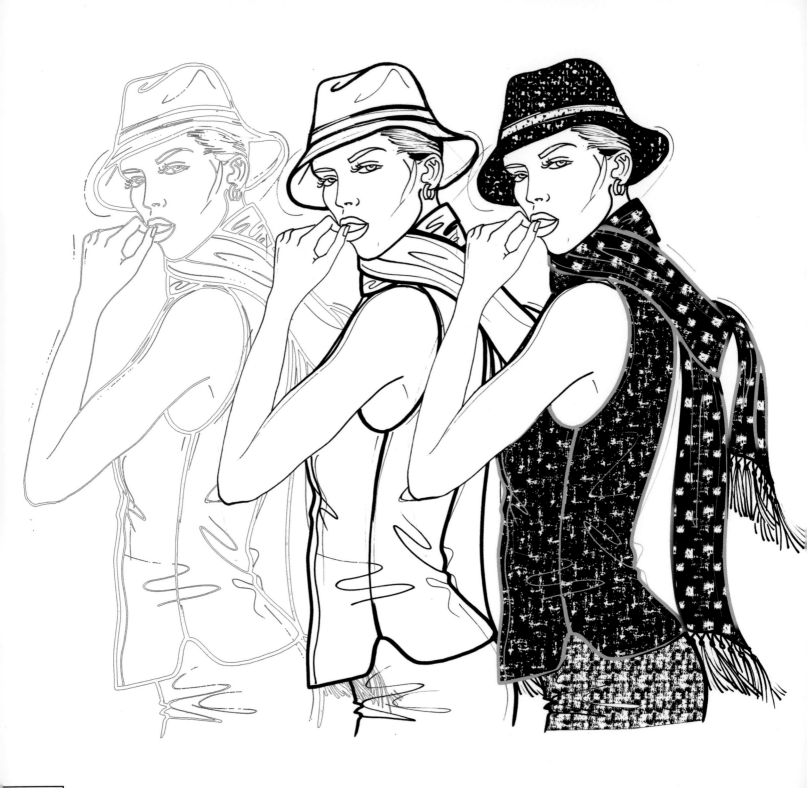

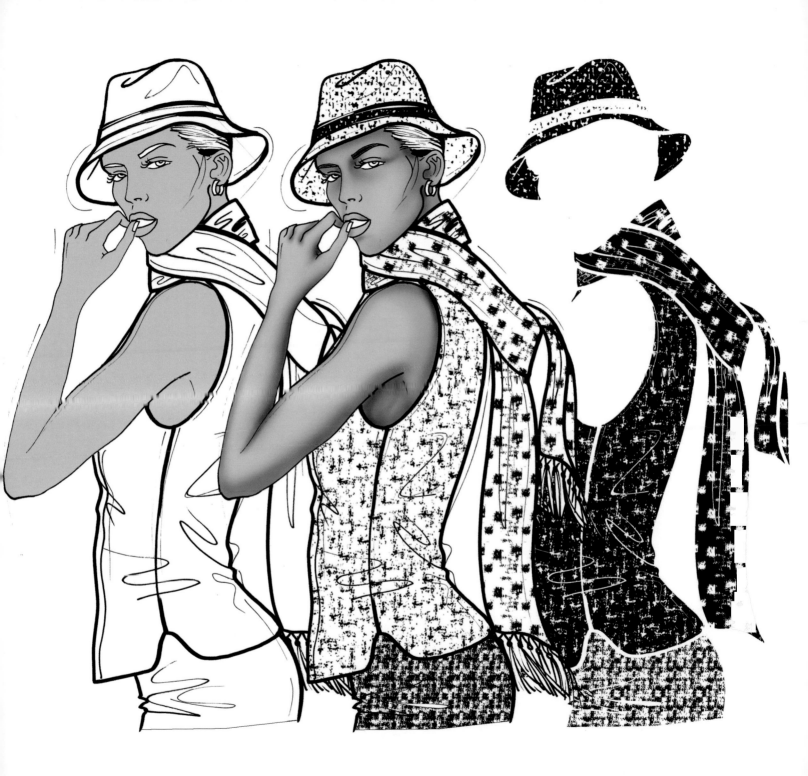

Velvet

Velvet was most likely first made in ancient China but magnificent velvets have been produced in Europe since the 12th century. In the 19th century, velvet was commonly used for suits and jackets. Since then, it has been considered a luxury fabric and is employed mainly in the making of eveningwear – with a notable exception during the 1970s when it was used widely for making daywear such as skirts, jackets and trousers. A close-knit fabric with a short, dense pile and a soft, smooth, luxurious surface, made by weaving loops of thread into the fabric and then trimming them after weaving. Velour resembles the look and feel of velvet but is knitted, not woven. Originally made using silk, velvet is now made using cotton, wool, synthetic fibres or blends. Velvet can be produced in numerous variations – short, long or mixed pile length; fine, coarse or super-coarse; or embossed (découpé), which exhibits a raised pattern.

Corduroy

Corduroy is made using similar a technique but the fabric structure consists of alternating ridges (also called wales) and channels (bare to the underlying fabric structure), which create a ribbed texture. Corduroy fabric is classified by the width of the wale and can vary from pinwale to wide. This variation of velvet was most likely first produced in England. Though the name sounds vaguely French (cord du roi), this phrase is not used in French and was probably coined in English to sound French.

Velluto

Molto probabilmente il velluto venne prodotto per la prima volta in Cina, ma a partire dal XII secolo si sono prodotti degli splendidi velluti anche in Europa. Nel XIX secolo il velluto era usato comunemente per la confezione di abiti e giacche. Da allora è stato considerato un tessuto di lusso e viene impiegato principalmente per gli abiti da sera – con un'evidente eccezione, negli anni Settanta, quando veniva usato per l'abbigliamento di tutti i giorni, comprese gonne, giacche e pantaloni. È un tessuto lavorato a maglie fitte, con un pelo corto e fitto e una superficie morbida, soffice e sontuosa, ottenuta tessendo anelli di filo nel tessuto stesso e rifinendoli in seguito. Il velluto in origine veniva prodotto utilizzando dei fili di seta, adesso lo si fa con fili di cotone, lana, fibre sintetiche o miste. Si può produrre in un'ampia gamma di variazioni – a pelo lungo, corto o misto, fine, massiccio o molto spesso, o a rilievo – *découpé*. Il velour ricorda al tatto e alla vista il velluto.

Velluto a coste

Il velluto a coste viene tessuto utilizzando una tecnica analoga. La struttura di questo tessuto consiste in un'alternanza di coste e scanalature, la cui superficie è posta al di sotto di quella del tessuto. La trama finale appare rigata. Il velluto a coste è classificato in base allo spessore delle coste, il quale può variare di molto. Questo tipo di velluto fu prodotto per la prima volta in Inghilterra.

Samt

Samt wurde wahrscheinlich zuerst im antiken China hergestellt, aber seit dem 12. Jahrhundert wurden phantastische Samtstoffe in Europa gefertigt. Im 19. Jahrhundert wurde Samt häufig für Anzüge und Jacken verwendet. Seitdem wird es als ein Luxusstoff betrachtet und wird hauptsächlich in der Herstellung von Abendkleidung benutzt – mit der Ausnahme, dass es während den 70ern breite Verwendung in der Produktion von Tageskleidung wie Röcken, Jacken und Hosen fand. Ein engmaschiger Stoff mit einem kurzen, dichten Flor und einer weichen, luxuriösen Oberfläche, die gefertigt wird, indem Schleifen von Garn in den Stoff gewebt und nach dem Weben gekürzt werden. Velours ähnelt dem Samt sowohl im Aussehen als auch im Griff, aber wird gestrickt und nicht gewebt. Ursprünglich wurde es mit Seide gefertigt, aber heute wird Samt mit Baumwolle, Wolle, synthetischen Fasern oder Fasermischungen hergestellt. Samt kann in zahllosen Variationen produziert werden – kurze, lange oder gemischte Florhöhe; fein, grob oder besonders grob oder geprägt (ausgeschnitten), wodurch ein angehobenes Muster erzeugt wird.

Kordsamt

Kordsamt wird mit einer ähnlichen Technik gefertigt, aber die Stoffstruktur besteht aus abwechselnden Erhöhungen und Kanälen (wo die darunter liegende Stoffstruktur frei liegt) und so wird eine gerippte Textur erzeugt. Kordsamt wird nach der Breite der Rippen klassifiziert und kann von Babycord bis zu Breitcord variieren. Diese Variation von Samt wurde sehr wahrscheinlich zuerst in England produziert.

Terciopelo

Probablemente, el terciopelo se elaboró por primera vez en la antigua China, aunque en Europa se han fabricado algunas de las variedades más lujosas desde el siglo XII. En el siglo XIX, el terciopelo solía utilizarse para confeccionar trajes y chaquetas. Desde entonces, se ha considerado un tejido suntuoso que se reserva sobre todo para los vestidos de noche, con una notable excepción durante la década de 1970, cuando se utilizaba para confeccionar ropa de calle como faldas, chaquetas y pantalones. Para la elaboración de este tejido de punto apretado, pelo denso y corto, y superficie suave, tersa y suntuosa, los bucles de hilo se ligan y se cortan después de calarlos. La apariencia y el tacto del veludillo son parecidos a los del terciopelo, aunque el primero se teje en lugar de calarse. Aunque antiguamente se fabricaba con seda, actualmente el terciopelo se obtiene del algodón, la lana, las fibras sintéticas o las mezclas. Existen muchas variaciones del terciopelo: de pelo corto, largo o combinado; fino, grueso o muy grueso, y gofrado, que se caracteriza por el estampado en relieve.

Pana

La pana se obtiene mediante una técnica similar, aunque la estructura del tejido consiste en la alternancia de relieves o canutillos y hendiduras (que permiten apreciar la estructura subyacente del tejido) que crean una textura estriada. El tejido de pana se clasifica según la anchura del canutillo. Probablemente, esta variación del terciopelo se originó en Gran Bretaña.

Le velours

Le velours a fort probablement été d'abord fabriqué en Chine, mais de magnifiques velours ont été produits en Europe à partir du XIIe siècle. Au XIXe siècle, le velours était couramment utilisé pour les complets et les vestes. Depuis, il est considéré comme une étoffe de luxe et sert surtout à la confection de tenues de soirée – à l'exception notable des années 1970 où il est utilisé pour faire des vêtements de tous les jours comme des jupes, des vestes et des pantalons. L'étoffe est tissée serrée, avec un velours court et fourni et une surface douce et somptueuse, obtenue en tissant des boucles de fils dans le tissu et en les coupant après le tissage. Le velours rasé ressemble au velours, mais il est tricoté et non tissé. Fait à l'origine avec de la soie, le velours est aujourd'hui produit avec du coton, de la laine, de la fibre synthétique ou des mélanges. Le velours peut être produit sous une multitude de formes – velours court, long ou de longueur mixte ; fin, gros ou très gros ; ou découpé, qui affiche un dessin en relief.

Le velours côtelé

Le velours côtelé est fait à l'aide de la même technique, mais la structure du tissu est créée en alternant des côtes et des sillons (pelés jusqu'à la structure sous-jacente du tissu), ce qui lui donne une texture côtelée. Le tissu de velours côtelé est classé par la largeur de la côte qui peut varier de très petite à très grosse. Cette variante du velours a probablement été d'abord produite en Angleterre. Bien que son nom en anglais semble vaguement français (corduroy), il n'est pas utilisé en français et a probablement été inventé pour avoir l'air français.

VELVET AND CORDUROY

VELLUTO E VELLUTO A COSTE

SAMT UND KORDSAMT

TERCIOPELO Y PANA

VELOURS ET VELOURS CÔTELÉ

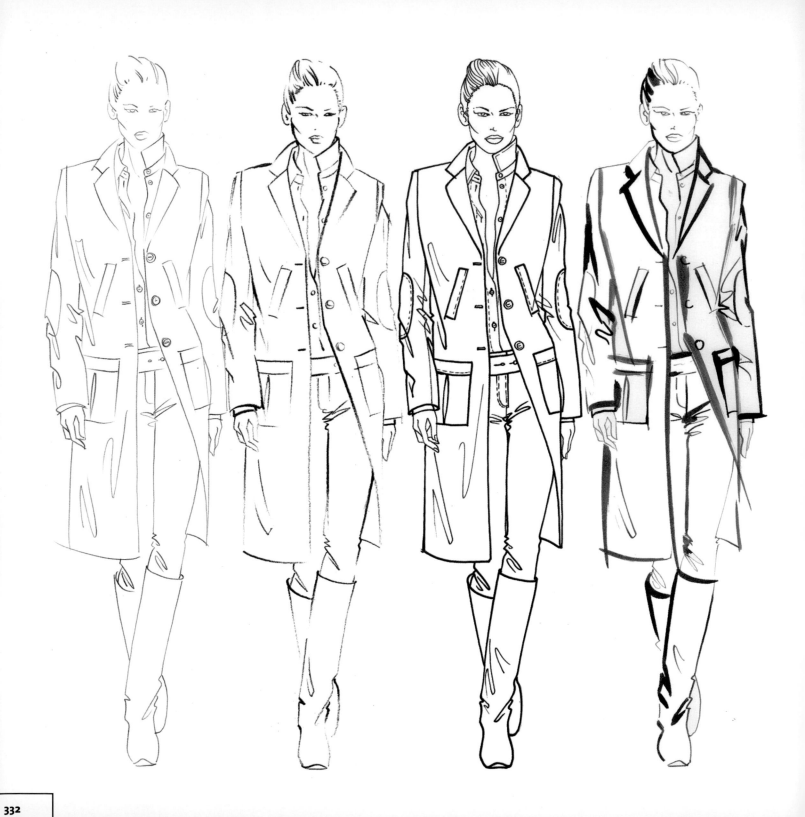

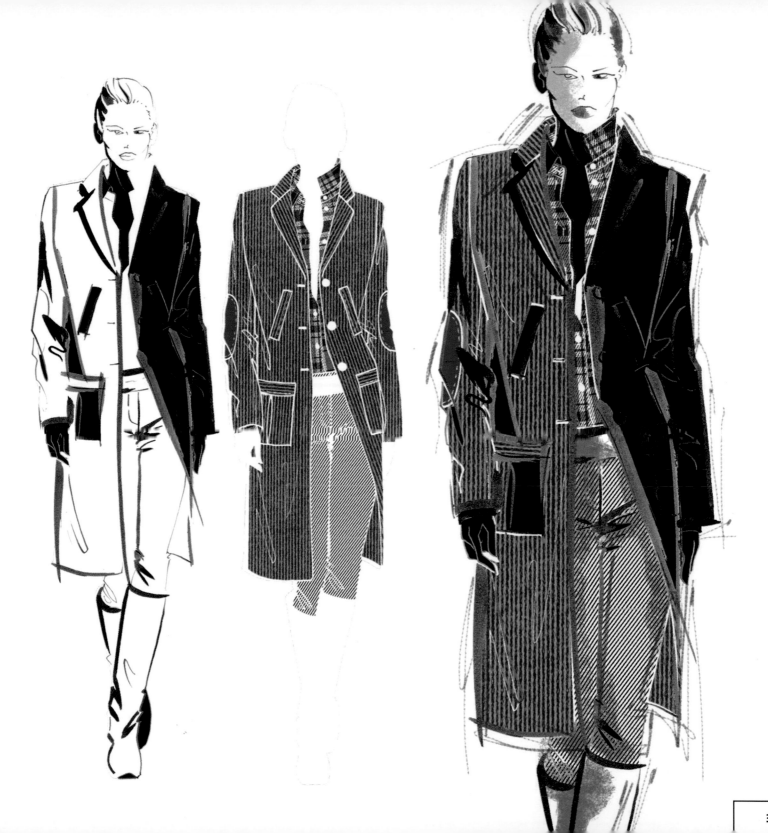

334

English

Miscellaneous Fabrics

The patterns in this section have been included to provide a sampling of textures and fabrics that do not easily fit into the standard fabric categories but which may be of interest to the fashion designer.

Italiano

Tessuti misti

I motivi in questa sezione sono stati inclusi per mostrare una campionatura di trame e tessuti che non rientrano nelle categorie standard, ma possono essere interessanti per gli stilisti e i disegnatori di moda.

Deutsch

Andere Stoffe

Die Muster in diesem Abschnitt wurden ausgewählt, um eine Auswahl von Geweben und Stoffen zu haben, die nicht einfach in den Standardkategorien eingeordnet werden können, aber für Modeschöpfer von Interesse sein könnten.

Español

Otros tejidos

Este apartado recoge una muestra de texturas y tejidos que, aun siendo difíciles de agrupar en alguna de las categorías estándar, pueden resultar de interés para el diseñador de moda.

Français

Tissus divers

Les motifs de cette section ont été inclus pour fournir un échantillonnage de textures et de tissus qui ne cadrent pas facilement dans les catégories habituelles des tissus, mais qui peuvent être d'un certain intérêt pour le dessinateur de mode.

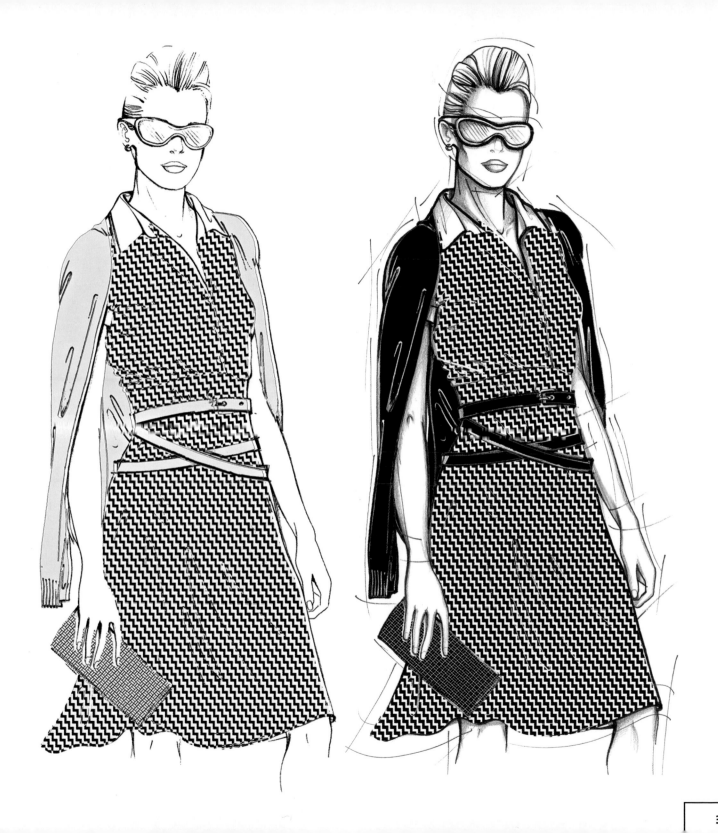

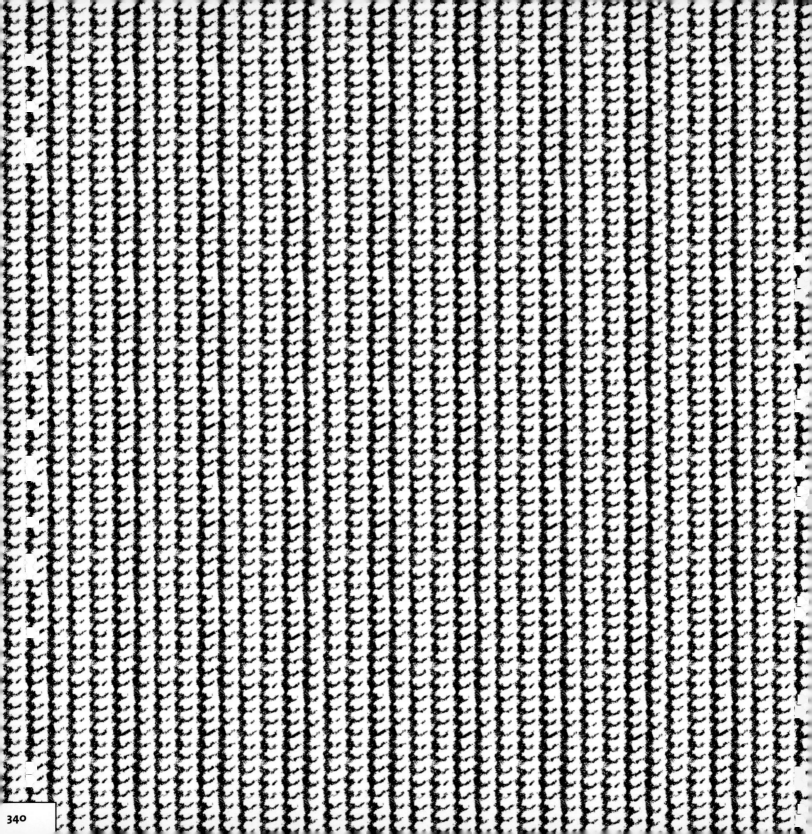

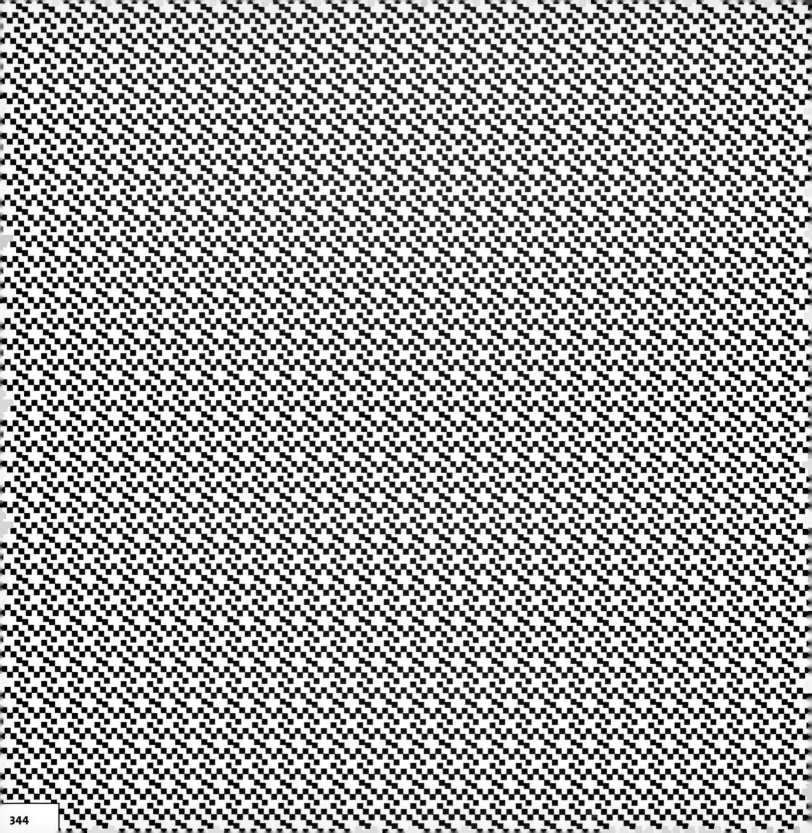

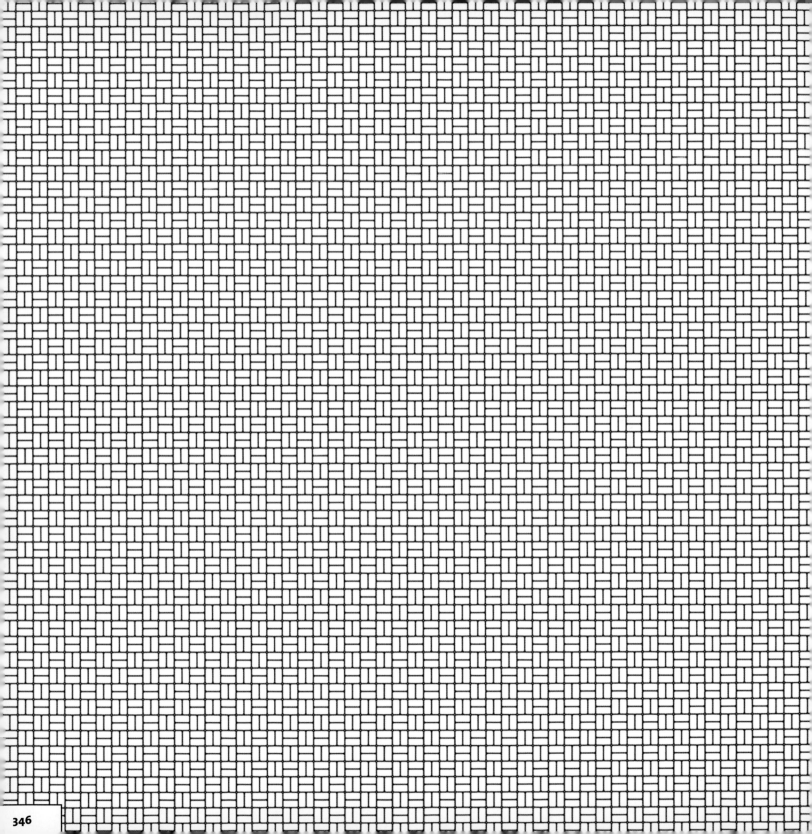

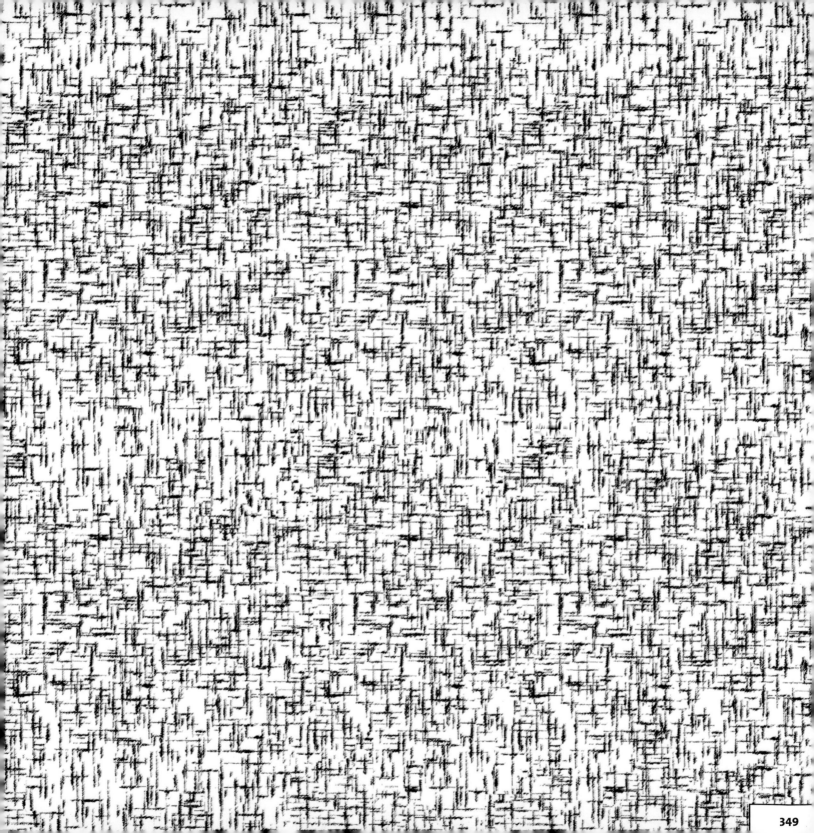